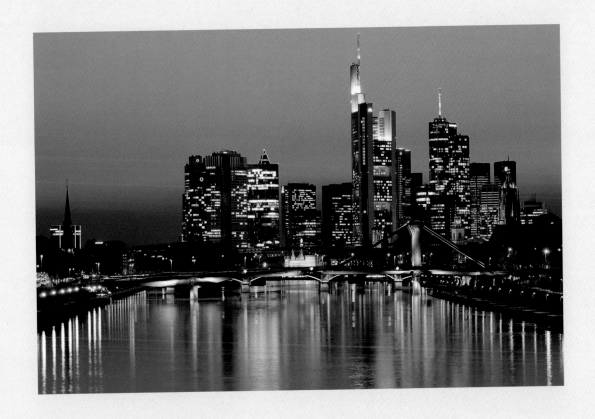

Journey through

FRANKFURT

Photos by
Tina and Horst Herzig

Text by
Kerstin Wegmann

Stürtz

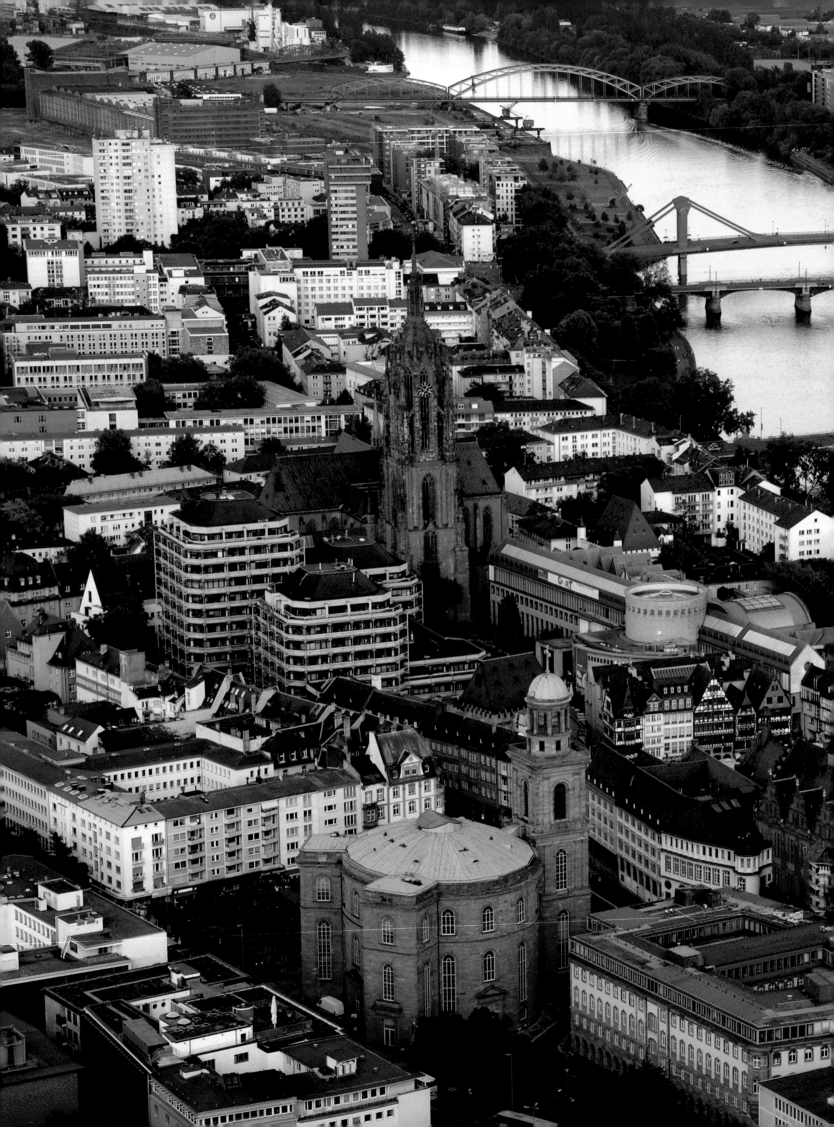

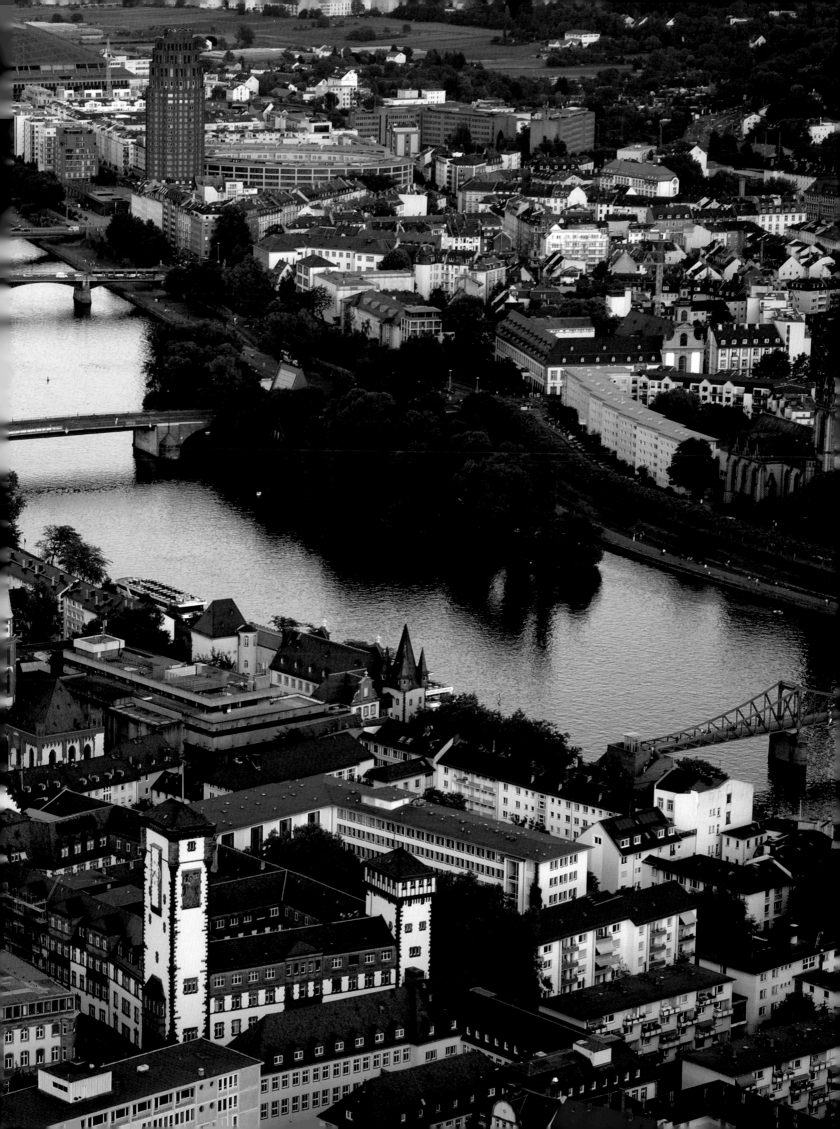

First page:
The city skyline is particularly impressive when at dusk the lights of the skyscraper banks and offices are reflected in the River Main – the very towers that have earned central Frankfurt the nickname of Mainhattan.

Previous page:
This is what Frankfurt looks like from the visitor's platform of the Maintower, open all year round – and 200 m / 650 ft up! Beneath you in miniature are all the sights: the Paulskirche, Römerplatz, the cathedral, the River Main and the skyscrapers and in the distance the hills of the Taunus, Vogelsberg, Spessart and Odenwald.

Below:
Römerberg has served a a venue for markets, fai and festivals since the 9th century – and also a a dreaded place of exec

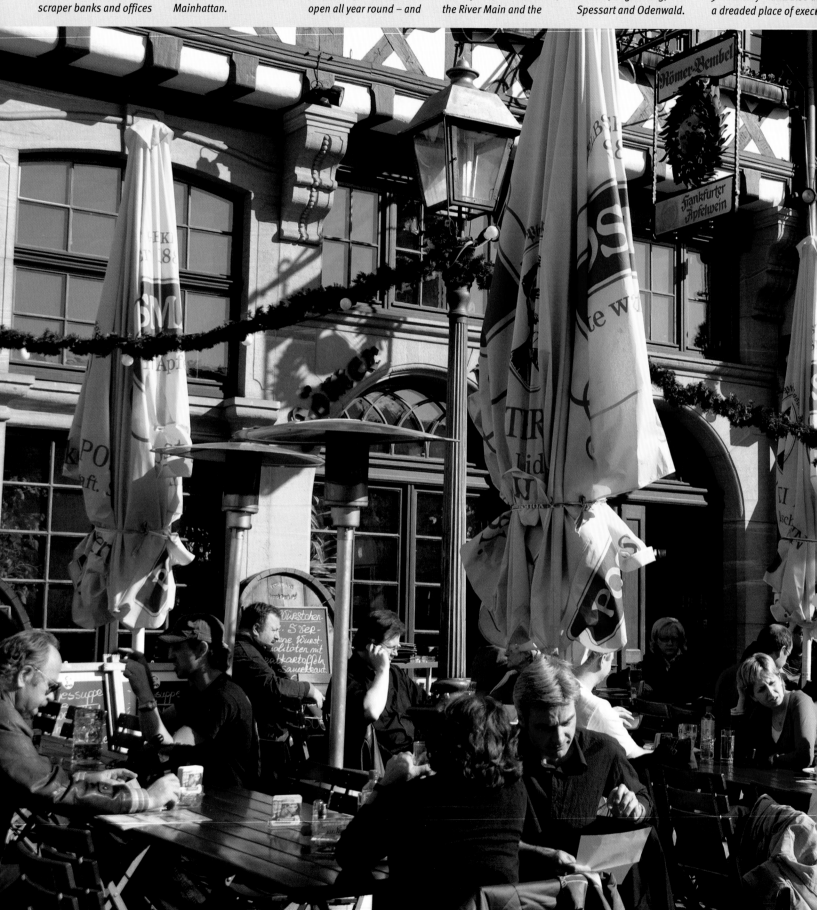

. Now popular with
et artistes and tourists
humming with jovial
vity, the mood here
ay is decidedly less
odthirsty…

Page 10/11:
*The Katharinenkirche and
the café at the Hauptwache
offer welcome respite from
the mad bustle of the city
centre, with the Zeil shop-*

*ping centre just a stone's
throw away. The windows
of the banks in the back-
ground remain lit until well
into the evening hours.*

Contents

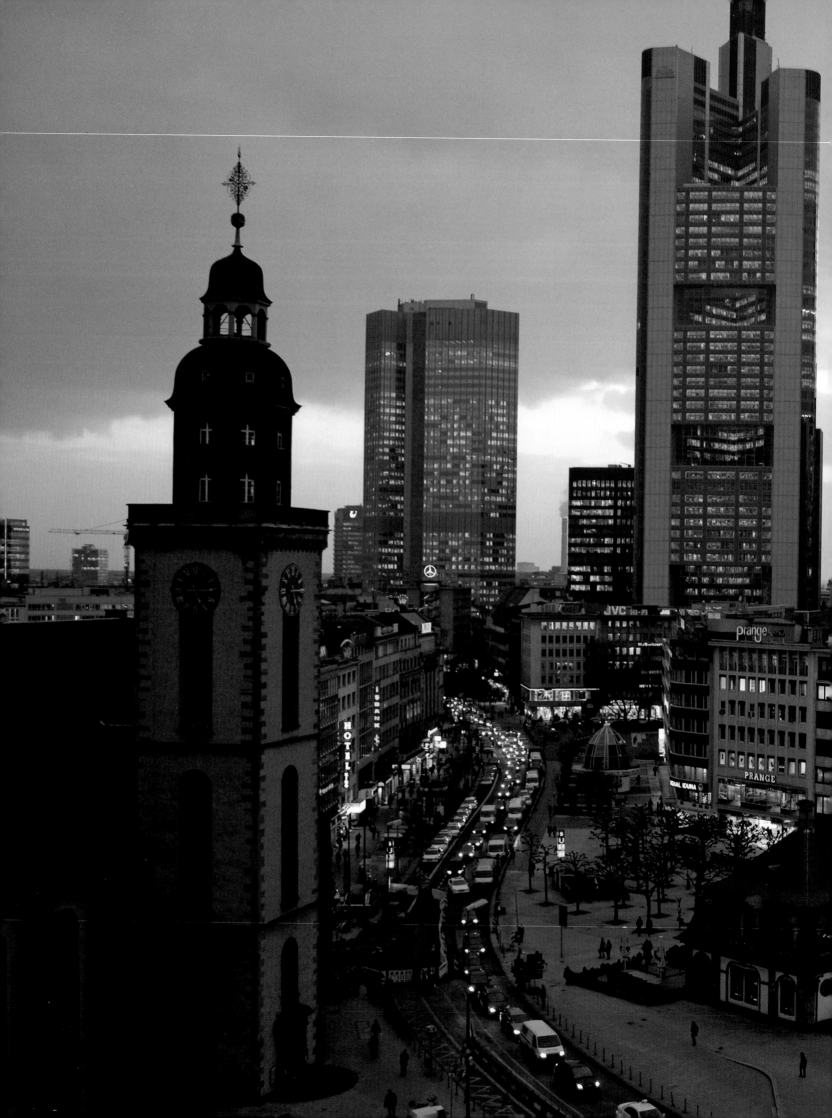

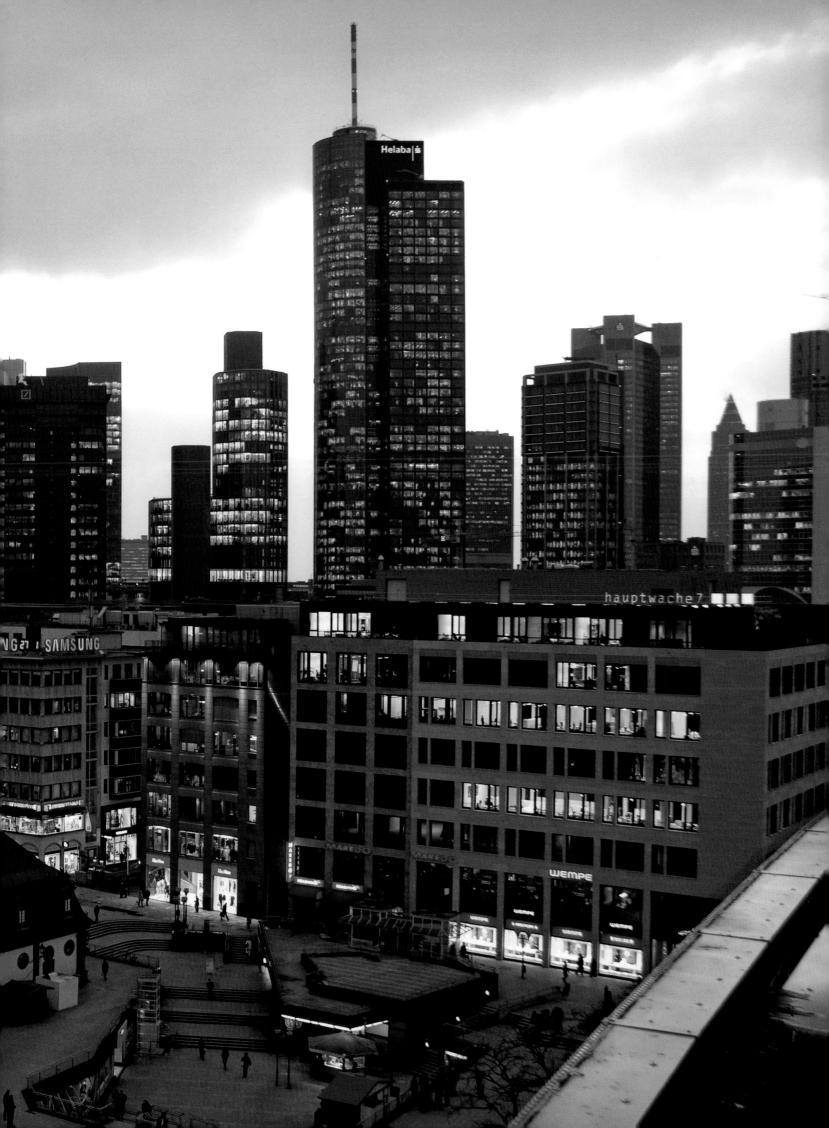

The reflective glass facades of Mainhattan's skyscrapers are a city landmark. The names and logos of the banks that have turned Frankfurt into a financial metropolis beam out from the top of the tallest towers. There is an ongoing battle as to who's the biggest and best, with architectural singularity and harmonious accord with the existing edifices the major criteria.

The smallest metropolis in the world" is how the people of Frankfurt like to describe their native abode. They are proud of the fact that with just 660,000 inhabitants Frankfurt is pretty small for a city – yet still has special status. It's an impressive number four on the stock exchange index – right behind New York, London and Tokyo. Its importance as a centre of banking and finance is underlined by the fact that both the European Central Bank and Germany's top credit institute, the Deutsche Bundesbank, are headquartered here. With the biggest book fair in the world and its famous museums and art galleries, in all things cultural Frankfurt has long transcended the national boundaries of Germany. The Frankfurt School, which evolved from the Institute for Social Research, and its critical theory influenced left-wing intellectuals and the student movement of the 1960s across the globe. The Frankfurt skyline is unique throughout Europe, earning it the mildly exaggerated pun of 'Mainhattan' in reference to the many skyscrapers that constitute it. Frankfurt also would have become the capital of West Germany at the end of the Second World War if Bonn hadn't won the relevant vote in 1949...

The cosmopolitan feeling of Frankfurt is not just down to its imposing architecture but also to its great internationality: every fourth citizen holds a non-German passport. Many *Frankfurter* are thus multilingual. There are countless immigrants but also many 'doing life' in Frankfurt as employees of one of the ca. 100,000 non-German firms or international concerns. This global flair is further enhanced by the many international kindergartens, schools and various other institutions which have been set up here, such as the largest English Theatre on the Continent.

Frankfurt is also a major traffic hub. Approximately 350,000 travellers pass through the city every day. Frankfurt Airport was the first in Germany to service jet aircraft and is now one of the world's chief air terminals. With its huge main station, Frankfurt is also the biggest nerve centre on the German rail network.

Frankfurt is, however, not without charm, much of which lies in its many contrasts. Despite its cosmopolitanism, the city has kept its old traditions and quaint corners. It's often only a short crawl from the latest must-go-to bar to the age-old *Eppelwoi-Lokal* or cider tavern – or from the chic bank high-rise to one of the popular 'watering holes' or *Wasserhäuschen* acting as both a kiosk selling alcoholic beverages and a meeting point for the locals in that particular part of town. Walk just a bit further and you're out of the rat race and suddenly surrounded by peaceful parks and recreation areas. Like a ring of green the old city fortifications, flattened in the 19th century, now encircle the present city centre. Carefully tended landscaped gardens and the former national garden show complex on the River Nidda are welcome places of respite, especially in summer, where people barbecue, sunbathe, party – or just simply relax.

Franconofurd – the city of kings and emperors

First signs of habitation around what is now the cathedral of St Bartholomew's go back to the New Stone Age. The Celts permanently settled here in c. 450 BC on a hill well up above a ford through the River Main. The archaeological park near the cathedral documents the Roman and Carolingian periods of settlement in Frankfurt. The Romans turned the town into a military fort and checkpoint to guard a major roadway where it crossed the Main. The foundations for Frankfurt's metamorphosis into a major national centre were laid under the Carolingians when Emperor Charlemagne summoned the chief ecclesiastical representatives of the Frankish Kingdom here to take part in a church synod. The present name of the city dates back to this time; documents make first mention of a Franconofurd or ford of the Franks in 794. The excavated foundations in front of the cathedral trace the outlines of the kings' hall Ludwig the Pious, Charlemagne's son, had built here. The first Frankish king to be elected in Frankfurt was Lothar II in 855. As a result the city was officially made seat of all royal elections in Karl IV's Golden Bull of 1356. Frankfurt quickly became a popular place of residence for secular dignitaries and rulers – even if today's city doesn't betray many signs of such noble and important activity. You can scour the city

In the Römer the council has decided the fates of the city for over 600 years. The Kaisersaal or imperial hall in the town hall has seen many a magnificent feast in honour of a newly-crowned monarch, with huge oxen roasted on spits on Römerberg to curry favour with the masses. The balcony is now where the national football teams of Germany (both men's and women's) are feted on their return home from successful championship games.

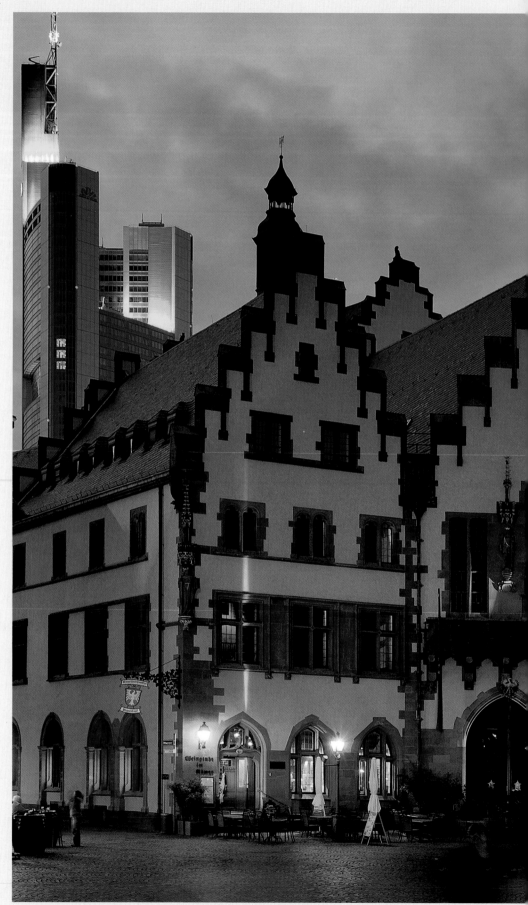

for mighty castles, splendid palaces and the like in vain. Frankfurt's era as royal electoral seat and later site of imperial coronations ended with Franz II in 1792. He was the last emperor of the Kingdom of Germany in the Holy Roman Empire to be crowned in Frankfurt's imperial cathedral. Between him and his predecessor Lothar II a total of 34 monarchs were elected in Frankfurt.

Civic autonomy and financial power

Even in the Middle Ages, first and foremost Frankfurt was a town of the people and in 1372 was made an independent free city of the Holy Roman Empire with financial autonomy, answerable only to the emperor himself. Both kings and emperors patronised the city, giving it many privileges, one being the right to hold a fair in autumn and later also in spring. As Frankfurt lay on a major thoroughfare, it wasn't long before it grew into a wealthy metropolis. The influx of traders and visitors to the fairs from near and far made it necessary to set up uniform rates of exchange in the 16th century, heralding the birth of the Frankfurt stock exchange. The citizens were proud of their independence and the economic power of their city. They weren't always so enamoured of the local patricians, however, who made up the vast majority of the city council, sparking off periods of unrest and revolt.

The patricians weren't stripped of their privileges until 1816, however, after Frankfurt had first lost its right to self-govern under Napoleon and was then again made a free city on his downfall. The financial engines driving the city in this period were the banks and not the fairs. With its leading institutes of Rothschild and Bethmann, Frankfurt soon became

14

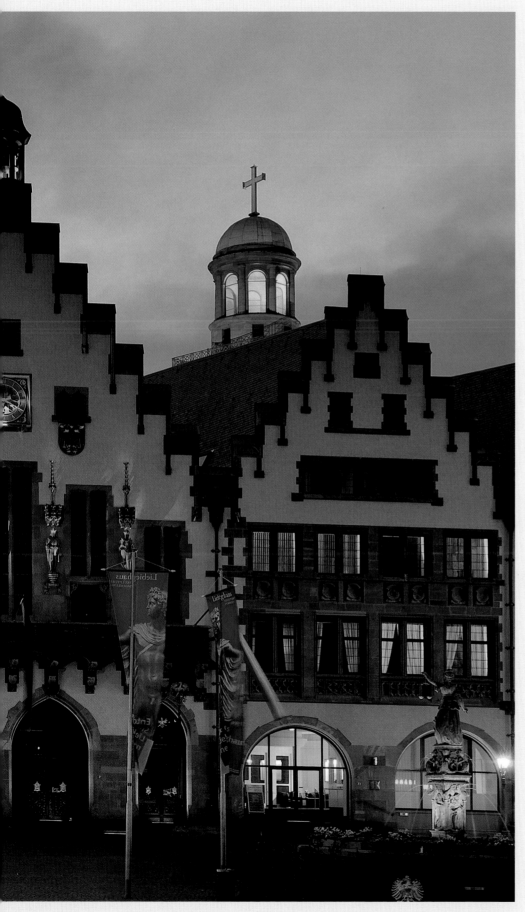

a financial centre of European calibre. The fairs and trade on the other hand suffered great loss due to crippling customs regulations. Frankfurt only again boomed on becoming the seat of the German government. The members of the assembly brought a new lease of life to the bourgeois upper classes and added an extra sparkle to society. Many foundations and institutions were founded during this epoch, many of which still benefit Frankfurt today. The Städel school and art institute were opened, attracting artists of renown from all over Europe. The "gallery of natural history specimens" opened by the Senckenbergische Naturforschende Gesellschaft or natural history society, whose exhibits range from dinosaur skeletons to birds, fish and insects to the remains of primitive man, is still a huge hit with visitors. Civil establishments and clubs, such as the Frankfurt art and museum societies, greatly furthered the city's cultural endeavours. The city library also arose during this time; despite being bombed to blazes during the last war, it now poses as Frankfurt's chief literary venue, the Literaturhaus. These middle-class foundations blossomed again at the turn of the 19th century and in 1914/1915 the citizens of Frankfurt even managed to endow an entire university. A total of 14 million Reichsmarks were collected for this purpose.

The cradle of German democracy

With the increased civic power of the free city behind them, new liberal forces and associations gathered momentum and Frankfurt became a centre of the revolutionary Vormärz or pre-March movement. In 1833 the Frankfurt Wachensturm was to prompt a national and democratic uprising throughout the whole of Germany. Students and exiled Polish officers planned to storm the police stations in Frankfurt where the former Hauptwache and Konstablerwache guardhouses now stand. They hoped to appropriate the weapons and money held there and then seize the representatives of the German princes in government at the Thurn and Taxis palace near the Hauptwache. They were betrayed, however, and the revolt was brutally crushed. The support they had hoped to gain from the civilian population was not forthcoming. Parliament nevertheless ruthlessly hunted down possible conspirators and contacts to the movement, with government diplomats disgustedly branding Frankfurt a "den of liberals".

When in 1848 the liberals proved successful during the March Revolution and the first freely elected German national assembly moved into the rapidly converted Paulskirche, Frankfurt

flew the national flag of black, red and gold with jubilant pride. The euphoria was not to last long, however. Underprivileged citizens in particular felt misrepresented by the members of the house, most of whom belonged to the educated classes, and September marked a further period of unrest. The national assembly had failed and the government of the German Confederation was reinstated.

Frankfurt's end as a free city was sealed by its Prussian occupation in 1866 during the Austro-Prussian War, when Otto von Bismarck made the town suffer from extensive reprisals. He still feared the liberal tendencies which had incurred his displeasure in his days as Prussian envoy to the German government.

Years of foundation and destruction

In the *Gründerzeit* or founding years of the last quarter of the 19th century Frankfurt underwent a new economic and cultural boom. Many buildings and institutions were established which Frankfurt is still proud of today; the main station, Festhalle venue, palm garden and villas in the west end are just some of these. The industrial revolution also took firm hold of the city, with the Adlerwerke, the works which during this period became one of the leading manufacturers of bicycles, typewriters and cars, being perhaps the most famous example. As a direct result of this economic growth the local populace also exploded, encouraging the city to invest heavily in its infrastructure. The sewage system and water supply were extended and the first trams introduced. Further achievements were made in the stable years prior to the economic crisis. The Großmarkt-halle, the huge market hall and then biggest complex of buildings in town, opened for business in 1928 and IG Farben, a fusion of Bayer, Hoechst, BASF, Agfa and a number of smaller companies, began constructing one of the largest office buildings of the day. The resulting, truly monumental Poelzig-Bau, once the IG-Farben headquarters, is now used by the university of Frankfurt.

The dawn of National Socialism triggered a sorry chapter in the history of the city. Due to its liberalist traditions and high percentage of Jewish citizens, who had left their distinctive mark on Frankfurt's municipal and cultural life as bankers and benefactors, the great metropolis, the centre of international trade and finance, was deliberately demoted to a provincial town and redefined as the "town of German craft". Very soon after Hitler's party came to power the first reprisals were made against Frankfurt's Jewish community. The Jewish lord mayor fled the city; many other Jews were

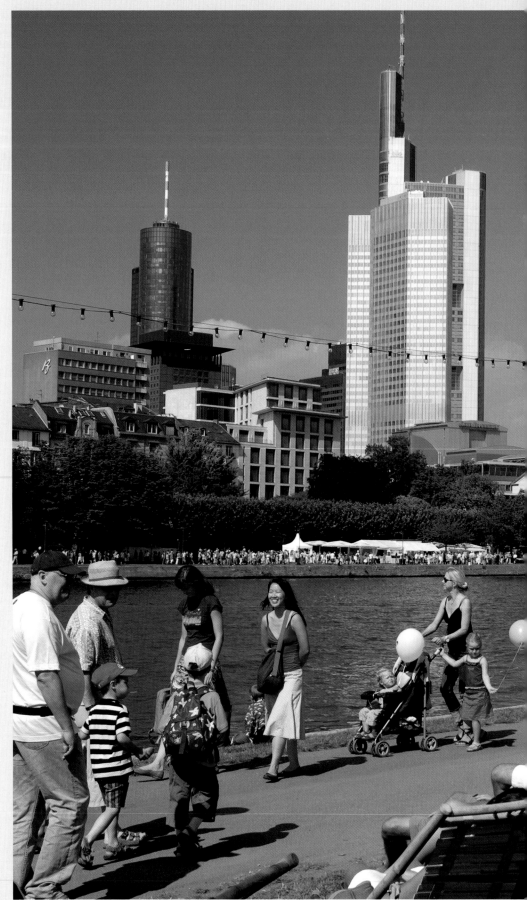

The annual festival on the Museumsufer attracts over two million visitors to the city. The museums that line the banks of the Main put on a very special show during the festivities, with countless outdoor performances turning the river front into a giant stage. With the added bonus of tasty dishes and imaginative crafts on sale from all over the world, this is well worth a visit!

hounded from their public offices and the university, to the founding of which they as patrons had greatly contributed just a few years before. In 1933 a third of Frankfurt's professors were of Jewish origin. On *Kristallnacht* in November 1938, as in other cities throughout the Third Reich, the synagogues of Frankfurt were consumed by fire. The only one to survive the night – and the bombings that were to follow – was the Westend synagogue whose architectural Assyrian and Egyptian elements still surprise the casual meanderer. The Großmarkthalle and Festhalle, once places of bustling trade and mercantile pleasure, became halls of terror where Jewish citizens were rounded up before being deported. Tiny name stones set into the walls of the Battonn Cemetery today remind us of the Jews of Frankfurt who were murdered during the Holocaust. There are 11,134.

Frankfurt was first heavily targeted by the Allies in 1943. The many massive attacks of March 1944 finally reduced the city to a pile of rubble. Two million bombs fell on the city in the space of just a few days, destroying or badly damaging eighty percent of its fabric. One of the biggest old towns in Germany was more or less eradicated. Haus Wertheym is the only half-timbered building to have survived – and only because the fire brigade kept an escape route beside it that ran from the Römerberg to the Main filled with river water. Many of the old houses now gone had massive cellars which from 1940 onwards were linked, turning them into a huge air raid shelter. Thanks to this wise foresight the number of deaths in the raids on Frankfurt was low compared to many other cities.

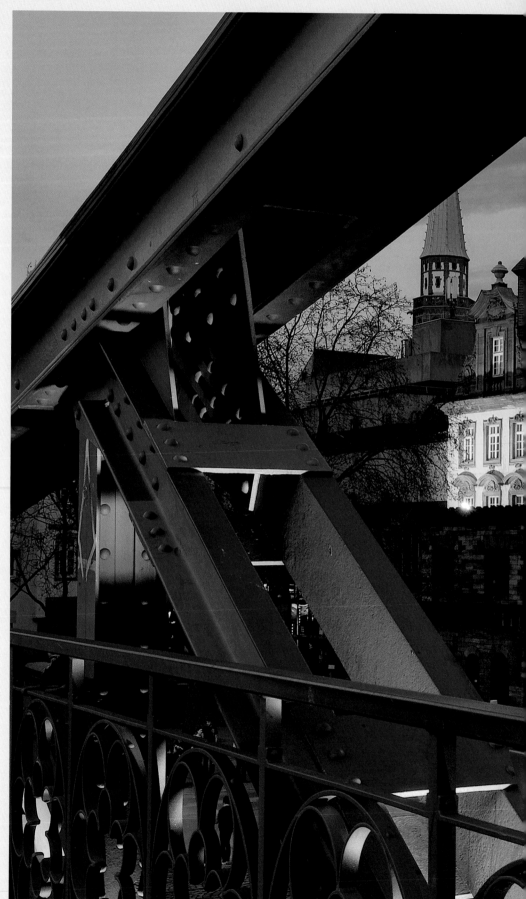

The Historisches Museum in the Saalhof documents the history of Frankfurt from its first settlement to our modern forms of habitation. During the 12th century the castle complex was built to replace the old imperial palace on the cathedral mound. The best way to reach the museum from Sachsenhausen is via the Eiserner Steg footbridge over the Main. The interesting steel structure makes a popular artistic motif.

Rebuilding and reconstruction: a bone of contention

Rebuilding of the city began with citizens simply trying to clear away the ruins. Acting under the *Trümmerbeschlagnahme-Anordnung* a commission was set up to manage the debris; under its auspices wrecked buildings were expropriated and torn down, rubble was carted away and reworked into new building materials.

To start with efforts were concentrated on creating desperately needed new housing and on the reconstruction of the Römer and Paulskirche. As the former seat of the national assembly the latter was to be a symbol of and memorial to democracy and freedom. The centenary of the first free German parliament was scheduled for 1948 and Frankfurt's cradle of German democracy was to give the entire country a renewed sense of hope. With the help of generous donations from all over the country the church was finished in time for the celebrations. And with its inauguration the people of Frankfurt dared to nurture another hope; the magistrate was planning on building the post-war German government a new chamber and meeting place here. But even the construction of yet another brand-new, modern parliamentary building couldn't tip the balance in favour of Frankfurt. With a majority of 200 versus 176 votes, in 1949 Bonn was made the provisional capital of Germany.

The heftiest debate, however, took place between those wanting to reconstruct the old town as it was and those planning a radical redesign. Despite the dire housing situation, all building was frozen in this area until 1952 when an agreement was reached: distinctive landmarks were to be re-erected as close to their original state as possible while leaving room for contemporary flats, offices and business premises and generously extending the network of streets. The result is still a bone of contention; the Technisches Rathaus put up in the gap be-

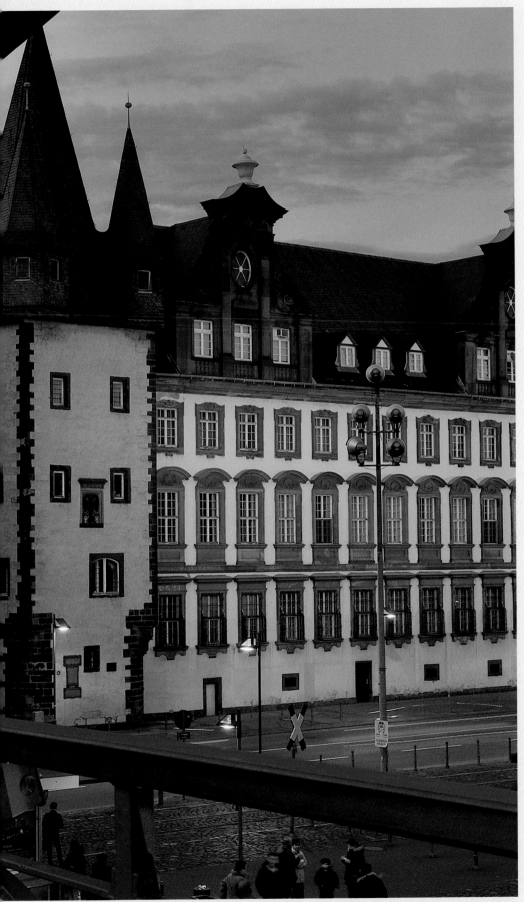

tween the Römer and the cathedral in 1974 is considered to be the most hated building in Frankfurt. In a countermove, between 1983 and 1986 the houses on the east side of the Römerberg were partly restored; the original half-timbered facades – or what was left of them – were used to front new edifices behind them. The decision to now tear down the Technisches Rathaus has recently fuelled further discussion; the empty space is to be filled with reconstructions of seven half-timbered medieval buildings. The plan is to keep to strict guidelines so that at least here people can begin to imagine what Frankfurt once must have looked like. As a tourist destination the city will undoubtedly profit from this resolution – although the enthusiasm for the much-photographed east side of the Römerberg is already causing disconcertment. Even those familiar with the complete history of Frankfurt continue to find the half-timbered façade pleasing – with the knowledge that it's just a reconstruction and thus not authentic leaving a bitter aftertaste.

On the whole the city regrets much of its hasty removal of the original foundations reduced to such by the bombs. Even one of its major landmarks, the opera house, was threatened with demolition on several occasions, its long-standing ruins in the heart of town a memorial to the terrors of war. In the 1950s scrap merchants were given permission to comb the remains for recyclable metal. Over 400 metric tons of it were removed and melted down, without paying any heed to precious ornamental work or any other useful salvage. In 1965 Rudi Arndt, later lord mayor of Frankfurt, even suggested blowing the ruins up. He promptly earned himself the nickname of "Dynamite Rudi", despite him later professing that he had never given the undertaking any serious thought. The rebirth of the opera house, like the original before it, is largely down to the people of Frankfurt. A campaign was launched to save the building and in an exemplary collection 15 million Deutschmarks were amassed, forming the financial basis for a rebuilding project which totalled over 160 million marks. A good 37 years after its destruction, in August 1981 the opera was ceremoniously reopened. For many of its inhabitants, Opernplatz is still the most beautiful spot in Frankfurt.

Street battles and skyscrapers

In the post-war period Frankfurt morphed back into a centre of business and finance and economically at least became the most important city in Germany. After the open spaces had been built up in the 1950s, the question was raised

as to how urban development was to progress to best provide room for the number of banks setting up shop here. The west end, then one of the most beautiful and stylish parts of town, was suddenly being eyed up by the planners. This was where at the turn of the 20th century well-to-do citizens had settled to escape the confines of the inner city. By the 1960s and 1970s many of them had moved further afield to the wider environs of Frankfurt and the quarter was mostly inhabited by factory workers and white-collar clerks. Speculators considered buying up neighbouring houses in order to procure space for new high rises and push prices up. Attempts were made to remove annoying tenants by overcrowding them, failing to undertake repairs and even damaging living quarters. In 1970 the conflict between the mass of unused space on the one hand and the desperate need for accommodation on the other led to the first squats in Germany being formed. The squatters had great support from the German populace even though they carried out their actions on the back of the then nationwide, radical leftist student movement. Ordinary workers, the immigrant workforce and church and trade unions in particular were on their side. The first forced removals of squatters promoted even more radicalism and street battles in Frankfurt-Westend. A law passed in 1972 against the misappropriation of living space by the state of Hesse put an end to speculation over land; however, the last squat on Siesmayerstraße was only handed over to the new owners, the Deutsche Bank, in 1986. Between them the Westend action group, founded in 1969, and the squatters had managed to save at least some of the villas worth salvaging from demolition – even if these are no longer used privately but as offices by banks and insurance companies.

The first skyscrapers in Frankfurt, some of which contributed to the aforementioned speculation war, were harbingers of the city's present skyline. Starting in the 1950s and 1960s with the telecommunications offices on Hauptwache, the Hotel Inter-Continental and the Zürich-Haus at just under 70 metres (230 feet), the contemporary towers kept on growing in size until they reached skyscraper height. In 1976 Marriott Hotel's Westend-Gate broke the barrier at 159 metres (522 feet). The Silver Tower belonging to the Dresdener Bank was next in

1978, clocking up 166 metres (545 feet), and in 1984 the twin towers of the Deutsche Bank joined the merry throng at a mere 155 metres (508 feet). The Silver Tower was the tallest building in Germany until the second generation of giants began mushrooming towards the heavens in the 1990s. For a brief period the Messeturm at the exhibition grounds (257 metres/843 feet) was number one in Europe – until it was topped by Frankfurt's Commerzbank Tower, two metres higher.

Even if in 2004 Frankfurt had to hand over its title as top European skyscraper city to Moscow, its skyline was and still is the city's landmark, trademark and pride and joy. At the last skyscraper festival in 2007 around 1.2 million visitors seized the opportunity to look behind the glass facades. The highest building in town, however, was and has been since its completion Frankfurt's telecommunications tower, the Fernmeldeturm or Europaturm, opened in 1979 at a record elevation of 337.5 metres (1,107 feet).

Page 22/23:
Visible for miles around, the Messeturm marks the site of the third-largest exhibition grounds in the world. The neighbouring wasteland is soon to have a brand new visage, that of the appropriately named Europaviertel between the main station and trade fair, complete with office blocks, hotels, shops and flats.

Page 24/25:
The cityscape is positively dominated by skyscrapers in glass, steel and concrete in a whole host of designs. Tucked in between the modern Gallileo (far left) and the quarter-sphere of the Skyper is the Silver Tower, one of the first high-rises in Frankfurt erected in 1978. Beyond the towers the multitudinous tracks of the local rail network snake out of the main station.

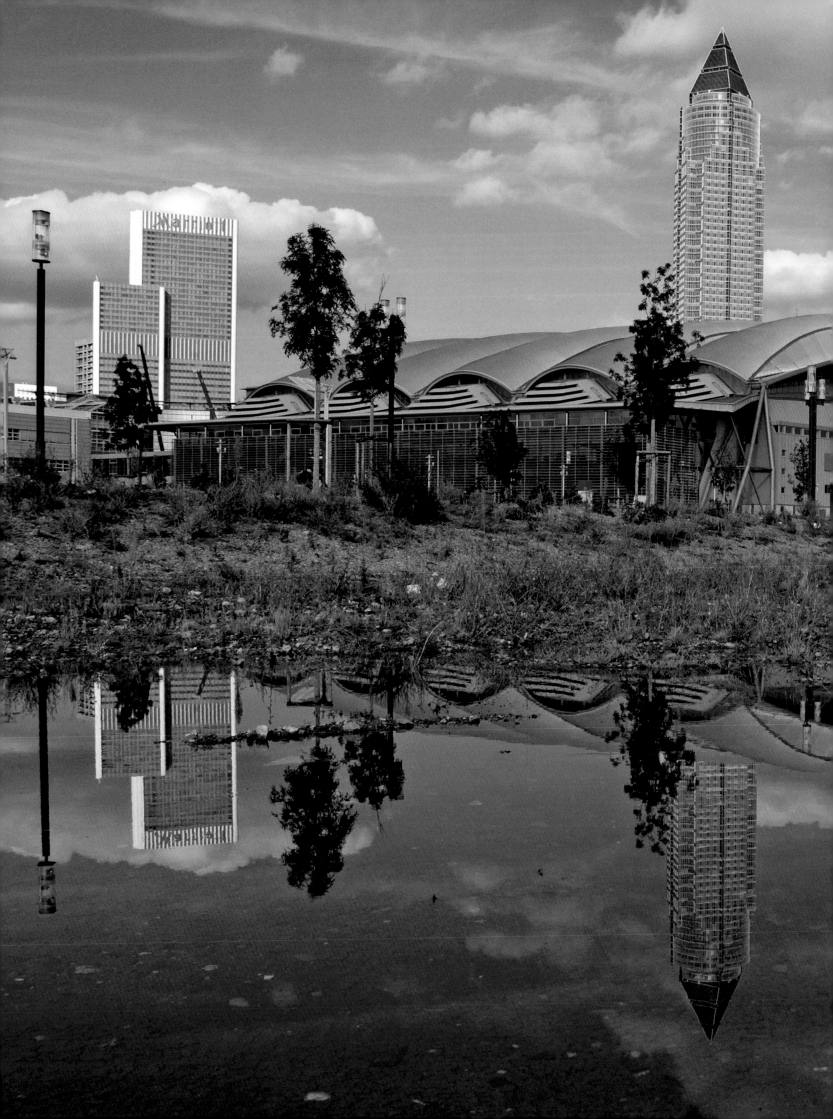

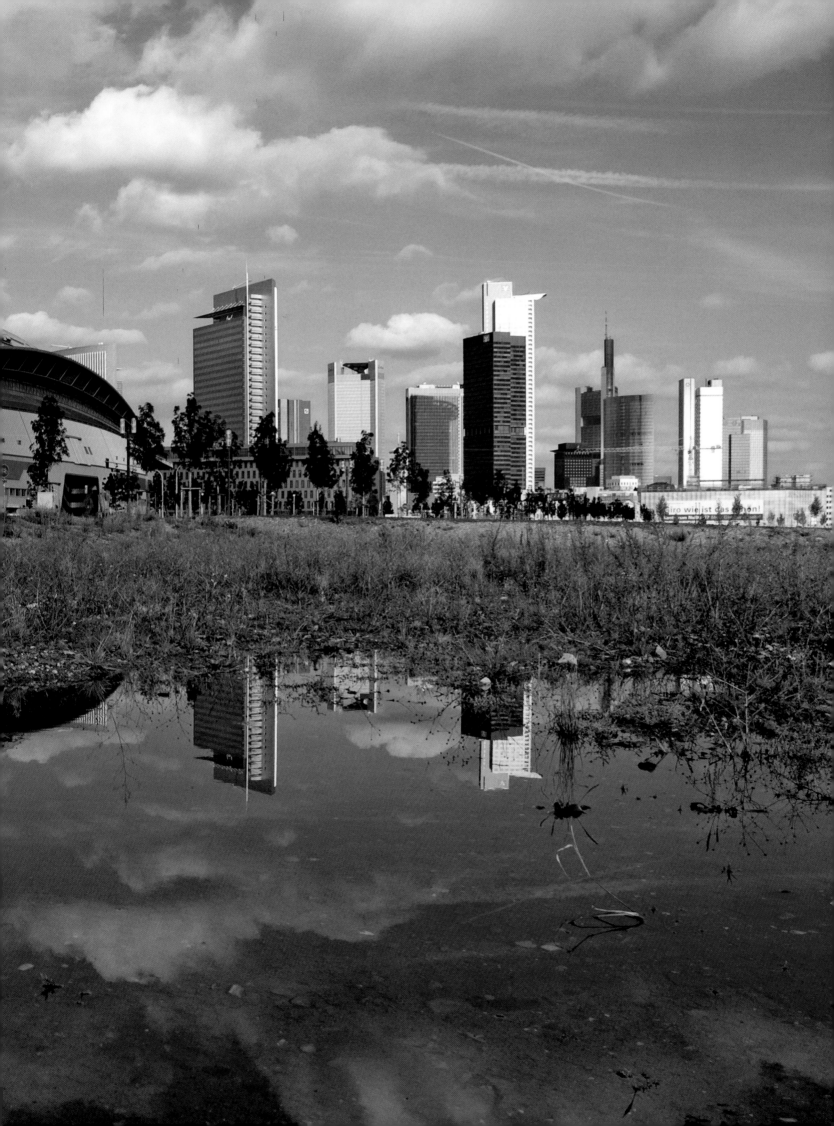

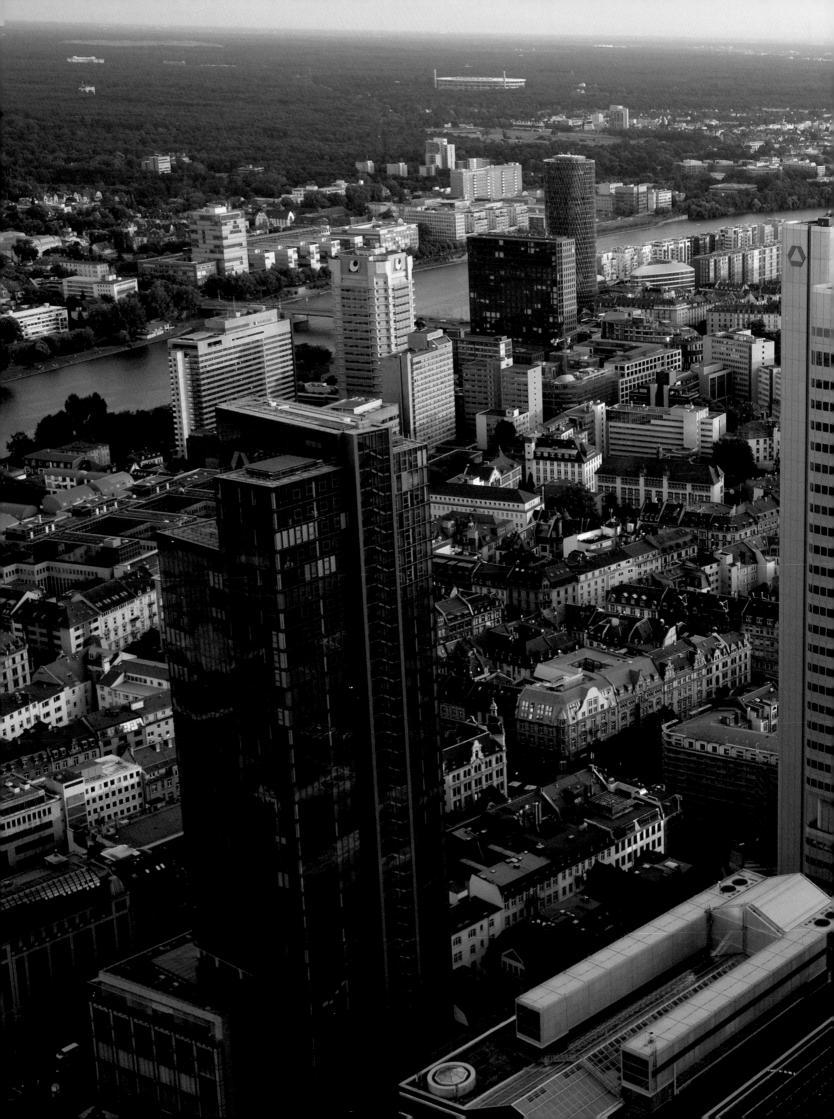

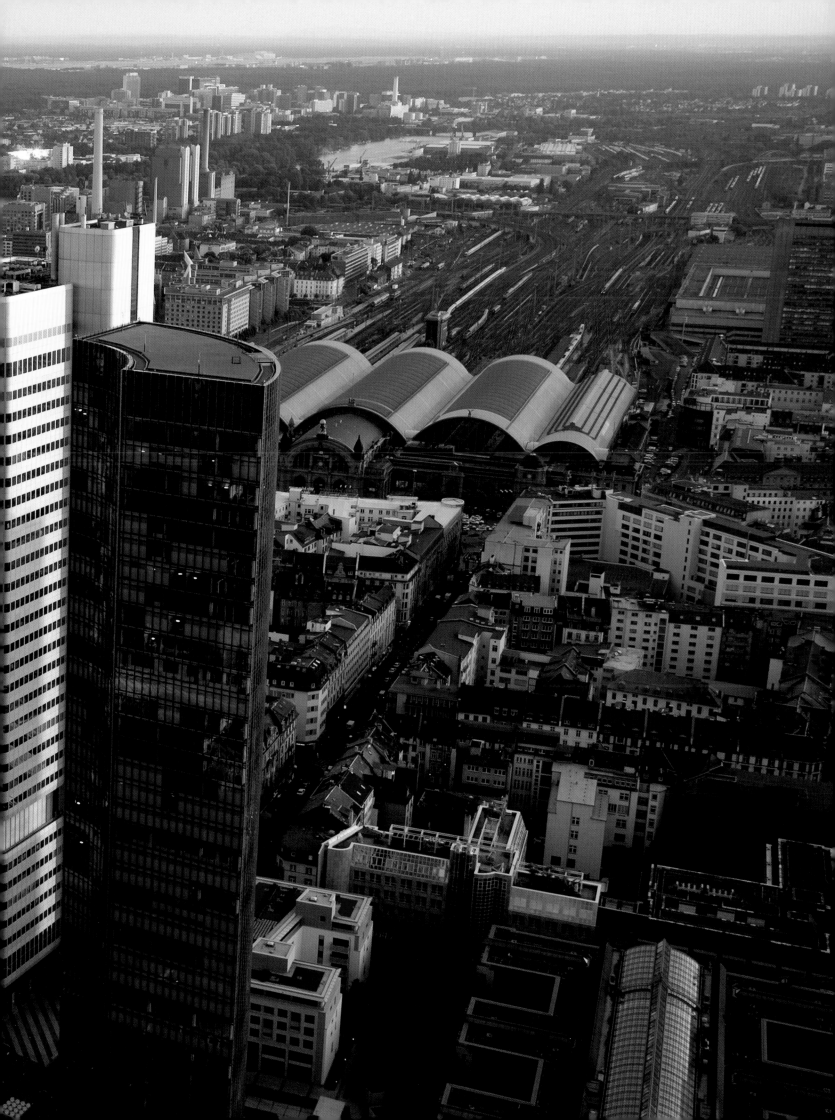

The old town and city centre

Römerberg is the main square in the old part of Frankfurt. The edifices that lend it its charm are mostly reconstructions; in 1944 the old town was almost totally obliterated by bombs, with the present facades recreated from old pictures and erected to front modern buildings in the 1980s. The fountain in the foreground, crowned by the figure of Justice, was where red and white wine once flowed during coronations – at the expense of the newly appointed ruler.

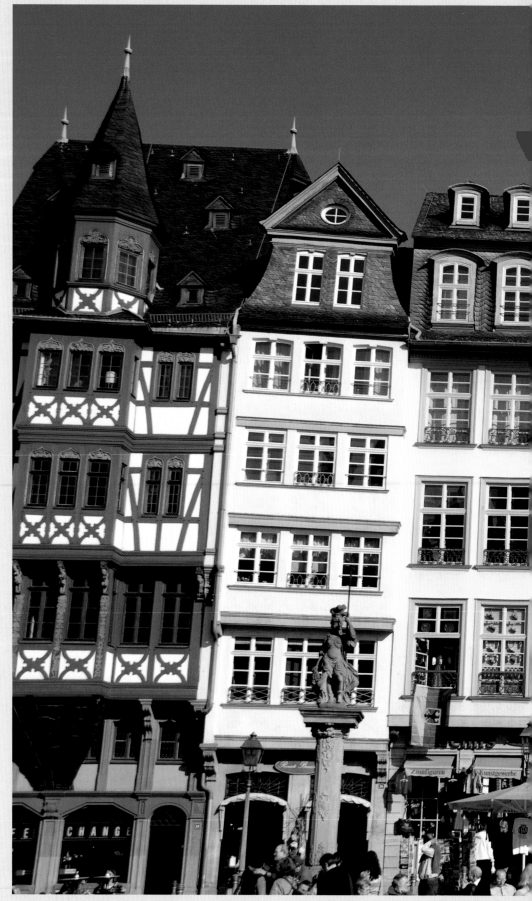

The Römerberg marks the centre of what was one of Germany's major half-timbered cities before World War II. Today, this is hard to believe. Only the Römerberg is reminiscent of the old town; with the Rathaus or town hall, over 600 years old, on the one side of you and the steeple of the cathedral poking up above reconstructed ancient facades on the other, you can almost sense the city's former greatness. Just move slightly to one side, however, and you espy the metropolitan pillars of modern Frankfurt. The giant skyscrapers and staid office blocks are just a few minutes' walk away from the ornate, cheerful timber framing of the Altstadt.

Not far from the Römerberg, the site of the old trade fair, there are many historic places of interest. Kings and emperors were crowned in the cathedral of St Bartholomew's. Next-door archaeological excavations have laid bare the foundations of Roman baths dating back to the 1st and 2nd centuries, of a Carolingian imperial palace and late medieval town houses. The Paulskirche is also very close, where the first freely elected parliament in Germany once held session. The Altstadt or old town also boasts a fine selection of museums and galleries; the Schirn puts on regular international exhibitions of art, for example, and the museum of modern art is famous for both its artefacts and its architecture.

The city centre is characterised by the Alte Börse (old stock exchange), the banks and the Zeil, Frankfurt's high-street shopping centre. The Goethestraße between the Zeil and Opern-platz touts luxury goods from all over the world, with the Freßgass running parallel to it akin to a giant food outlet catering for all kinds of culinary persuasion.

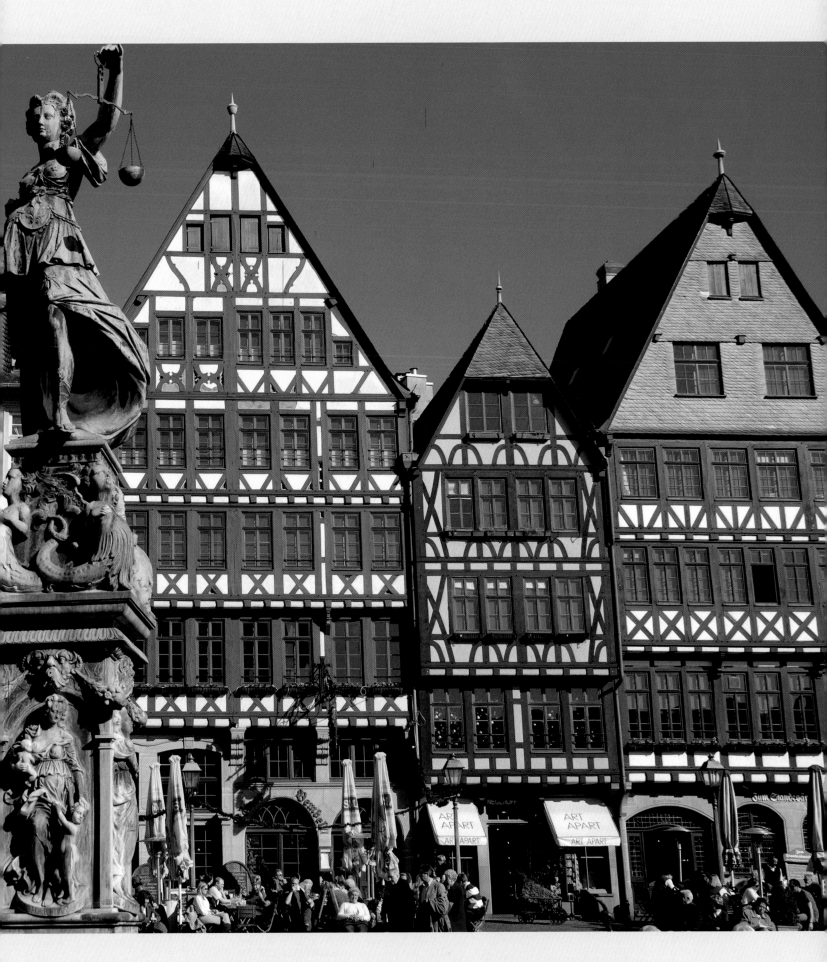

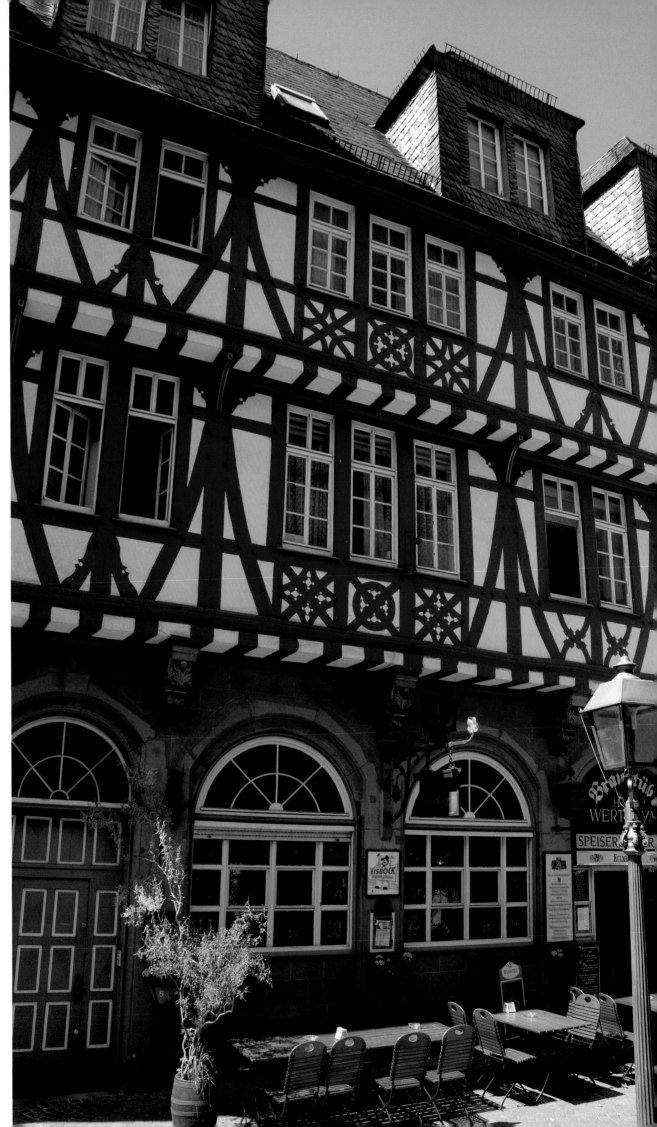

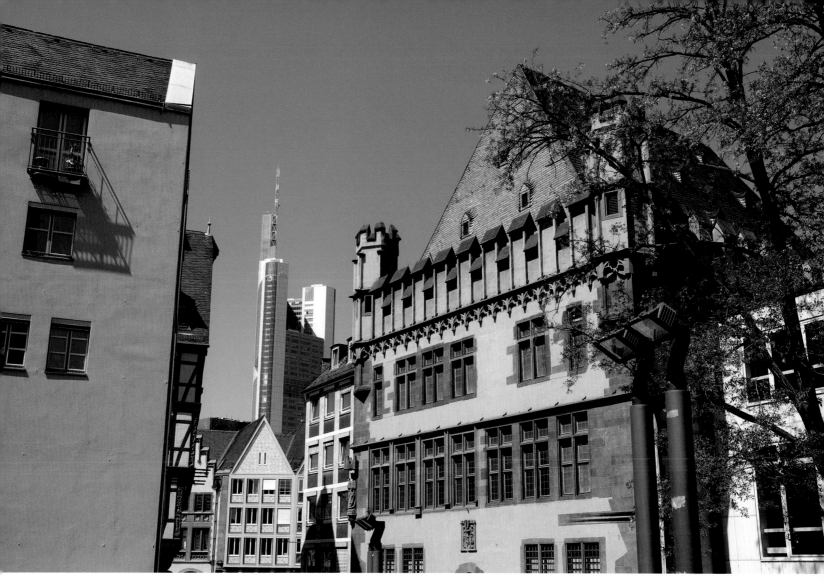

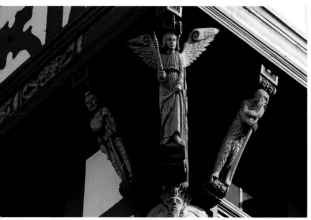

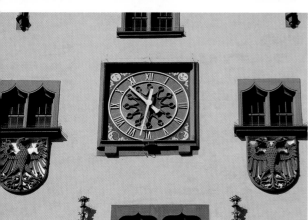

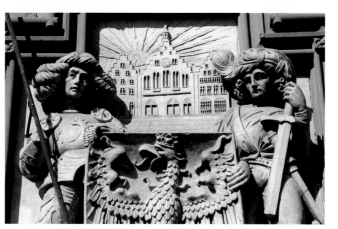

Far left:
Many tiny figures of wood adorn the façade of the Großer Engel building. They are not only attractive; they also act as supports for the upper storey.

Left:
The High Gothic Leinwandhaus was built in 1396 to encourage business at the trade fair. After a turbulent history as a warehouse, courtroom, field hospital and barracks the building is now a museum of comedy.

Far left:
Coats of arms on the Römer in Frankfurt.

Left:
Full of confidence and optimism the Römer gleams in the morning sun on a relief set into the main building of the town hall.

29

St Bartholomew's Cathedral in the heart of the old town originated as the chapel of the Carolingian imperial palace from the 8th century. Numerous additions and conversions have produced the present edifice. The cathedral is historically significant in that it was where the kings of Germany were elected from 1356 onwards and the emperors of the Kingdom of Germany in the Holy Roman Empire were crowned from 1562 to 1792. The steeple is largely attributed to Madern Gerthener who was master builder of Frankfurt from 1395 to 1430. The present octagonal, ribbed cupola, intended to resemble the imperial crown, was planned by Gerthener but not built until after the Prussian-Austrian War.

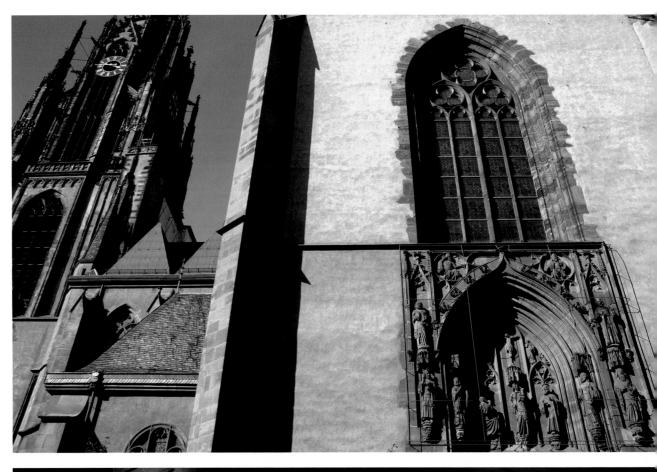

With the right lighting – as here during the biennial Luminale or festival of light – the neo-Gothic height and structure of the otherwise rather plain cathedral seems especially imposing.

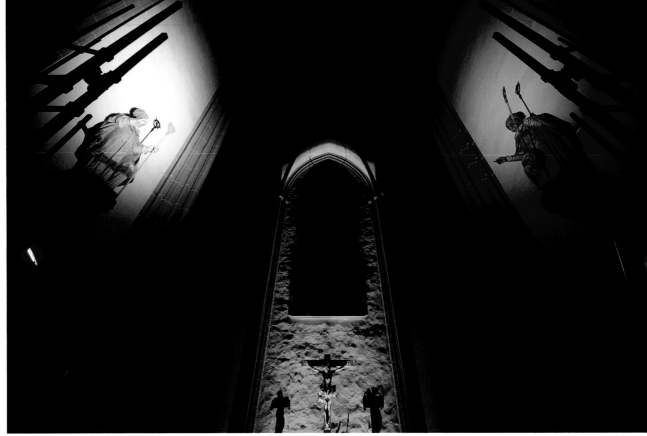

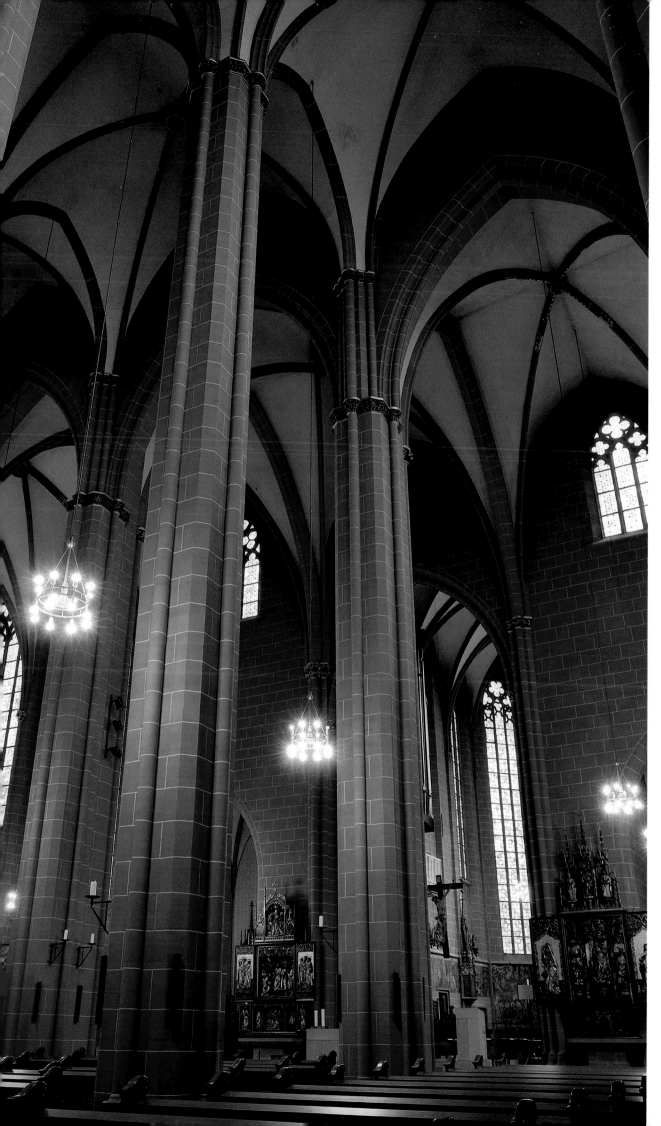

On entering St Bartholomew's the visitor is struck by two things: the surprising shortness of the nave and the vibrant red of the interior, painted to match the 14th-century original. You will find no ornate windows here, however; these were destroyed during the war and replaced by simple tinted industrial glass donated by Frankfurt businesses.

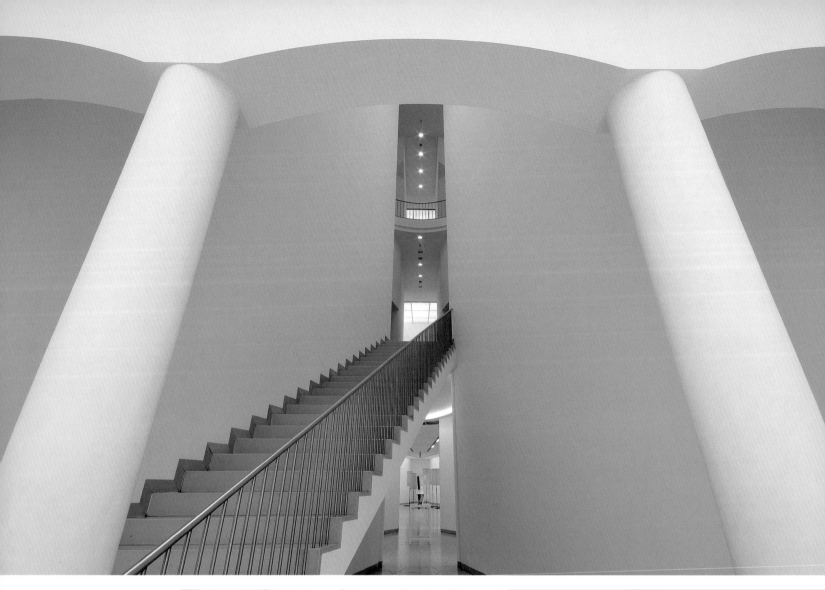

The wedge-shaped Museum für Moderne Kunst, MMK or the museum of modern art, is known locally as the "slice of cake". The interior is impressive, with Hans Hollein's walkways, stairs and inlets making a walk round the museum quite an experience. The exhibits include works by none other than Andy Warhol, Roy Liechtenstein and Joseph Beuys.

The Schirn art gallery is of world renown. It has no collection of its own but puts on various exhibitions and projects devoted to certain topics or artists. It works closely with international houses of art, such as the Tate Gallery in London, the Hermitage in St Petersburg and the Museum of Modern Art in New York. Its name refers to its site in what was the centre of the old town: a Schirn was an open market stall as used by Frankfurt's guild of butchers in the narrow streets that once ran between the present gallery and the River Main.

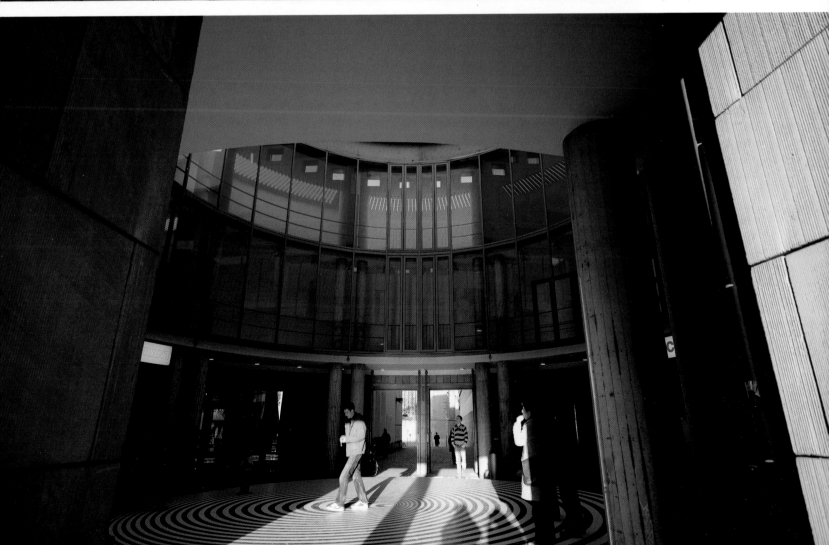

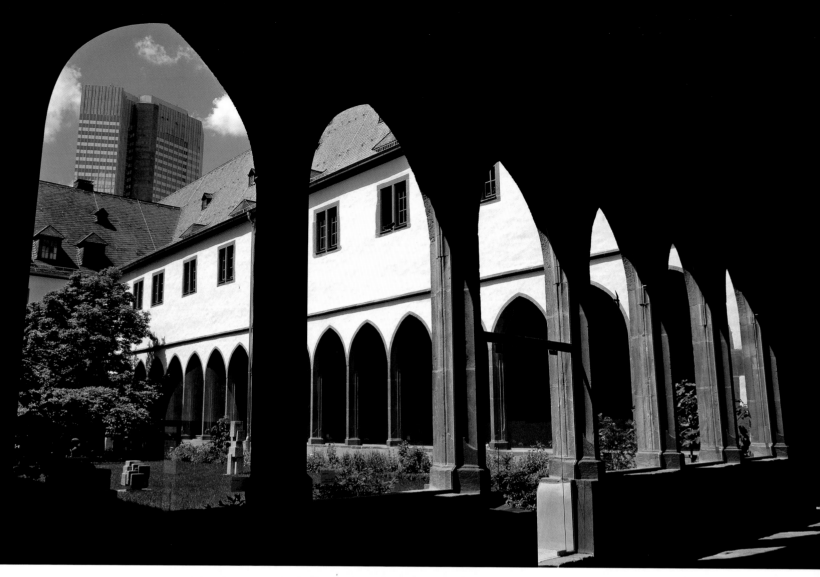

The cloisters of the Carmelite monastery, founded in 1246, provide a place of refuge in the heart of the metropolis. The arcade and courtyard contain frescoes by Swabian artist Jörg Ratgeb from the 16th century and depict the founding of the order and the birth and passion of Christ. They are heralded as the most important pre-baroque wall paintings north of the Alps. After its destruction in 1944 the church was not reconsecrated and is now part of the archaeological museum. The former monastery is also home to the institute of city history and cabaret Schmiere.

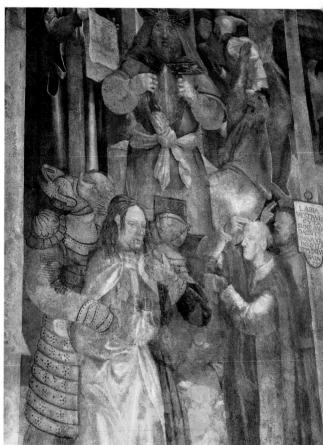

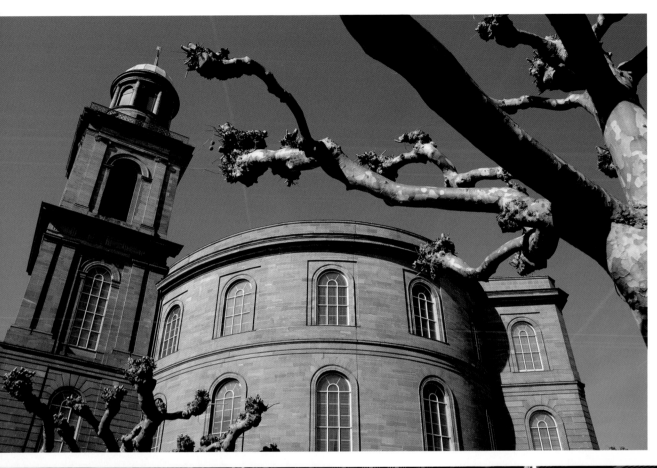

The Paulskirche is often celebrated as the cradle of German democracy and is where in 1848/49 the first freely elected parliament for the whole of Germany held session, with the recently built church (1833) hurriedly converted into a governmental chamber. On their inauguration the parliamentarians were euphorically received and the whole city proudly flew the national flag of black, red and gold. Even if the assembly failed, the constitution it issued formed the basis of the Weimar Constitution and the present constitution of Germany. Its great symbolic importance meant that the Paulskirche was quickly rebuilt after World War II. The lights hanging from the ceiling indicate where the pillars for the organ loft once stood.

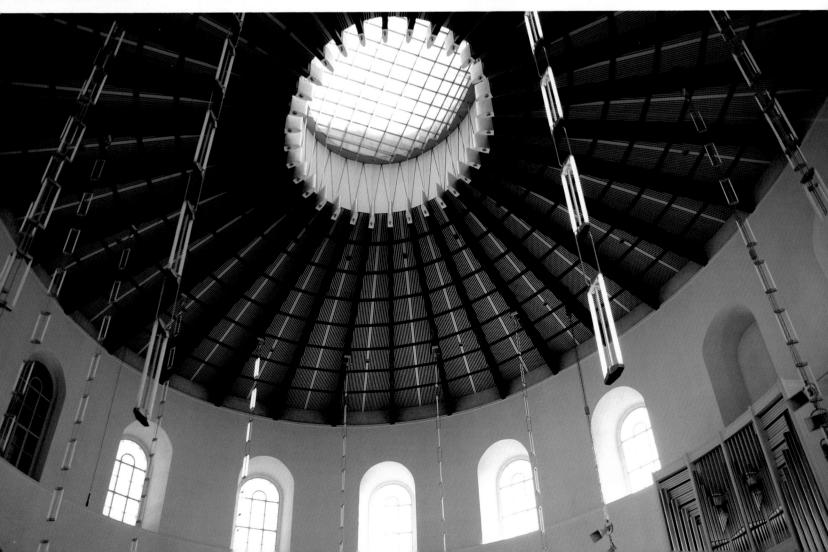

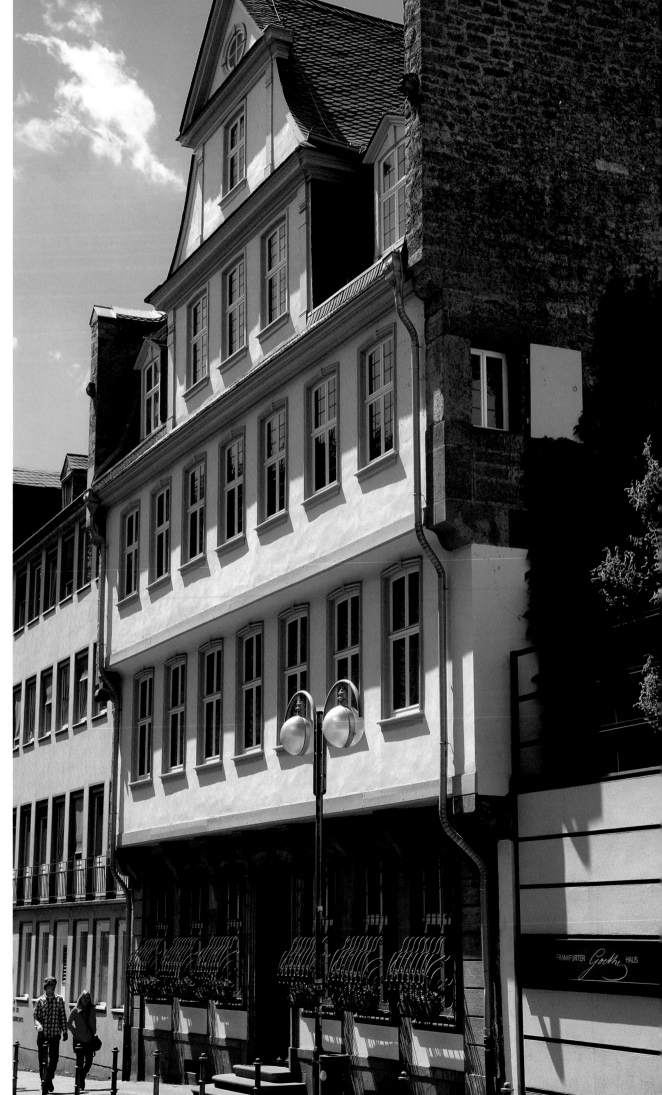

On August 28, 1749, at the Goethehaus the city's most famous citizen first saw the light of day. Even if Johann Wolfgang von Goethe didn't stay in Frankfurt, only coming back on sporadic visits, his birthplace is a huge attraction. It's not a museum of literature as such but more a museum of culture, showing how a bourgeois family in the 18th century would have lived. The poet's room contains the desk where the young writer penned his early works, among them Götz von Berlichingen, the first version of Faust and The Sorrows of Young Werther.

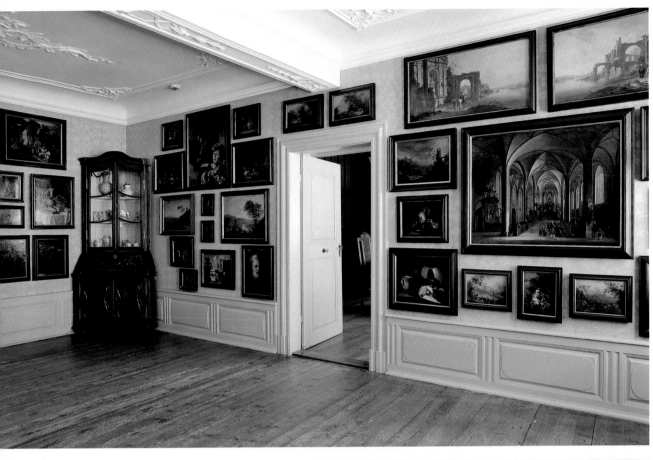

Johann Caspar Goethe, the father of the later privy councillor, was a passionate collector of contemporary Frankfurt art. His collated works are again on show in the paintings gallery. Like the remaining contents of the house, reconstructed at the end of the Second World War, they were carefully listed and hidden safely away close to Frankfurt before the outbreak of hostilities.

In the library next door Goethe's father amassed close to 2,000 books from all fields of study. This vast range of topics provided the young Goethe with plenty of inspiration and formed the basis of his comprehensive knowledge of both the arts and the sciences. This is where the book of Dr Faust is said to have fascinated the boy, later resulting in his most famous drama Faust.

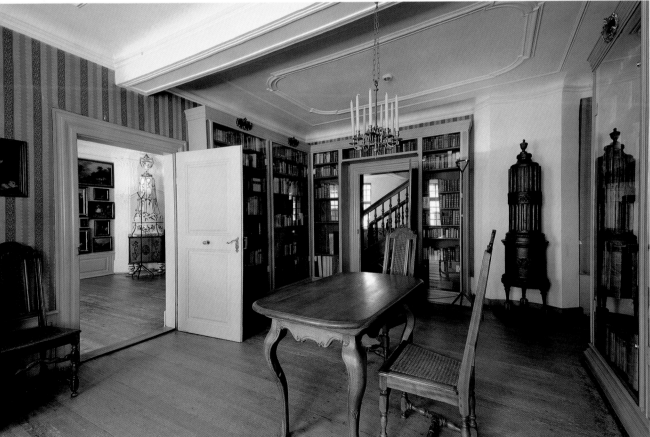

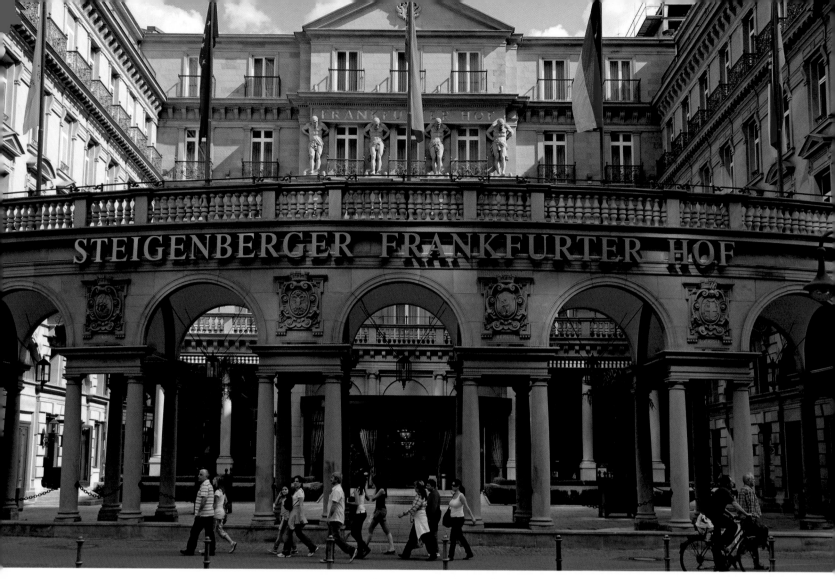

Erected in the style of the High Renaissance between 1872 and 1876, on its opening the Frankfurter Hof was the best address in town. You can still spend the night in style at this traditional Frankfurt establishment. Thomas Mann, one of the hotel's more distinguished guests, greatly cherished its luxurious comfort; even if it was expensive, one knew "what one is paying for and does it with a kind of joy." In the hotel bar you can take royal high tea of an afternoon and during the Frankfurt Book Fair rub shoulders with writers and publishers.

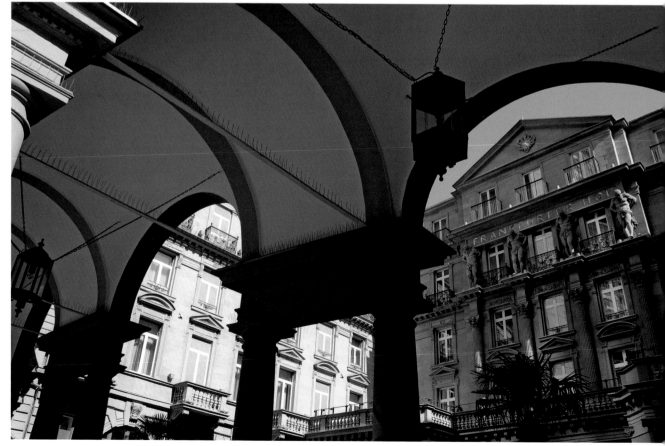

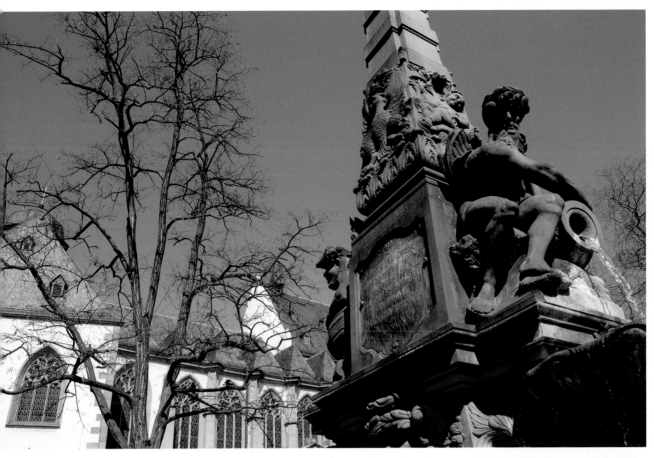

Left:
Liebfrauenberg is one of the most popular spots in town, with its late baroque, sandstone fountain dedicated to the Virgin Mary. On the edge of the square is the Gothic Liebfrauenkirche, built between the 14th and 16th centuries, whose quiet courtyard is a pleasant place to escape the city noise and traffic.

Below:
The people of Frankfurt just love to go shopping in the Kleinmarkthalle. The many market stalls have everything the Hessian palate could desire: local vegetables, meat and fish plus an extraordinary variety of exotic delicacies. Even if it's not the cheapest store in town, it's certainly the best for quality. And the obligatory friendly chat with local stallholders is free …

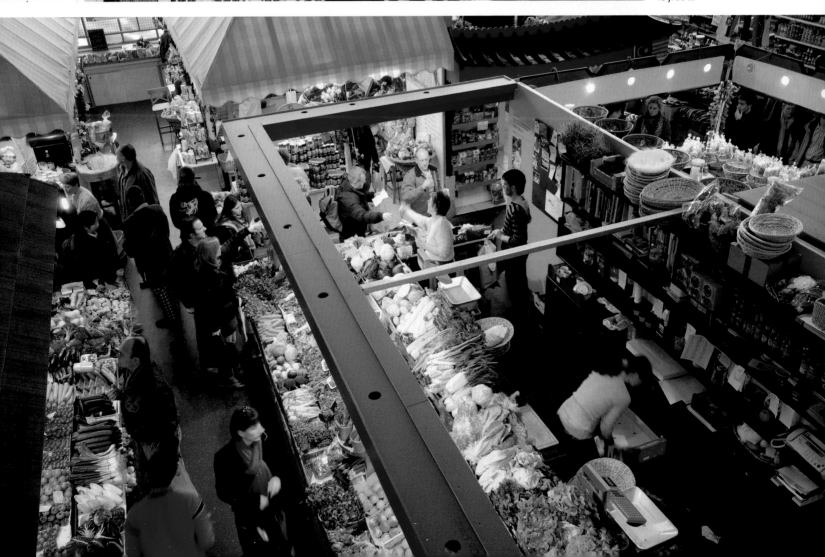

CIDER AND GREEN SAUCE –
FRANKFURT'S CULINARY SPECIALITIES

"*Wer nix uff's Stöffche hält, der daut aam laad! / Nix so uff dare Welt mecht aam so Fraad.*"

In the words of vernacular poet Friedrich Stoltze, if you don't like cider, you are to be pitied, for nothing else in the world can bring you so much joy. And cider is drunk here in abundance, with locals and tourists rubbing shoulders (and glasses of the alcoholic beverage) at the many *Ebbelwoi-Kneipen* or cider taverns dotted about the city. The atmosphere is at its most authentic in the traditional establishments of Sachsenhausen or Bornheim, where the Eulenburg pub, for example, proudly dates back to 1732. Cider or *Stöffche* is customarily served in a *Bembel*, a salt-glazed, round-bellied pottery jug, and a ribbed glass. Another major utensil is the *Deckelche*, a wooden mat placed on top of the glass to keep the flies out. In the old days a wreath of spruce with a *Bembel* in the middle hanging up outside the door indicated that cider was made on the premises, something now rarely found as cider is easier to buy than make. The dry and slightly bitter cider is often diluted with water or lemonade to make a "sour" or sweet type of shandy. You can savour all varieties in comfort aboard the Ebbelwei-Express, a converted tram that tours the various hidden corners of Frankfurt.

The people of Frankfurt like to soak up their intake of cider with some *Grie Soß* (literally: "green sauce") or *Handkäse mit Musik*. The latter is a cheese made of sour milk and marinated in oil and vinegar and seasoned with salt and pepper, the *Musik* being provided by a generous helping of raw onions. It is eaten with bread and just a fork; if you ask for a knife, even in your best German, you'll be immediately spotted as a tourist ...

Grie Soß is a thick, cold sauce made of sour cream, hard-boiled egg yolk and seven herbs (hence the colour and name). These are borage, chervil, cress, parsley, salad burnet, sorrel and chives and can be bought ready packed on the market in Frankfurt. Green sauce is so popular that in 2007 it even had a monument erected to it; in Frankfurt-Oberrad there are seven tiny greenhouses or green houses, as each one is painted in a different shade of green to match the appropriate herb.

The Main metropolis is also famous for its *Frankfurter*, thin pork sausages heated in brine.

These are often confused with *Wiener* which are made of pork and beef. *Wiener* get their name from a Frankfurt butcher who exported his frankfurters to Vienna ("Wien" in Austrian). And just to make things even more confusing, *Wiener* are known worldwide as frankfurters – except in Germany and Switzerland.

Sweet delights

There are also many sweet culinary delights to be had in Frankfurt. The most famous of these is the *Frankfurter Kranz*, 'invented' at the beginning of the 18th century. The round cake with its golden glaze of cracknel and décor of candied cherries is supposed to resemble a crown adorned with rubies in homage to the city's history as the place where the emperors of the Kingdom of Germany in the Holy Roman Empire were crowned.

On the Christmas market you can try *Bethmännchen*, like *Brenten* small sweetmeats made of marzipan, sugar and almonds. They are said to have originated from a chef employed at the house of banker Simon Moritz von Bethmann – hence the name – with the halved almonds representing each one of Bethmann's sons.

There is much more on the menu in Frankfurt than just traditional fare. The vast number of economic and financial businesses based in the city has nurtured a thriving international culinary scene that has class – and its price. On the opposite end of the scale is a mixed bag of simple pubs and snack bars selling food from all over the world, again reflecting the cosmopolitan makeup of the city. One place not to be missed in this respect is the Kleinmarkthalle, Frankfurt's small market hall, where during the week you can savour a variety of dishes or simply peruse the many stalls for edible specialities both local and exotic.

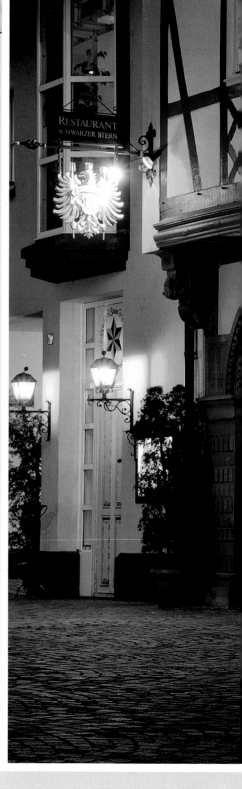

Left:
Frankfurt's national drink is Apfelwein or cider. Like wine, on pressing the drink is very sweet, then heady and half fermented, with actual cider only produced at the end. Those who like it less sour dilute it with water; adding lemonade to your cider is treated by real traditionalists as a heinous crime...

Above:
Schwarzer Stern on Röm berg is one of Frankfurt' more traditional pubs. First mentioned in 1453, it was destroyed in the Second World War and reconstructed along wit the other buildings on t east side of the square i the 1980s, more or less it once was.

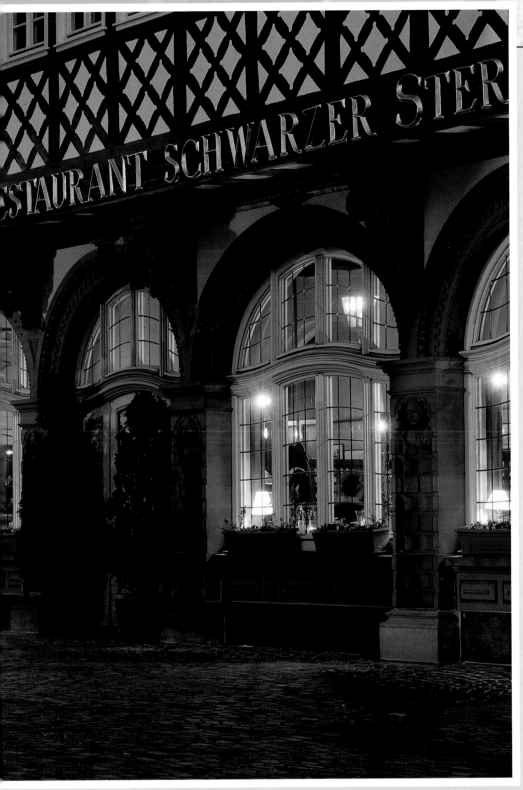

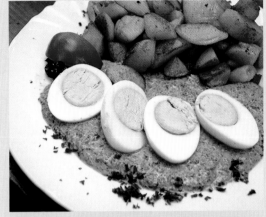

Right, from top to bottom: One national dish of Frankfurt is Grüne Soße or Green sauce which gets its name from the seven finely chopped local herbs it contains. It's traditionally served with hard-boiled eggs and potatoes.

Handkäs mit Musik, with the cheese made from sour milk, is not to everybody's liking. It is, however, extremely healthy with its high protein and low fat content.

Onion flan or Zwiebel-kuchen tastes best washed down with a glass of wine from the local Lohrberger Hang vineyard.

There's also something for the sweet tooth in Frank-furt: Frankfurter Kranz, a sponge cake made with butter cream whose shape and decor is supposed to resemble the imperial crown once placed upon heads of state here.

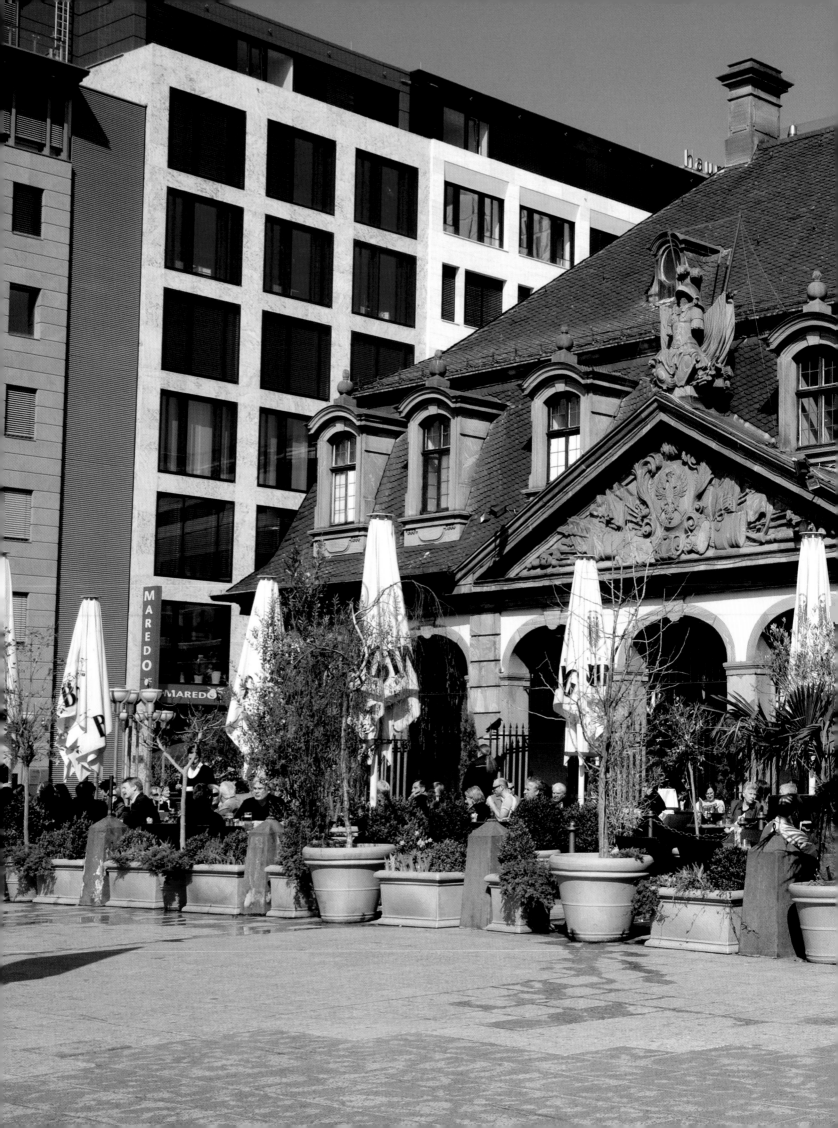

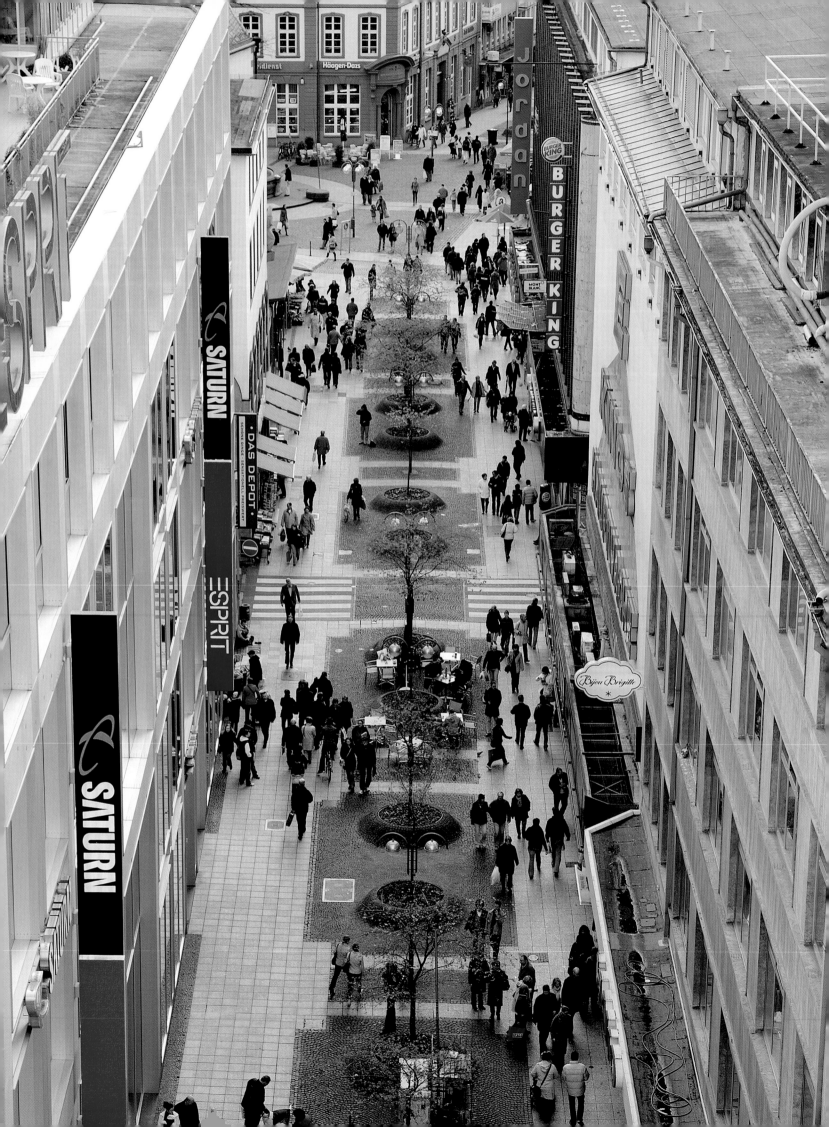

Page 42/43:
The square outside the Hauptwache is the modern centre of Frankfurt. The city's main shopping street, the Zeil, runs from here to Konstablerwache. The baroque building was once the city guardhouse and is now a popular café and meeting place. It was the site of the Frankfurt Wachensturm, the storming of the police stations by the pre-March movement.

Left:
The Zeil shopping centre is one of the more modern buildings in the pedestrianised high street. Behind the narrow façade is a long courtyard with the shops arranged in a spiral around it. The rooftop café and visitors' terrace afford grand views of the town below and the skyscrapers above.

Left:
This bronze sculpture by Richard Heß shows David sitting triumphant on the head of the slain Goliath. The artist placed it at the entrance to the Zeil as a "monument to the hopeful victory of the mind over the raw brutality of the world, of culture over commerce".

Left page:
The consumer temples of the Zeil also spill over into the narrow side streets, such as the Liebfrauenstraße shown here. If you keep going, you end up on Liebfrauenberg, with Paulsplatz and Römerberg beyond.

45

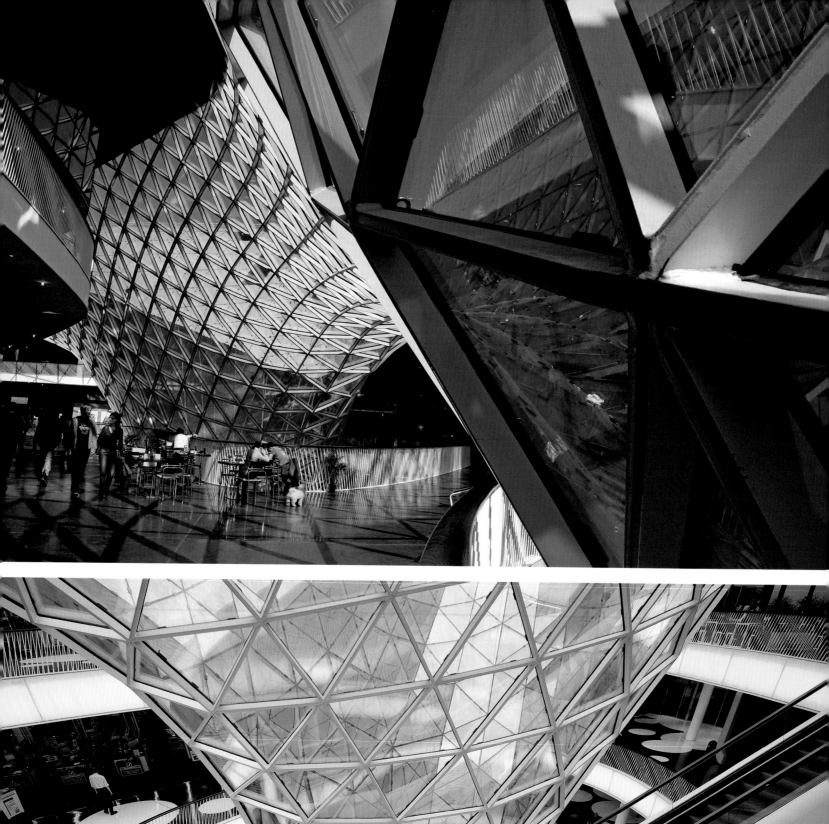
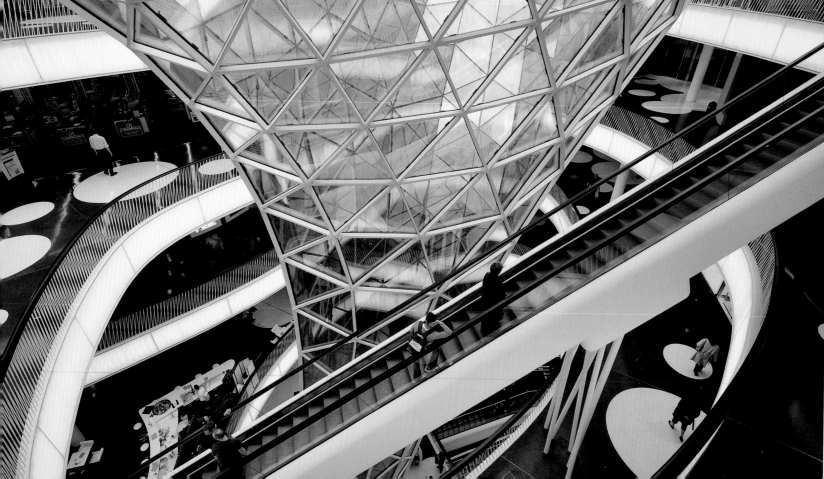

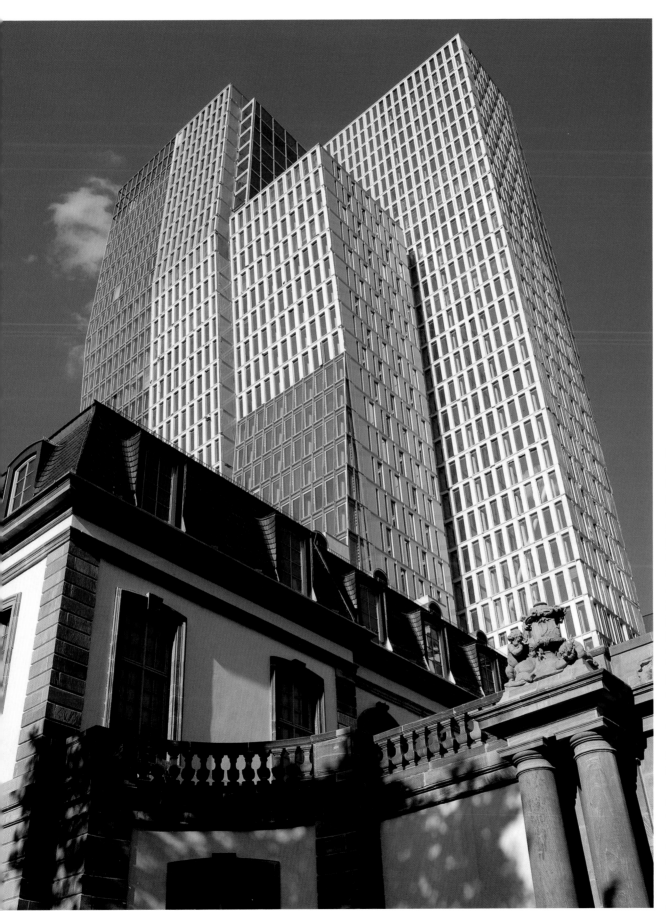

Photos, left page:
*Massimiliano Fuksas'
myZeil shopping centre,
recently opened in 2009,
definitely smacks of the
future. The rainwater
funnel of glass, which
winds down from the roof
through the building to
its opening in the outer
façade, is so cleverly inte-
grated as to form an or-
ganic whole. On their way
up, the escalators provide
visitors with ever more
fascinating views of the
mind-blowing interior.*

Left:
*Together with a number
of hotel and office blocks
and the reconstructed
Thurn and Taxis palace,
myZeil makes up the Palais
Quartier. This new fusion
of baroque and mod-
ernism, of historical fabric
and contemporary working
and shopping habits,
is a real eye-catcher in the
middle of the city.*

47

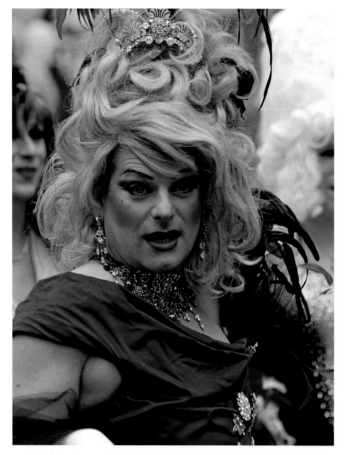

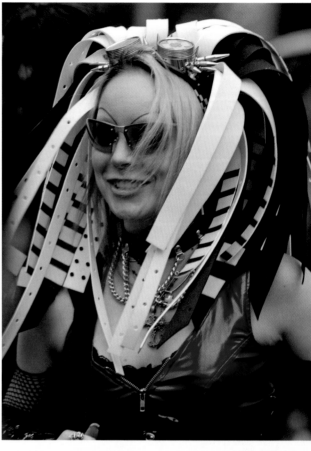

Bright, breezy and definitely brash is how the gay and lesbian community of Frankfurt celebrates Christopher Street Day! The imaginative, elaborate costumes are a delight to behold and manage to impress even the most staid onlookers. The parade starts out on Römerberg, all decked out in the rainbow flag for the occasion. The event isn't just a huge party but also a political gathering that pays homage to the first Christopher Street march staged by homosexuals in New York in 1969.

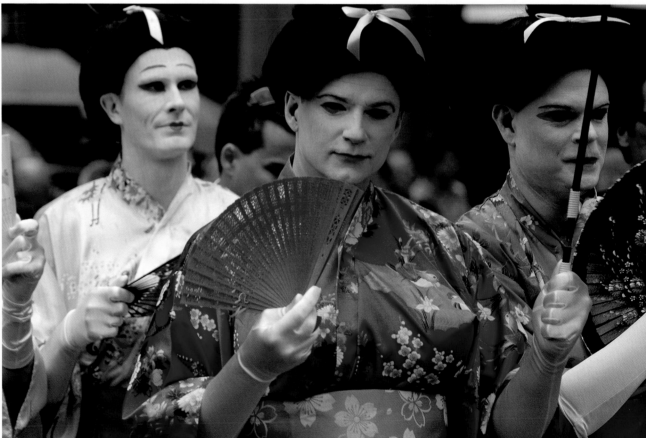

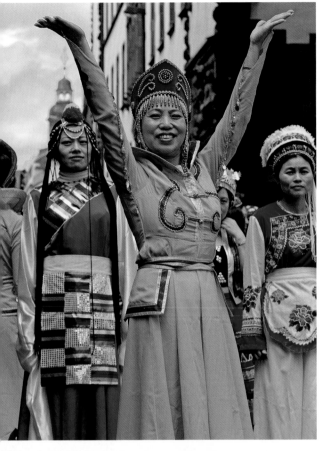

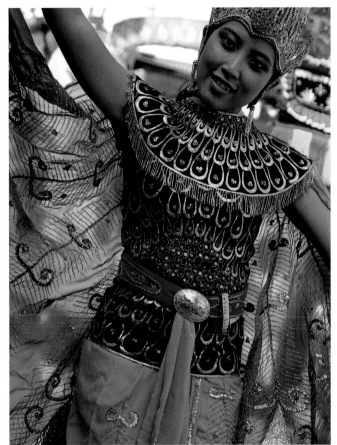

Frankfurt is something of
a melting pot, with inhabi-
tants – and thus languages,
traditions and culture –
from around 170 countries
of the world. The summer
Karneval der Kulturen
or carnival of cultures is
a great opportunity for
everyone to merrily display
the customs and identities
of their homeland – and
to make a colourful stand
for international tolerance
and understanding.

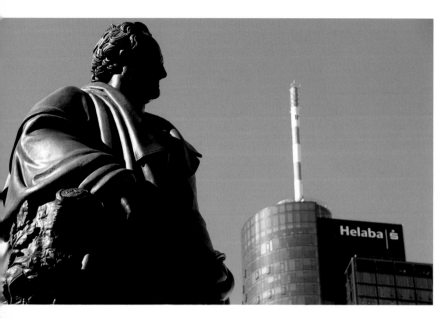

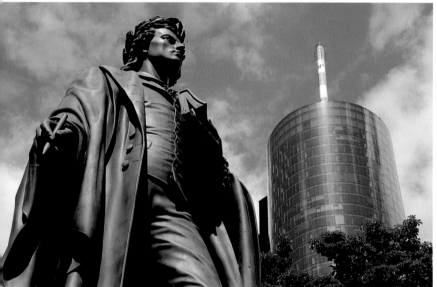

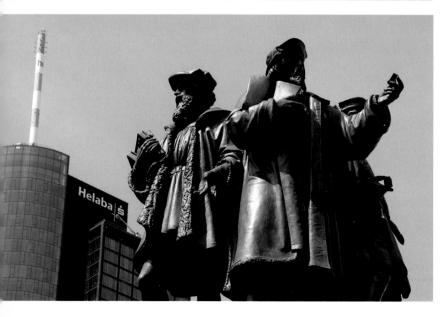

Below:
Collectively, Kalbächer Gasse and Große Bockenheimer Landstraße between Opernplatz and Börsenstraße are known locally as the Fressgass or food alley. The area does *indeed resemble a huge outdoor restaurant, with countless pubs, cafés and delicatessens to tempt hungry passers-by. This has been the case for the past hundred years which is why the word "Fress-* *gass" has become the vernacular nomenclature of choice. There's even an official Fressgass constitution intent on maintaining the appearance and character of the place.*

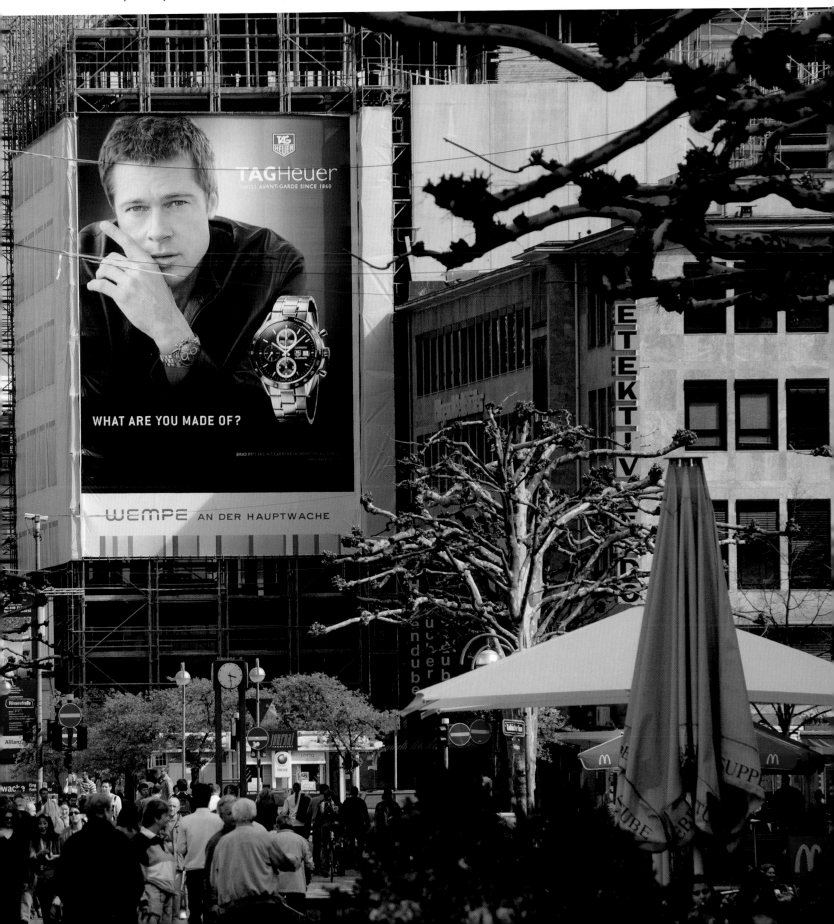

If you're looking for expensive bags, designer clothes, exclusive accessories or the finest jewellery, then head for Goethestraße, Frankfurt's luxury shopping boulevard. The big names in fashion can be found here alongside countless top boutiques. A well-stocked purse/wallet is a must if you're intending on not just window shopping …

Goetheplatz links Goethe-
straße to the square out-
side Hauptwache and the
Zeil. In 2008 the prince
of poets was reinstated
on the square named after
him.

In the boutique windows
on Goethestraße the crème
de la crème of the fashion
industry show off their
latest collections. It's
always worth taking a
look, if only to see what's
currently en vogue.

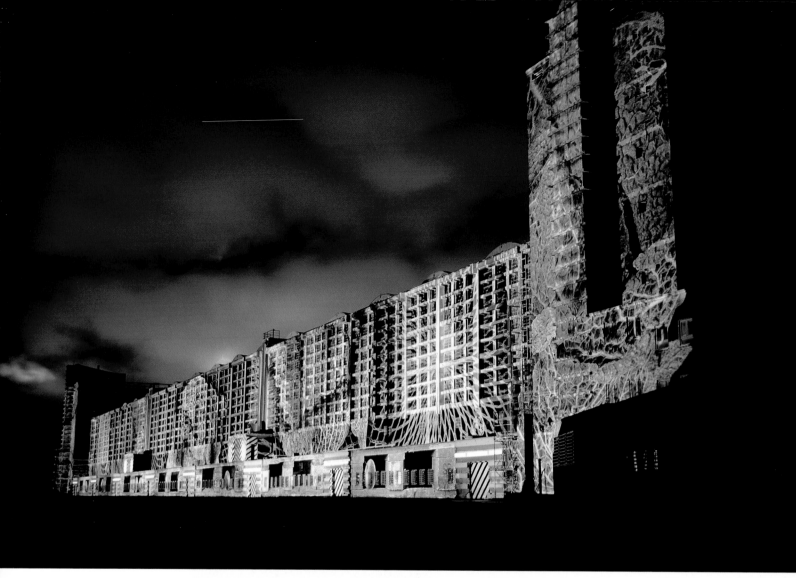

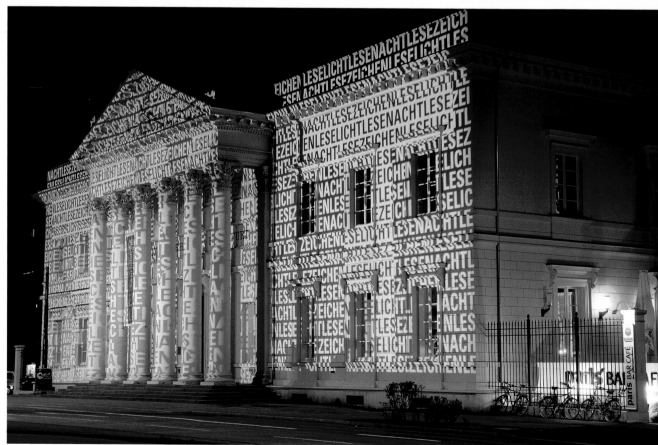

Above:
As part of the Light+Building exhibition, every two years for Luminale the entire city of Frankfurt is placed in the limelight. The pictures projected onto the Großmarkthalle, built in 1920 and shown here, accentuate the size of the building and its former function. The market hall will soon become part of the new European Central Bank.

Right:
At the last Luminale, alternating projections of letters, words and snippets of text transformed the portico and main building of the Literaturhaus into a work of art.

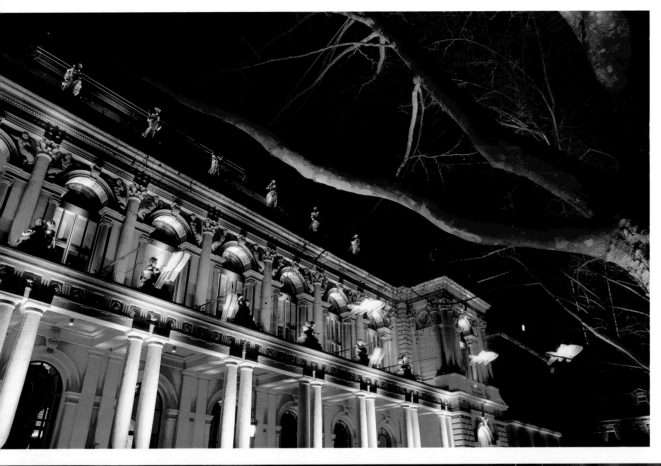

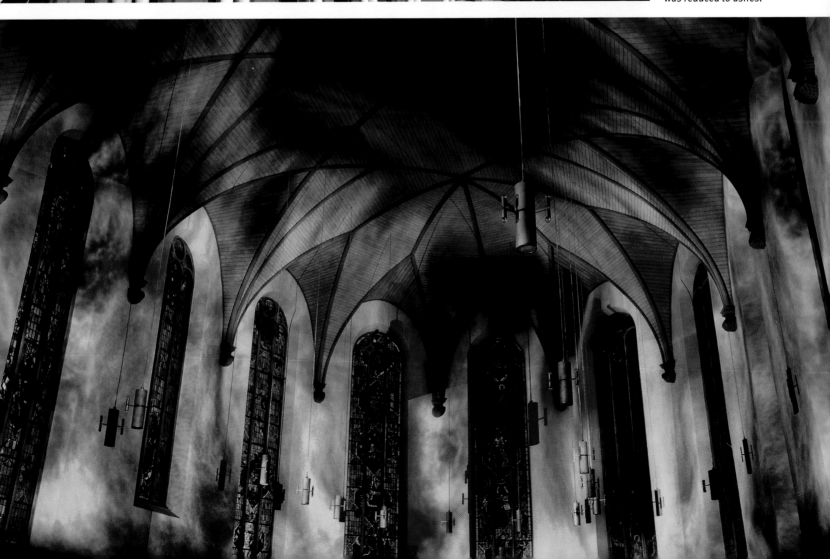

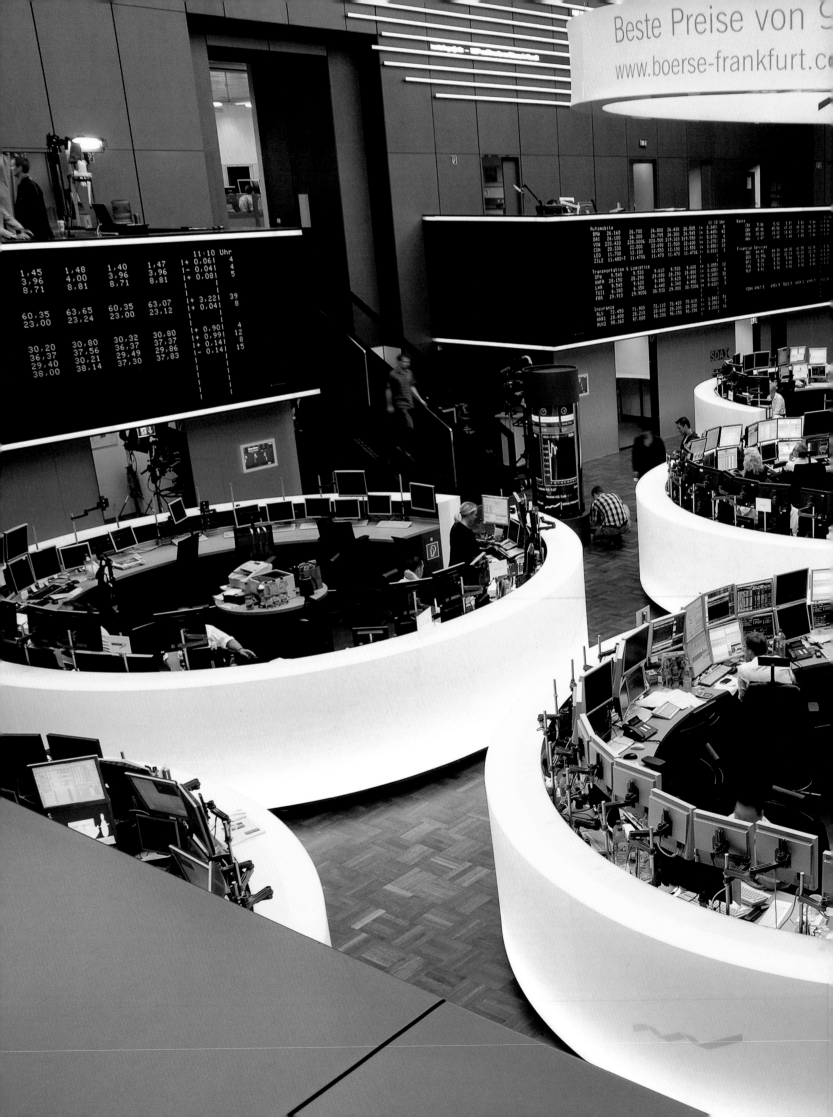

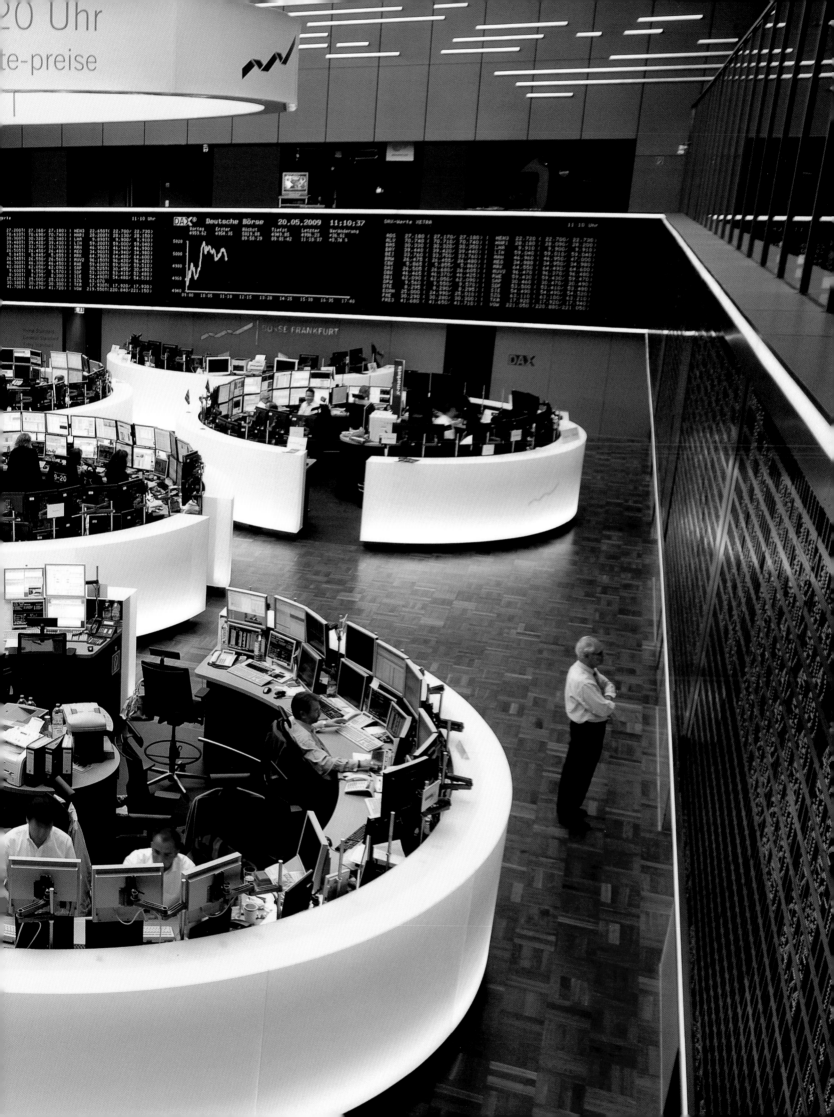

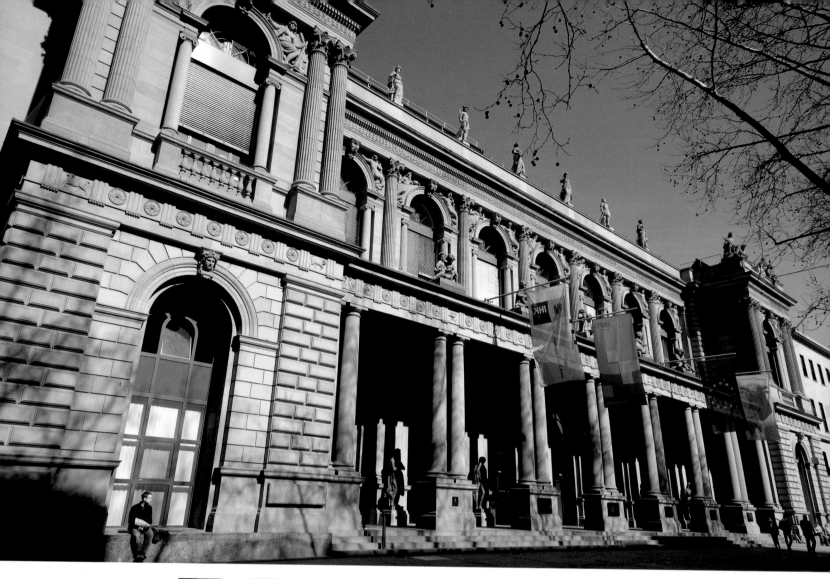

Above and right:
The Historicist new stock exchange, completed in 1897, is one of the chief examples of Wilhelmine architecture in Frankfurt. The portico is adorned with symbolic representations of the five continents and land-borne trade. The statues once decorated the entrance to the old stock exchange on Paulsplatz.

Page 56/57:
Even if much of its business is now done electronically, the old trade hall is still important for the Frankfurt stock exchange and securities trading. This is where ticketers fix prices and make deals.

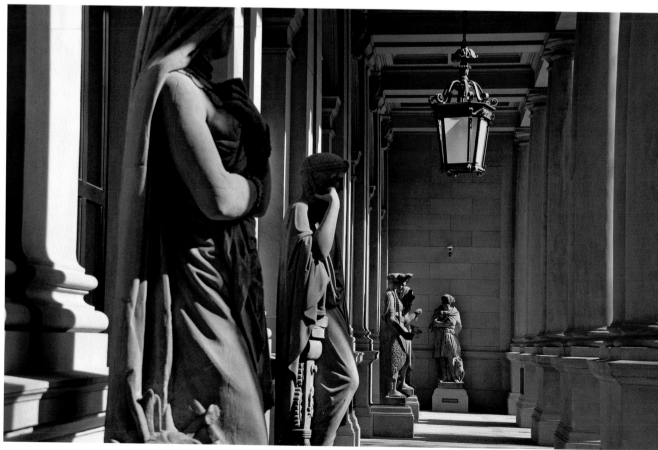

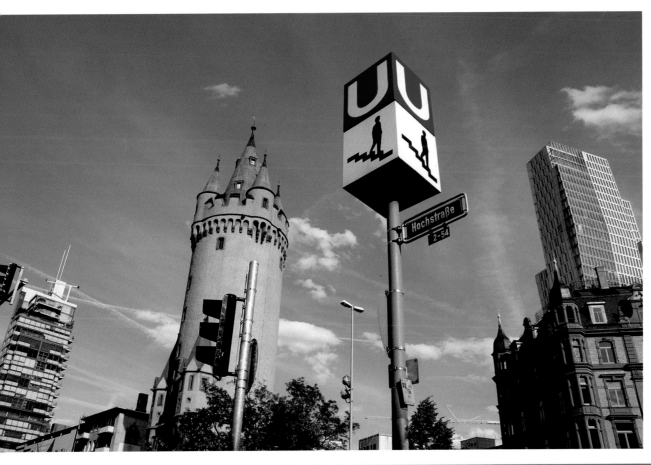

Left:
Eschenheimer Turm, erected by master builder Madern Gerthener in 1428, was once part of the town fortifications and is the oldest existing building in the city centre. Guests can now soak up its historic flair in the café and old guard room in the tower.

Below:
The old Senckenbergianum complex, once with a Theatrum Anatomicum, botanical gardens and hospital, is now swamped by modern office and residential buildings. The ventilation shafts sticking out of the ground from the underground car park symbolise the vast and extremely well-hidden network of pipes, sewers and cabling needed to fuel modern-day life in a big city.

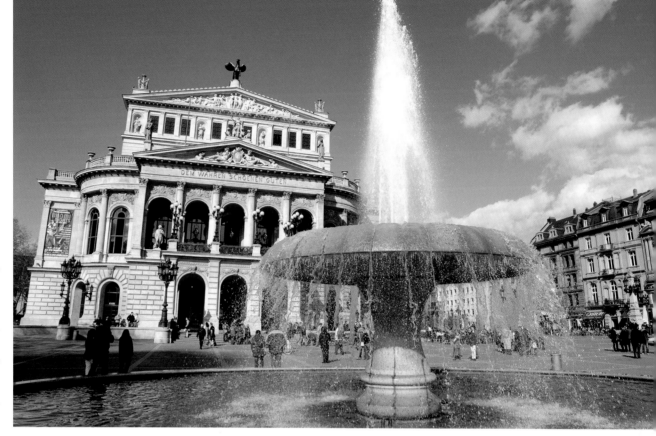

"To truth, beauty and good" is the inscription on the façade of the Alte Oper, the pride and joy of the people of Frankfurt. Both its initial construction and rebuilding at the end of World War II are down to the initiative of the local residents who provided the basic capital for both projects.

Opernplatz with the fountain at its centre and old opera house in the background is one of the prettiest spots in town. The many restaurants situated here profit from its unique atmosphere. Both locals and tourists alike can sit back and take in the beauty of the square over a leisurely meal or cup of coffee.

Right page:
The opera house only usually opens its doors for concerts and balls. At the annual German sports press ball and German opera ball the red carpet is rolled out for the stars – who come here in abundance.

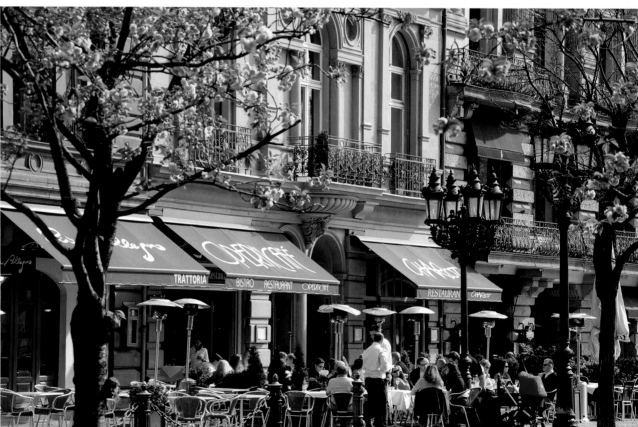

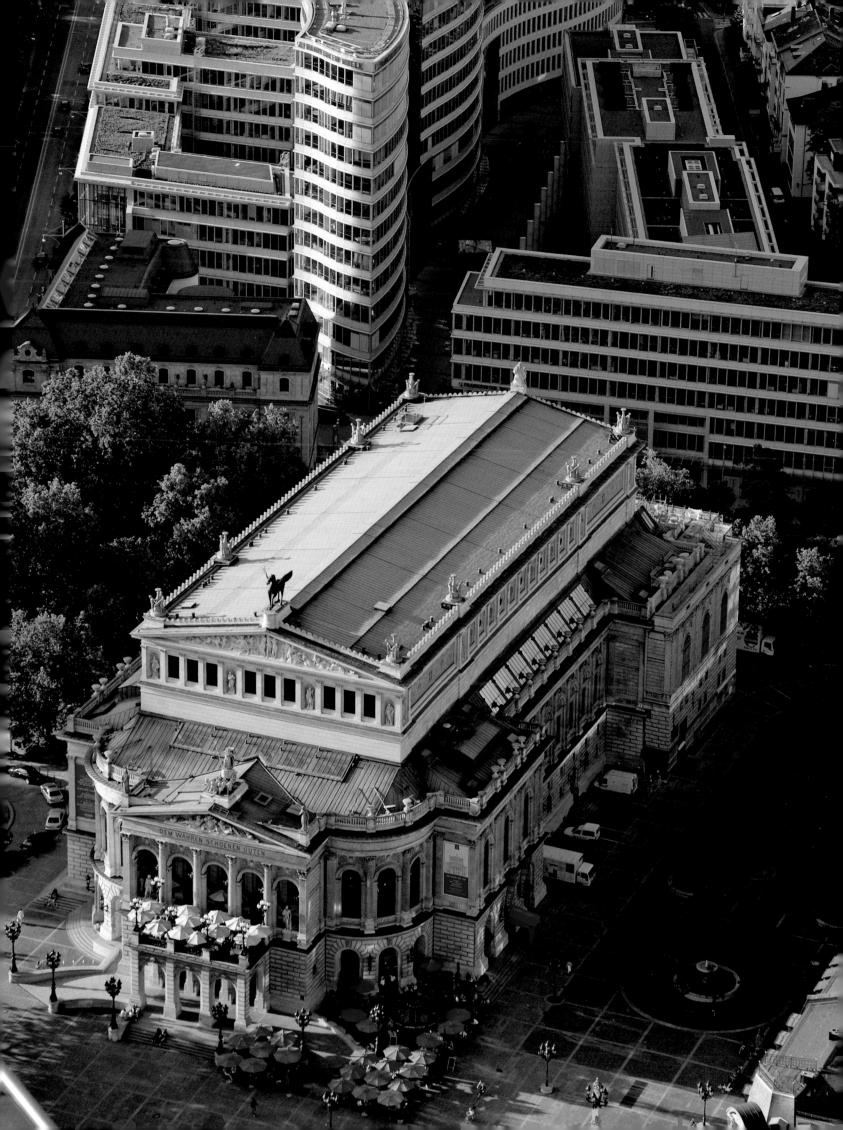

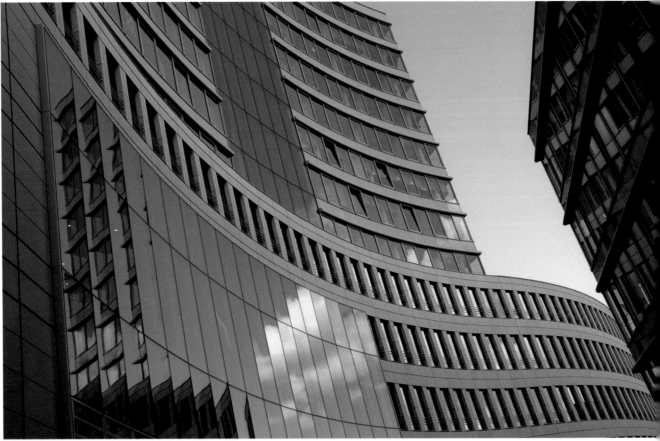

This page:
The state-of-the-art Frank-furter Welle links up to the back end of the opera house. Its light, wave-shaped front is lined with cafés and bars and traced by an artificial stream. Despite its pleasing design, the Welle is some-what off the beaten track and has problems attract-ing customers once the offices have closed for the day.

Right page:
Taunusanlage in the mid-dle of the banking quarter belongs to the green belt formed when the medieval fortifications were flattened. The park now provides a welcome oasis in the midst of high-rise buildings and office blocks – like in Central Park in New York or one of the many parks in London. At dusk the area is colonised by an army of municipal rabbits.

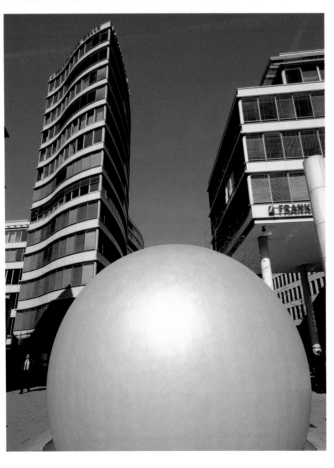

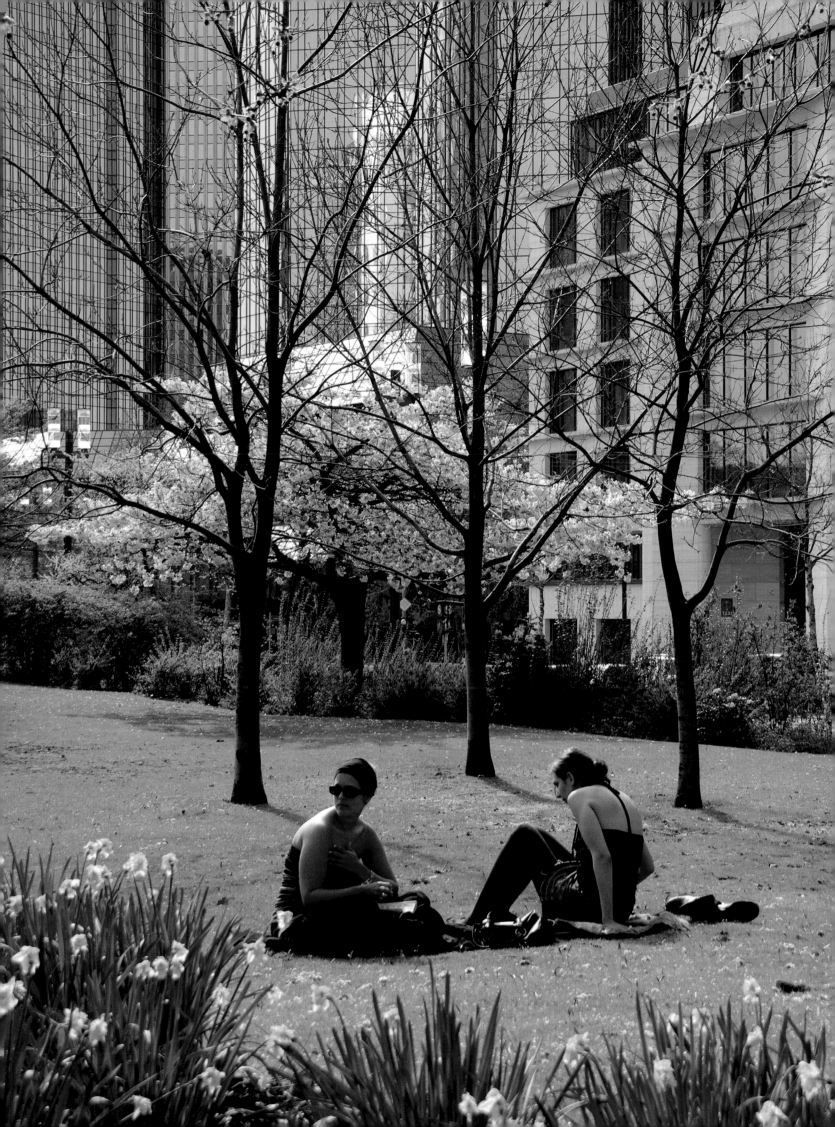

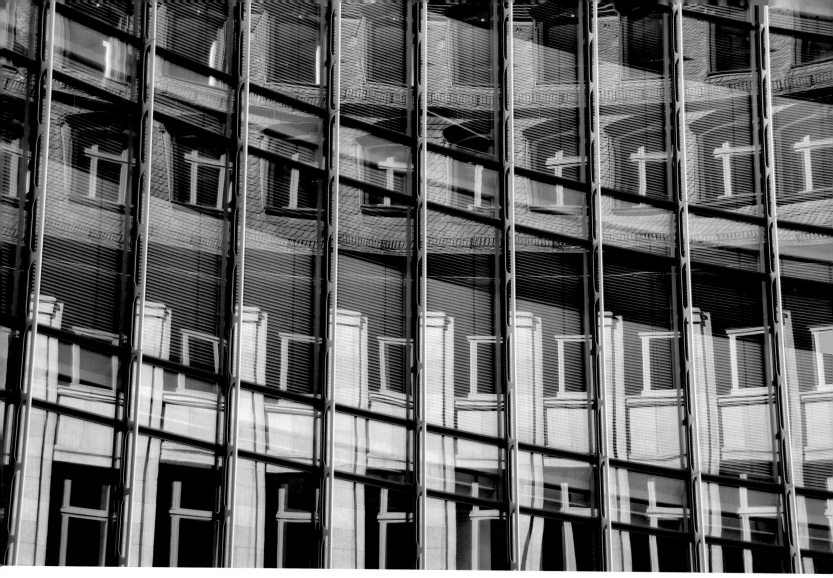

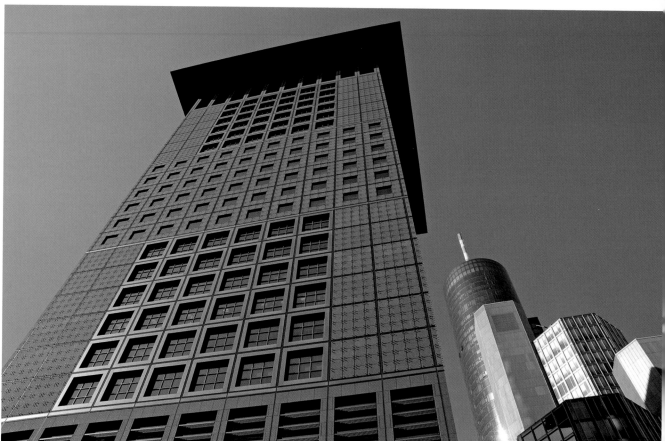

Above:
There are plenty of interesting perspectives and visual effects created by the city skyscrapers, such as here at Skyper, where the glass mirrors the façade on the other side of the street.

Right:
Its terracotta façade of natural stone makes the Japan Centre stand out from the steel and glass constructions of the other bank buildings. Its geometric design and overhanging roof are supposed to resemble a Japanese stone lantern. The dimensions of the base and pattern of the façade are derived from the tatami mat that is used as a floor covering in traditional Japanese houses.

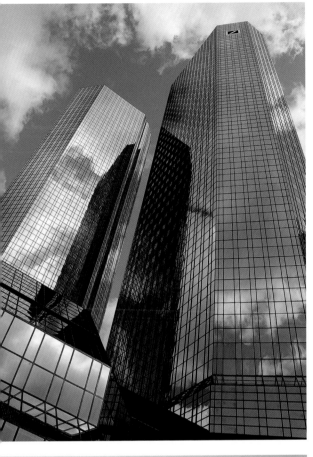

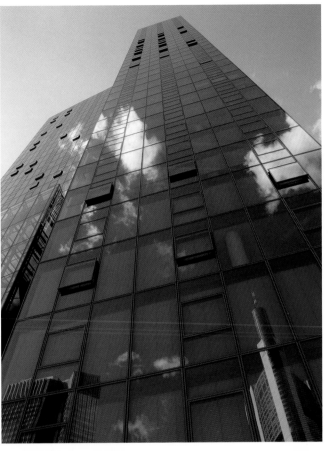

Far left:
You feel pretty small walking past the skyscrapers in Frankfurt – especially when you look up. But sitting on the upper floors of the twin towers of the Deutsche Bank, for example, on a fine day you can see as far as the hills of the Taunus, Vogelsberg, Spessart and Odenwald. If the weather's bad, on the other hand, you'll literally have your head in the clouds …

Left:
The name "Gallileo-Haus" (136 m / 446 ft high) is construed from mathematician Galileo Galilei and the street the building is on (Gallusstraße). Once part of the Dresdner Bank, since its takeover the building has been used by the Commerzbank.

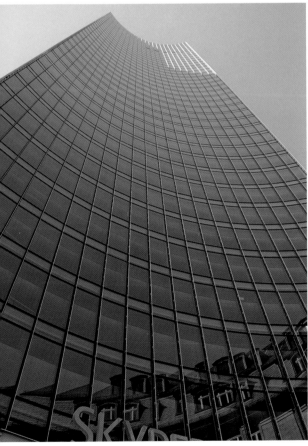

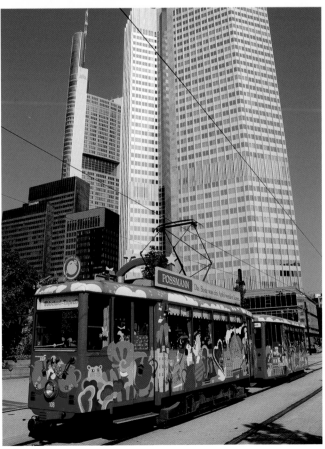

Far left:
Skyper is one of the more unusual Frankfurt skyscrapers. Shaped like a quarter circle, it towers a giddy 154 m (505 ft) up into the air. A glass hall connects it up to what was once the prestigious villa of the Holzmann Concern, built in 1915.

Left:
The seat of the European Monetary Institute since 1995, the Eurotower was given its name long before the euro was introduced. The giant tower (148 m / 486 ft) now houses the European Central Bank – which is scheduled to soon move to a new skyscraper on the Großmarkthalle site. To date, though, the bank is still 'patronised' by the Ebbelwei-Express tram, shown here on tour.

The Maintower is home to the highest radio and television studio in Germany. In the restaurant and bar on the top floors you can delight in the cosmopolitan flair of Frankfurt, especially at dusk when all around you the lights of the skyscrapers twinkle in the twilight.

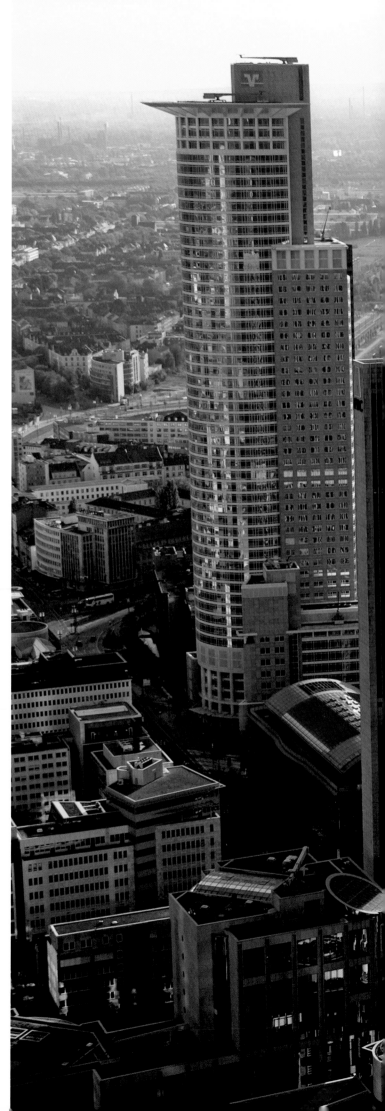

Right:
The visitor's platform of the Maintower, 200 m / 656 ft high, is reached by lift at a speed of seven metres (23 feet) per second. It's worth the trip, if just to see the other skyscrapers (more or less) on their own level. On a clear day you can gaze out across the city to the medium-range hills in the distance.

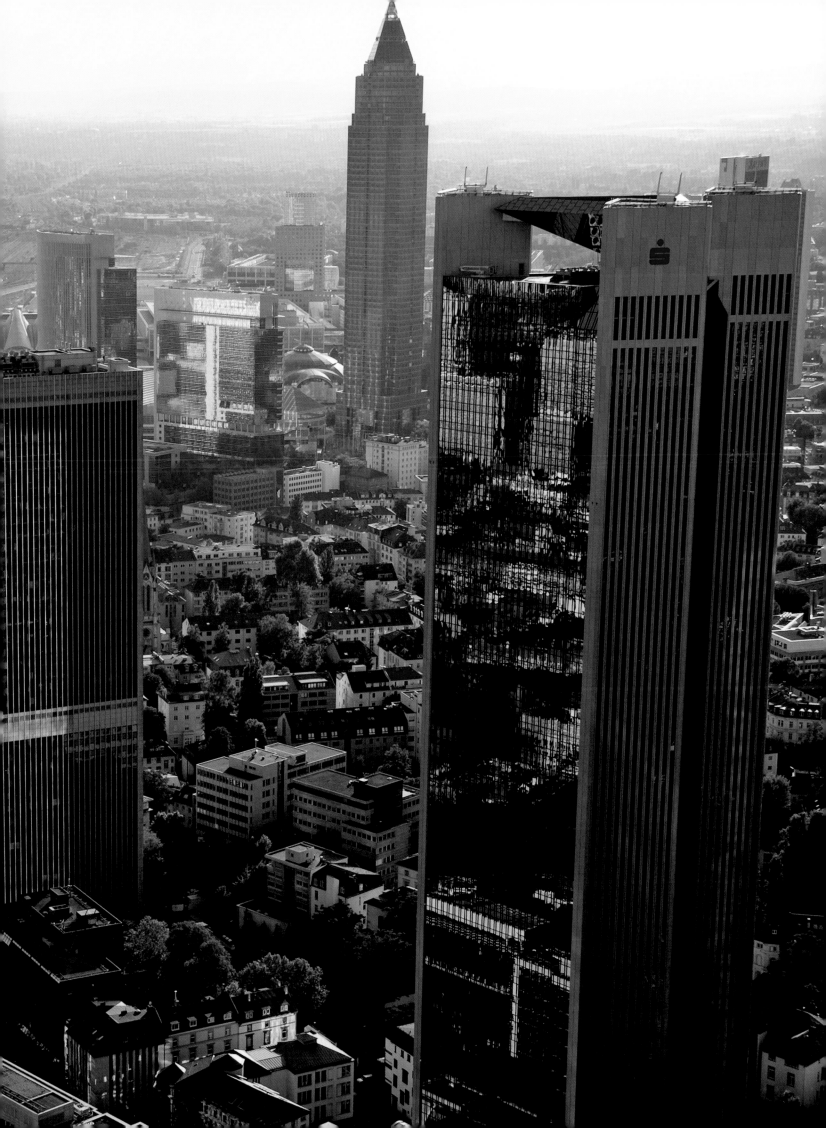

FROM MERCHANT BANKERS TO FINANCIAL METROPOLIS

Outside Germany Frankfurt is famous for three things: the airport, the stock exchange and its banks. The logos of the big financial institutions twinkle in the twilight from atop the highest buildings in town, giving the Frankfurt skyline its unmistakeable topography. The banks also secure the city financially, both with their business and their wealth of jobs. Nearly 75,000 people work in 266 finance houses in Frankfurt, with over half of them of non-German origin. Employed by banks active throughout the globe, their various nationalities and support of cultural and sporting activities in the city greatly contribute to the high quality of life here.

Frankfurt enjoys a long tradition as a centre of banking, a tradition inextricably linked to its history as a trading post and economic fairground. The first bankers were traders, handling banking affairs merely to support their own business transactions. Besides exchanging foreign currencies they bartered with bills of exchange as promises of payment. Through this system buyers had debts deferred until the next trade fair. Up until the mid 18th century this granting of credit and the financing of loans for transport costs, toll duties and taxes were the main activities of Frankfurt's merchant bankers. There was also pawnbroking which, on payment of a fee, enabled traders to store their unsold wares between fairs in the city and not to have to arrange for the dangerous and expensive return shipment of their precious goods.

The transition from merchant banker to private financier came in the second half of the 18th century. Frankfurt traders had often helped out the odd prince or two by granting them loans; now the regents' need for ready cash had grown to such an extent that a new business model was called for. Loans were split between interested financial investors and the banking institutions were able to levy a fee for their services with little risk to themselves. Another profit opening was the difference between the interest rate the banker loaned the money at and the rate at which he then loaned it to the client. The stock exchange subsequently evolved from a place where currency was exchanged to a money-lending organ dealing in not just coins but substantial loans from all over Europe. As a result many merchants relinquished their other trade activities to concentrate solely on the business of money.

The two financial houses of Bethmann and Rothschild gained particular significance in this field. By the end of the 18th century Bethmann had introduced imperial and royal loans to the market to the tune of several million florins, earning themselves a prestigious position on the German banking scene. The house of Rothschild became a formidable international presence by setting up branches in London, Paris, Vienna and Naples at the start of the 19th century, even managing to trump Bethmann. The Frankfurt stock exchange also grew in importance the world over.

With the abolishing of the monopoly on the issuing and distribution of loans, the introduction of a common currency for the entire German Empire and the increasing stance of the bigger corporate banks in imperial metropolis Berlin and other places, during the second half of the 19th century Frankfurt gradually lost its status as the financial capital and chief stock exchange of Germany.

International centre of finance

The fact that Frankfurt was able to again morph into the centre of finance it now is after the Second World War is due to the division of Germany and Berlin and the decision made by the Americans, British and French to found the Bank of the German Nations in Frankfurt to manage monetary reform. Through this the city later became the headquarters of the Deutsche Bundesbank or bank of Germany and what is now the European Central Bank. The big PLC banks followed, dragging the international giants in their wake. Even the Frankfurt stock exchange was able to latch on to its success of the 18th century and now enjoys a huge international reputation.

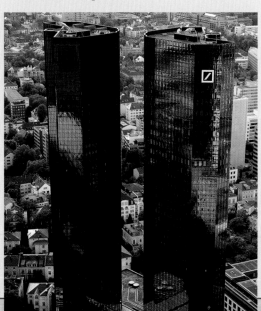

Left:
Probably the most famous high-rises in town are the twin towers of the Deutsche Bank (155 m / 508 ft apiece). Known locally as Debit and Cre... they are often used in the media to symbolise the world of banking ar... finance or the economi... power of Germany.

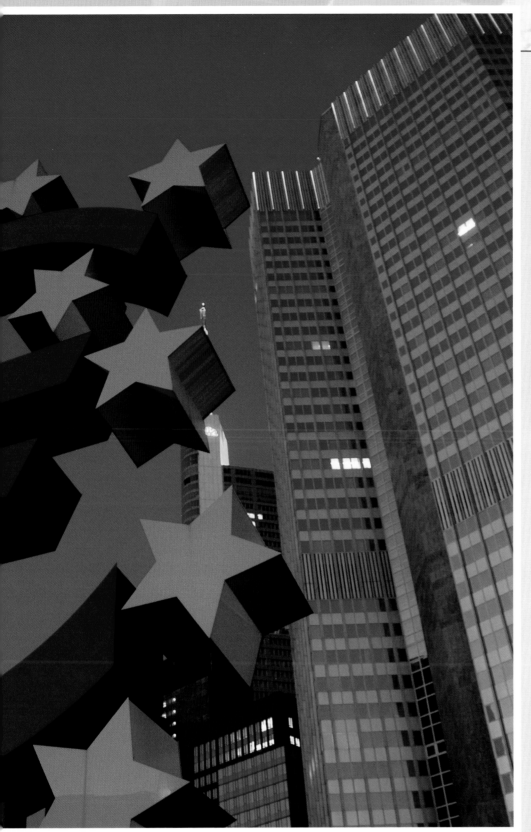

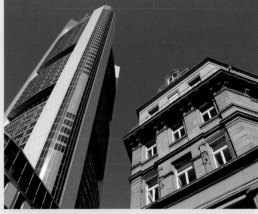

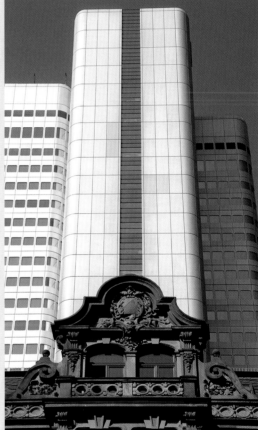

Above:
The enormous euro symbol outside the Eurotower is a popular photographic motif with visitors to Germany. It also shows just how proud Frankfurt is of the fact that it's the seat of the European Central Bank and home to the euro.

Top right:
At 259 metres (850 feet), the Commerzbank Tower is the highest skyscraper in the financial metropolis and for a brief period, from its completion in 1997 to 2003, the highest building in Europe. The tower was designed by famous British architect Lord Norman Foster.

Centre right:
The Silver Tower which once belonged to the Dresdner Bank is one of the most famous skyscrapers in Frankfurt. At 166 metres (545 feet), from 1978 to 1990 it was the highest building in Germany. It gets its name from its silvery aluminium cladding.

Right:
The museum of money run by the Deutsche Bundesbank deals with the history and manufacture of modern methods of payment. The museum also has various games to play, in which visitors can try their hand at monetary politics in the role of chancellor, president of the central bank or wage negotiator.

Right:
The English Theatre in Frankfurt has a long tradition dating back to 1979. It's now the largest English-speaking theatre on the Continent, with regular performances staged at the Gallileo-Haus.

Below:
Taunusstraße connects the bank towers of the Taunusanlage with Frankfurt's main station and station quarter. It cuts right through the middle of the red light district, where brothels, bars and 'dance' venues attempt to lure clients with garish neon lights and various other forms of advertising.

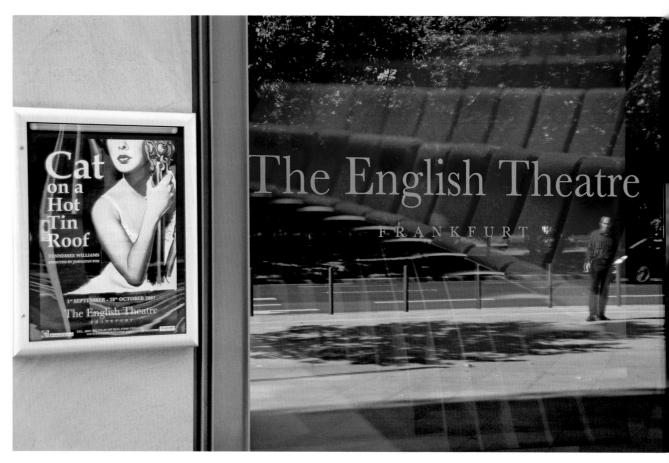

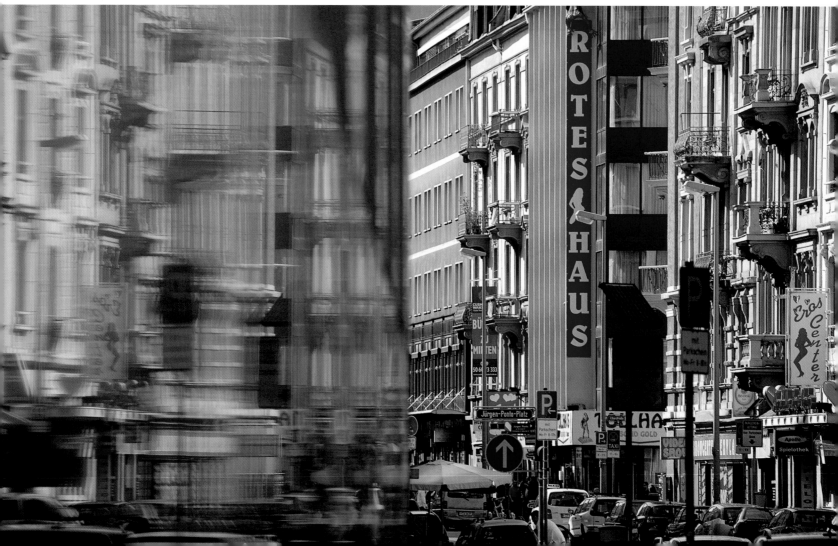

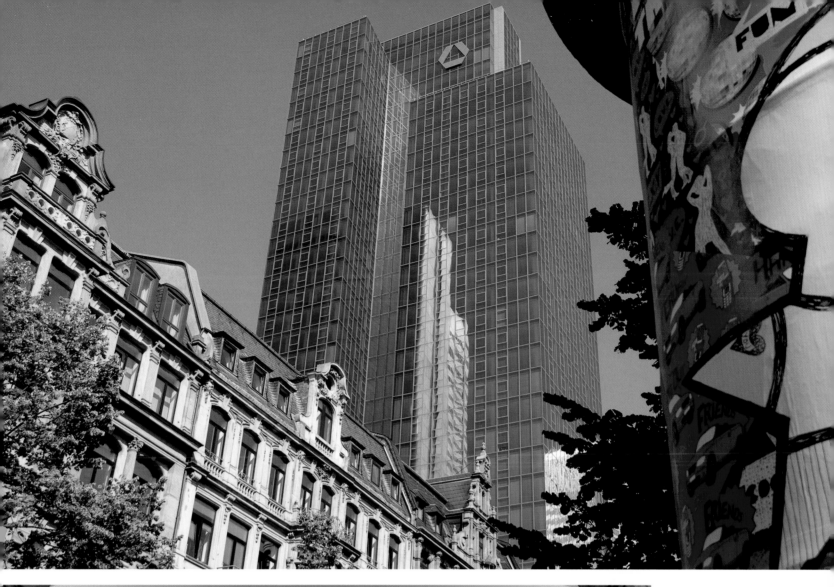

Above:
Starting at Roßmarkt,
Kaiserstraße runs from the
centre of town past Kaiser-
platz with the famous
Frankfurter Hof hotel to
the main station. It used to
be synonymous with the
words "mile of sin" in
Frankfurt, a mile that has
since been reduced to a
handful of erotic cinemas
and shops clustered round
the station.

Left:
Spared the devastation
of the Second World War
Kaiserstraße is one of the
few remaining showcase
boulevards in the city of
Frankfurt. Its Gründerzeit
buildings with their
richly ornate facades and
elaborate entrances are
a delight to behold.

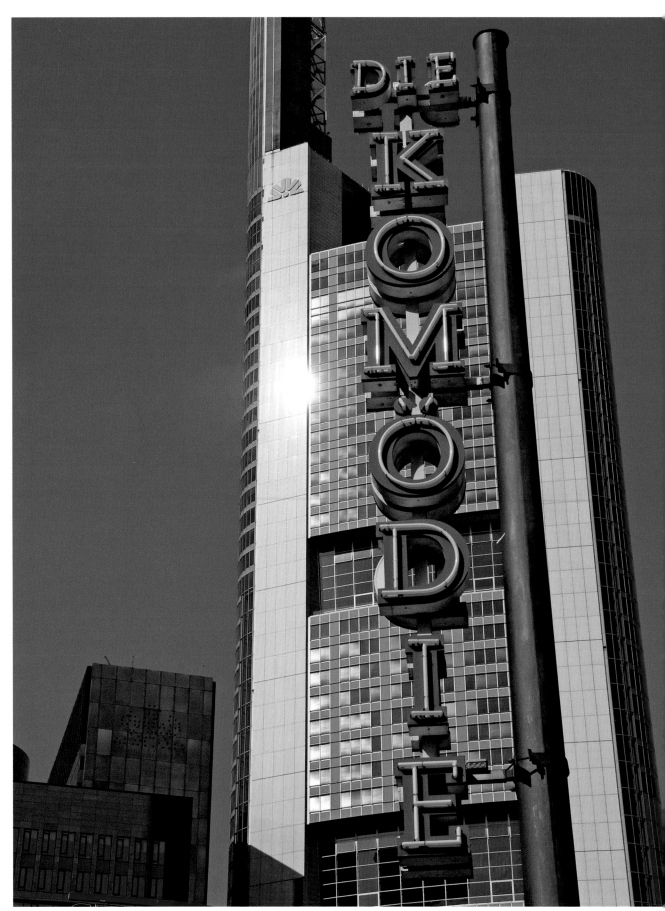

Die Komödie, specialised in light theatre, is one of Frankfurt's many and varied cultural venues. Here audiences can escape the fast-track world of business and the pressures of work and just sit back and enjoy the show. Frankfurt has exciting productions catering for all tastes, from variety shows, cabaret and plays in foreign languages to sophisticated drama and experimental theatre.

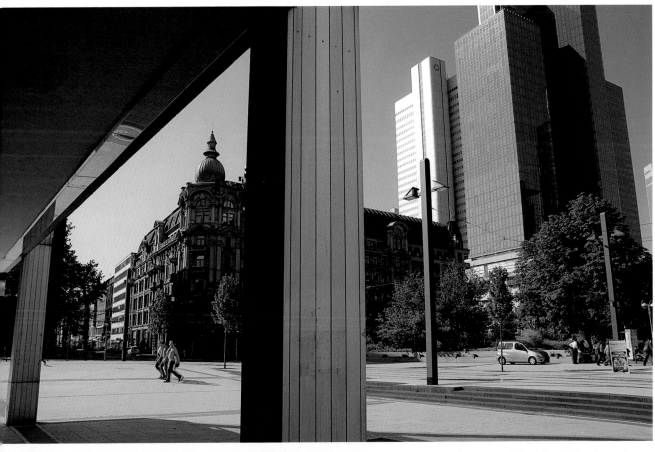

Left:
The epicentre of the
Frankfurt arts scene is
Willy-Brandt-Platz
opposite the European
Central Bank, where the
Städtische Bühnen offer
theatre and opera.

Page 74/75:
The elegantly arched
Holbeinsteg provides
pedestrians with a fast
and pleasant link between
Sachsenhausen and the
station quarter. It was part
of the Museumsufer project
of the 1980s intended to
better the various connec-
tions within the city and
across the River Main.
If you stop in the middle to
take in the spectacular
skyline and river bank, you
can feel the gentle wobble
of the suspension bridge.

Left:
The programme is ambi-
tious. The opera in Frank-
furt is one of the most
renowned in the world and
has been twice elected
opera house of the year
by international critics.
Frankfurt's theatre or
Schauspiel stages works
both by well-known
playwrights and up-and-
coming young authors.

73

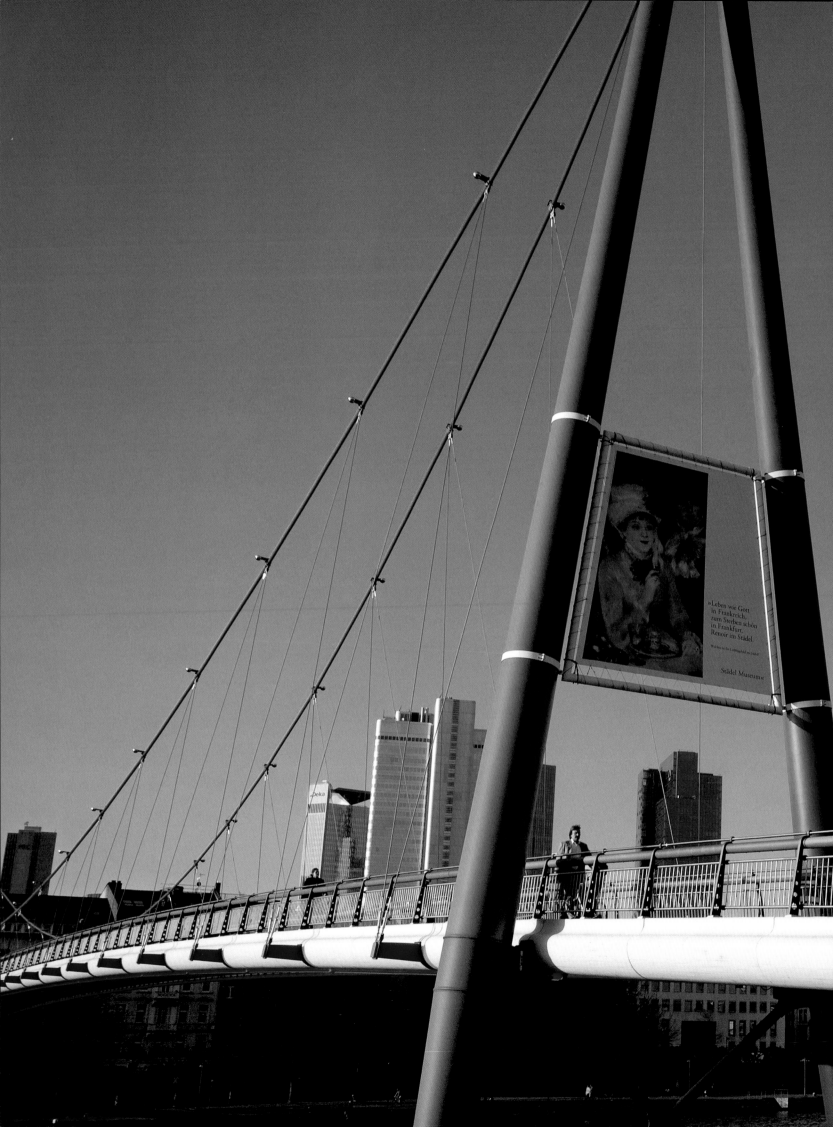

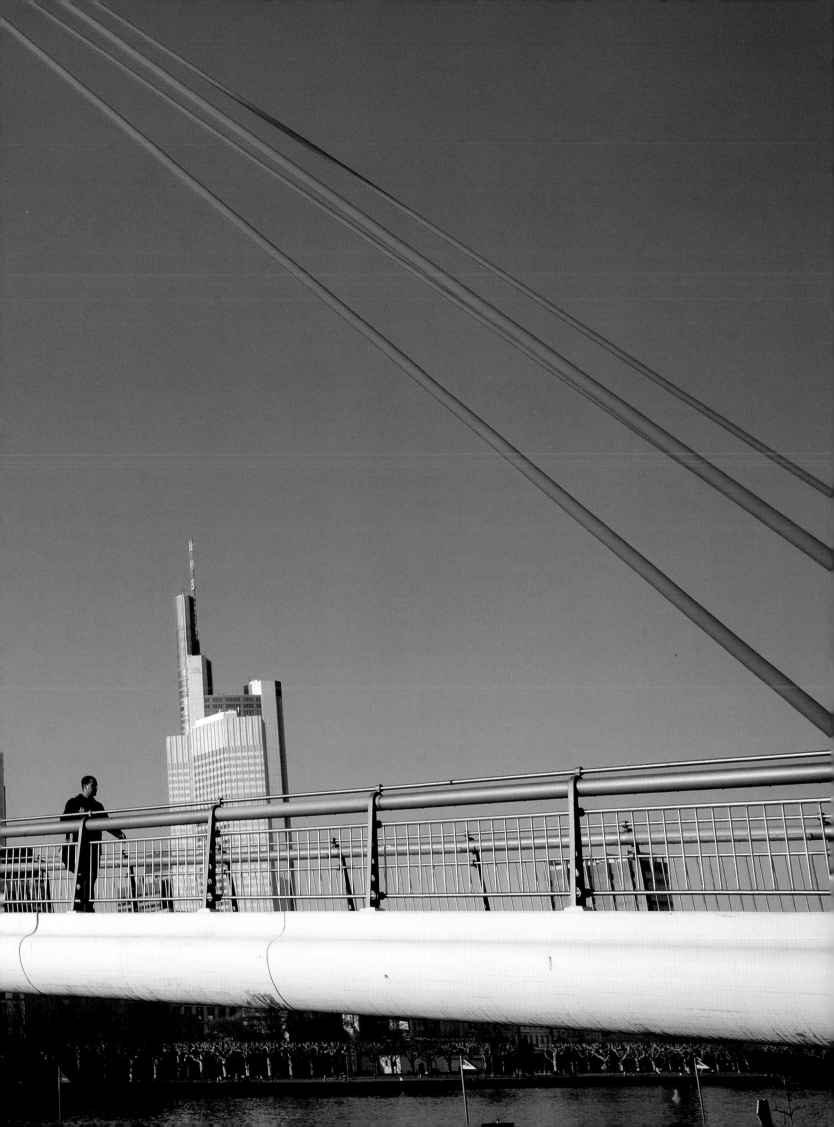

A walk through the suburbs

One good place to drink some Apfelwein and meet the locals is the Gemahltes Haus in the heart of Sachsenhausen. The many paintings on the façade and inside depict the art of cider making, life in Sachsenhausen and scenes from the surrounding countryside. They are the absolute highlight of the tavern where cider is still pressed. The menu features various local dishes, such as Grüne Soße and Handkäs mit Musik.

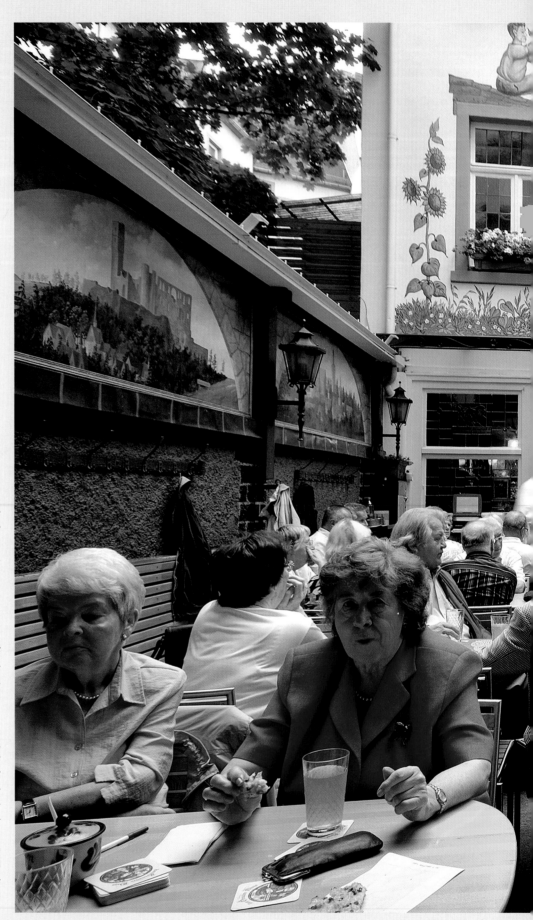

The true variety of Frankfurt can be found in the suburbs. In the 19th century well-to-do citizens fled the confines of the inner city to the quarters growing up around the Neustadt or new town. In the Westend in particular chic villas bear witness to the wealth of their former inhabitants. The main station, built in 1888, was embellished by street upon street of bourgeois housing where city life is now at its most colourful; this is where the red light district peddles its wares in neon-lit establishments and where just around the corner Frankfurt goes multicultural with its bevy of foreign restaurants, snack bars and shops.

Many of the villages and towns incorporated into the city during the 19th century have retained their characteristic centre, such as the studenty Bockenheim or the "merry village" of Bornheim. In the Middle Ages the people of Frankfurt were drawn to the latter by its pubs, dancing and ladies of ill repute and even today the atmosphere in the traditional cider taverns and trendy bars seems to be more spirited than elsewhere.

One popular place for Sunday outings is Höchst where the oldest building in Frankfurt stands, the Carolingian Justinuskirche. The tower of the Schloss rises above the town like a mighty fortress and the gardens of the baroque Bolongaro Palace are the perfect place for a gentle stroll.

Sachsenhausen, just across from the Altstadt, has been part of Frankfurt since medieval times. During the 19th century the first summer houses and villas were erected along the river bank, some of them now part of the Museumsufer or museum bank. The old heart of the suburb is famous for its nightlife. Totally enamoured with its *Apfelweinlokale* or cider taverns, American troops based in Frankfurt helped to spread the fame of this part of the city across the globe. The many pubs and bars of Old Sachsenhausen may now be in need of several coats of paint but are still a tourist magnet.

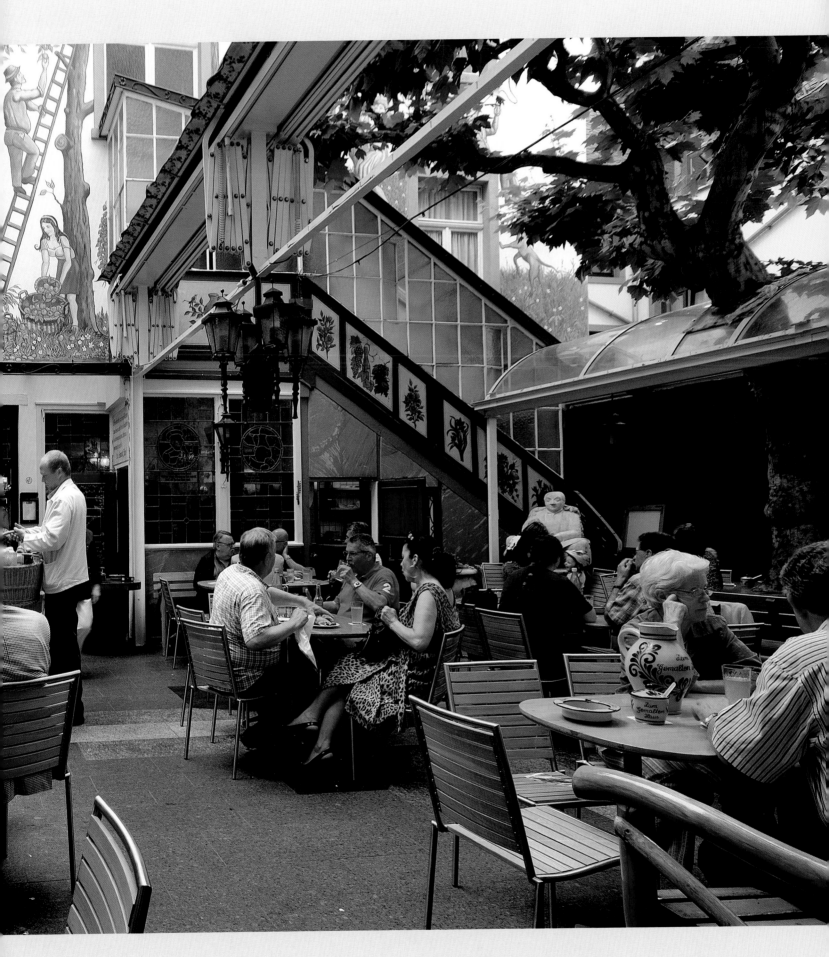

Page 78/79:
Only with great difficulty could the Zoological Society stump up the necessary funds for their Zoo-Gesell-schaftshaus, competed in 1876. Today the society headquarters is still used for a number of events and is also rented out for private functions.

Top and bottom right:
Between the suburbs of Ostend and Bornheim and not far from the zoo, the clock tower erected by the Ostend-Verein in 1894 is an absolute gem. Very close to it the Katakombe theatre has found a new home in an old cinema. Its programme largely comprises political review, a mixture of music and dance with a strong dose of social criticism.

Far right:
Back yards such as these are little havens of green in the densely populated streets of Frankfurt, with spirals of leaves often twirling their way along several gates and fences.

Right:
The Main Triangle in the Deutschherrnviertel juts out from the neighbouring office and residential blocks like the bow of a glass ship. This project is one of several similar undertakings that has turned the old abattoir and surrounding area into a popular quarter with a high quality of living.

Right page:
The best view of the Frankfurt skyline and steeple of St Bartholomew's cathedral can be had from the Deutschherrnufer with the Flößerbrücke in the foreground. The new recreational area, opened in 1998, joins the museum bank with the path running along the River Main (Mainwasenweg) to the Gerbermühle.

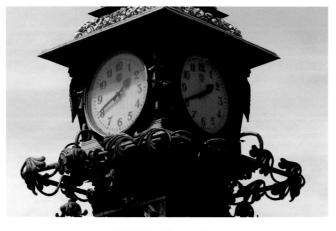

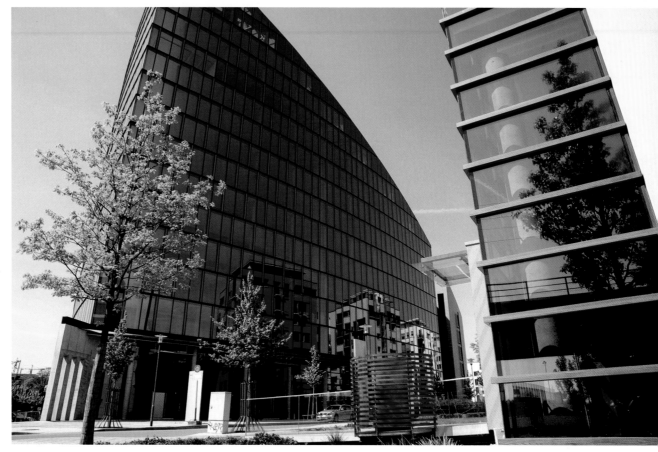

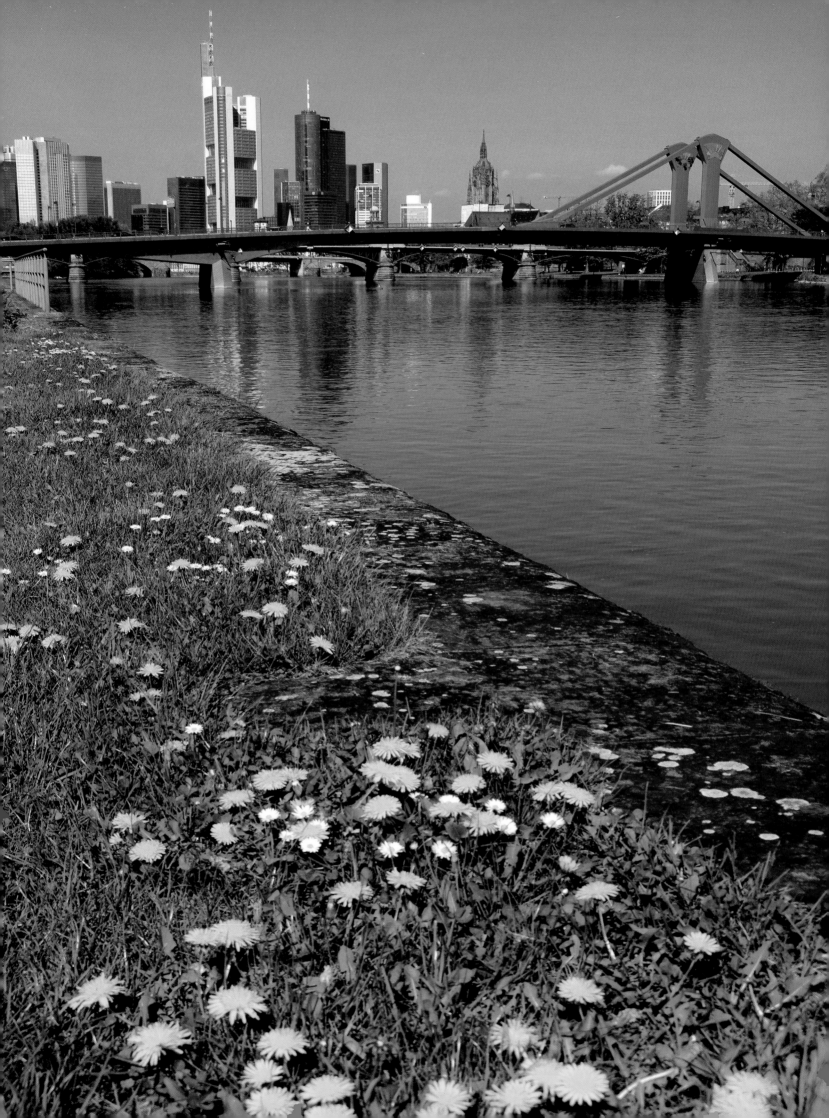

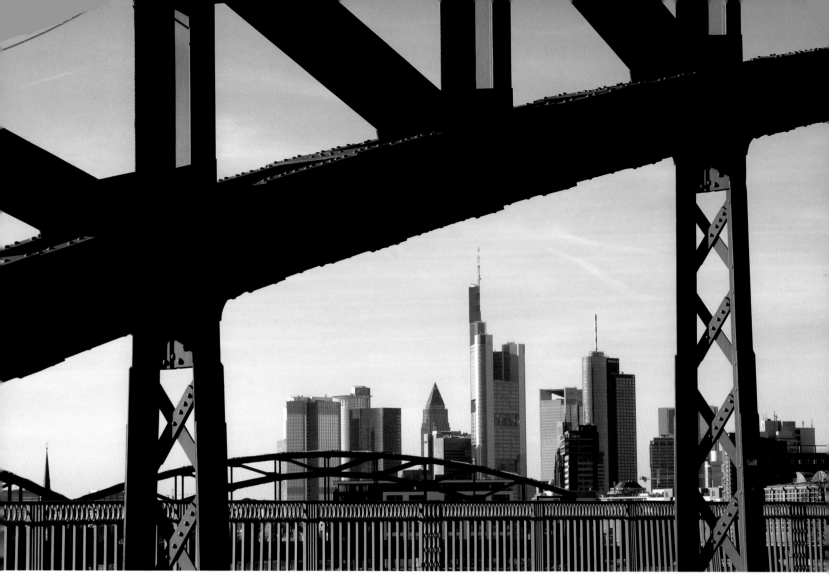

Above:
You can get to the Osthafen or east harbour from the Deutschherrnufer on foot by crossing the railway bridge with its impressive steel arches, opened in 1913. The new harbour was to help the city meet the demands of the industrial age at the end of the 19th century and is still in operation today.

Right:
If you're interested in industrial history, then it's worth taking a walk along the banks of the Main at the Osthafen. The area is now a pleasant park featuring many reminders of its former purpose, with harbour machines and loading cranes dotted about the grass.

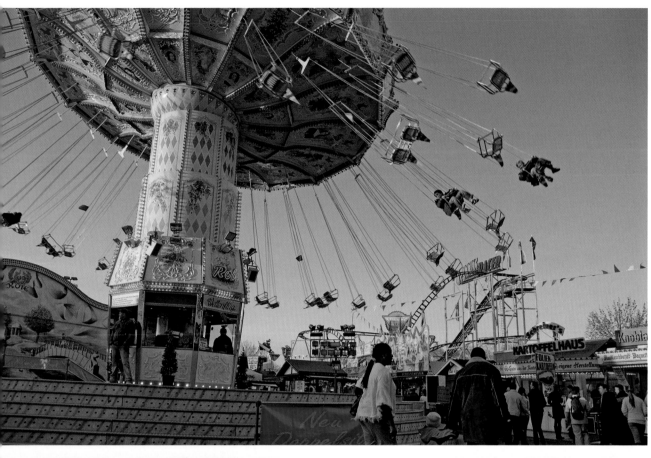

Left:
Dippemess is the largest public festival in the Rhine-Main area, opened in spring and autumn with the ceremonial tapping of a large barrel of beer. All the fun of the fair can be had on the rides, with gentle merry-go-rounds for the little ones and stomach-churning roller coasters for bigger and braver visitors. The word "Dippemess" is derived from the Hessian "Dippe" for the pots once sold by travelling salesmen here at the market.

Below:
The unpretentious Café Pflasterstrand at the Osthafen is a relaxed alternative to the more chic and trendy establishments on the opposite Deutsch-herrnufer.

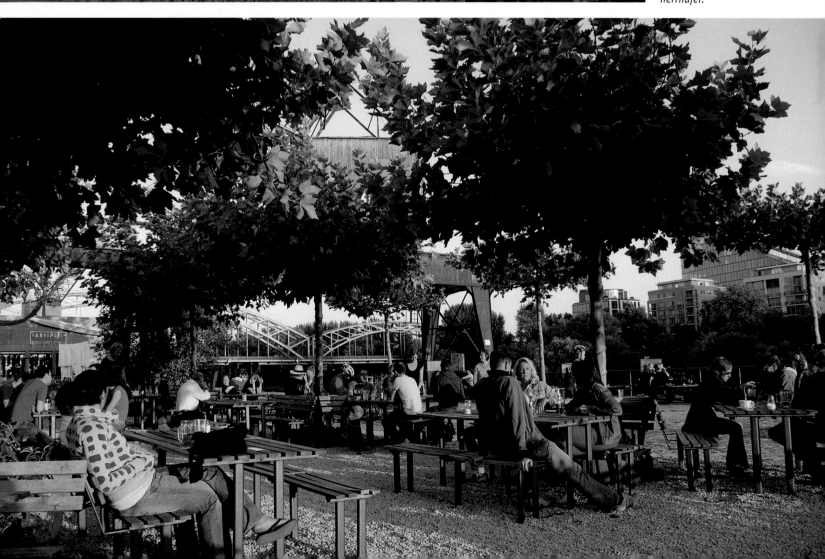

THE RIVER MAIN – SUMMER BEACH, PARTY VENUE AND CULTURAL OASIS

If you want to see the people of Frankfurt out of their suits and away from their world of banking and finance, simply spend a summer's evening on the banks of the River Main! Skaters, cyclists and joggers whizz along the paths on the left and right of the river, with the more relaxed citizens enjoying a picnic on the grass, talking, playing music or practising small feats of artistic mastery, such as juggling or balancing. When the sun slowly begins to sink behind the skyline, viewed in all its splendour from Sachsenhausen, bathing the glass facades in a warm golden orange glow, and a chance, lone rower sends ripples out across the river that gently lap the shore, you may well hear a sigh of contentment. Their love of their river not yet sated, the good burghers of Frankfurt then flock to one of the many cocktail bars and cafés that now line the banks for some light refreshment.

The Main metropolis also still has a harbour – but it's not because of this that the river is deeply rooted in the consciousness of the local inhabitants. Quite simply, the river gives them a better quality of life. The ford that once gave the town its name, causing people to settle here and the city to evolve, is a historical fact that seems to go largely forgotten.

The people of Frankfurt like to party here, too. One such occasion is the annual Mainfest funfair that dates back to the year 1340 when local fishermen thanked 'their' river for providing them with a living. The riverbank is also a popular venue for any number of special events, one being the World Cup when hoards of fans thronged the strand to watch football on massive screens floating on the river. And with a bit of luck, every second Saturday in the month you might be able to pick up a great bargain or find a rare treasure at the flea market held between Eiserner Steg and Holbeinsteg, with jumble, second-hand goods and also works of art on sale.

The municipal beaches offloaded from dumper trucks in summer, now such a frequent occurrence the world over, can also be found in Frankfurt. Here you can enjoy the sunshine with your feet in the sand, with soft piped music in the day and wild parties at night. Frankfurt also loves to go clubbing ...

Museum highlights

Tracing the contours of the Main on the Sachsenhausen side is the Museumsufer or museum bank, one of the city's cultural highlights. A total of 13 museums were established or refurbished here between 1980 and 1990, including the Städel with its collection of paintings, the German museum of film, a museum of applied art and the Liebieghaus sculpture museum. Inspirational walks can thus also be had on a wet day. At the end of August the Museumsufer throws a big party for itself, attracting over two million visitors to the city. Events on both sides of the Main then take off and the promenades are turned into a multicultural jamboree, with delicacies from all over the world to investigate and enjoy.

Following the south bank of the Main out of town you pass children's playgrounds, volleyball pitches and allotments until you reach the Gerbermühle. The former mill and tannery on the edge of town has been a popular 'country' pub since the beginning of the 20th century. Here you can walk in the footsteps of Frankfurt's most famous citizen, Johann Wolfgang von Goethe. As a guest of his friend who then held the lease of the mill, Frankfurt banker von Willemer, he became acquainted with his foster daughter and later wife Marianne. It's said that the 65-year-old Goethe and 30-year-old Marianne became very fond of one another, with their ensuing letters constituting much of the poetry voiced in Goethe's *West-östlicher Divan* (West- Eastern Divan).

The face of Frankfurt is also changing on the river front. In 2003 another skyscraper was erected on the west harbour, the Westhafen Tower. More office blocks and housing followed, some built on stilts and complete with their own moorings. The next big alteration will affect the area next to the Osthafen or east harbour. The European Central Bank is planning on constructing its Skytower here between the Main and the Großmarkthalle, two 180-metre high-rises entwined with one another. Once again the city will be faced with the challenge of how best to combine new and old ...

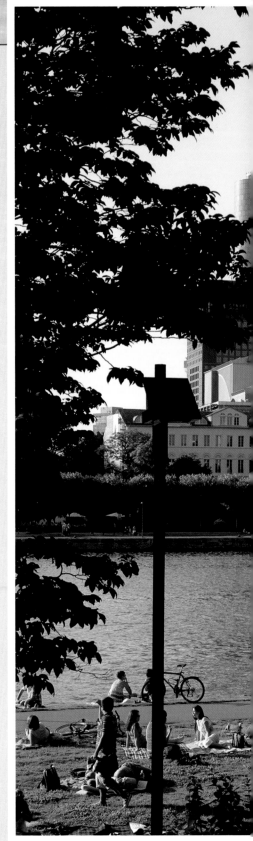

Left:
The river is also a hot favourite with sportsmen and women. People like to cycle or jog along the banks and rowers enjoy cutting through the water with their fellow crew.

Above:
The river banks are very popular in summer, with people going for walks, having picnics or just admiring the sunset together after a hard day at work.

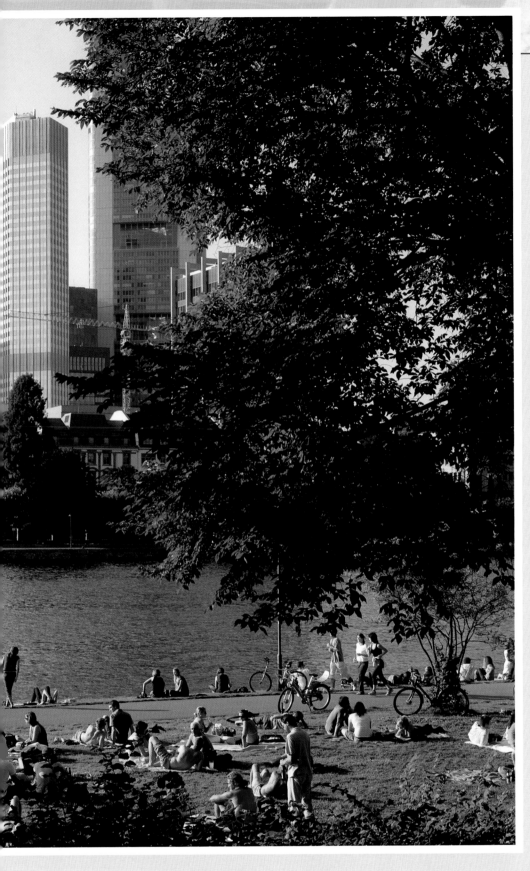

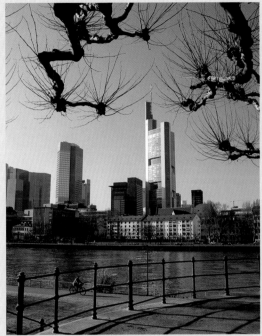

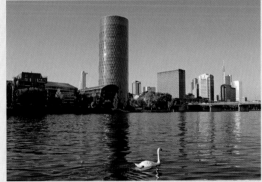

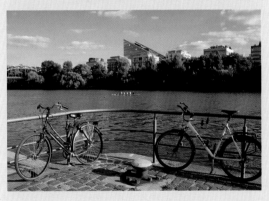

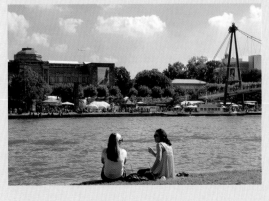

Right, from top to bottom:
There are especially good views of the skyline of Mainhattan from the banks of Sachsenhausen, south of the River Main.

The city is also constantly changing along the River Main. In 2003 Westhafen Tower was added to the skyline. Its diamond-shaped façade has earned it the local epithet of "the ribbed one" or "Ebbelwoi-Glas" in reference to the typical rhomboid design of cider glasses in Hesse.

At the moment the atmosphere on the shores of the Osthafen is relaxed. The planned building of the Skytower for the European Central Bank will undoubtedly inject new life into the area.

The annual Museumsufer festival draws visitors from all over the region to Frankfurt. The museums put on an interesting programme of events while punters party on both sides of the River Main.

Right:
The architecture of the Museum für Angewandte Kunst or museum of applied art in Sachsenhausen is well worth seeing, where the neoclassical Villa Metzler has been cleverly merged with a new building. Exhibits range from historic hand-crafted artefacts to modern and postmodern product design.

Below:
Only opened in 1984, the Deutsches Architektur Museum or German museum of architecture was threatened with closure in the 1990s. Thanks to a new concept it again enjoys increasing popularity. It now also features works by contemporary architects, with exhibitions geared towards both amateur enthusiasts and professionals.

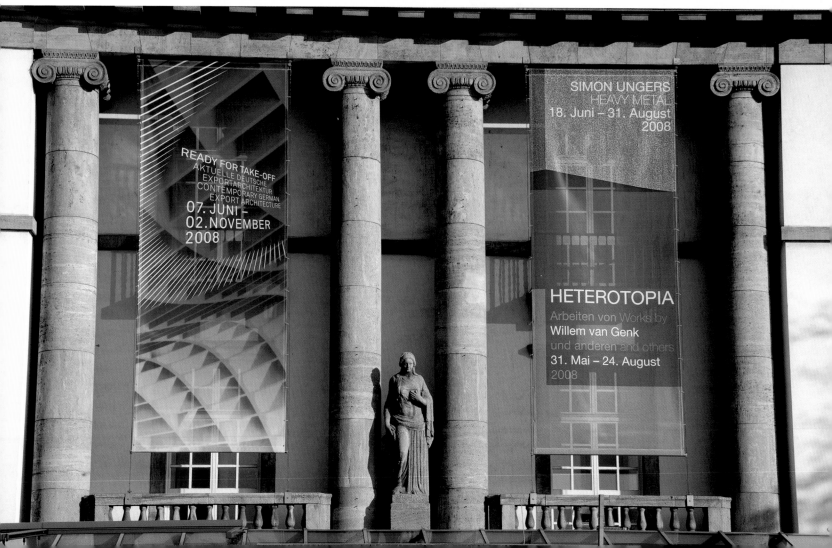

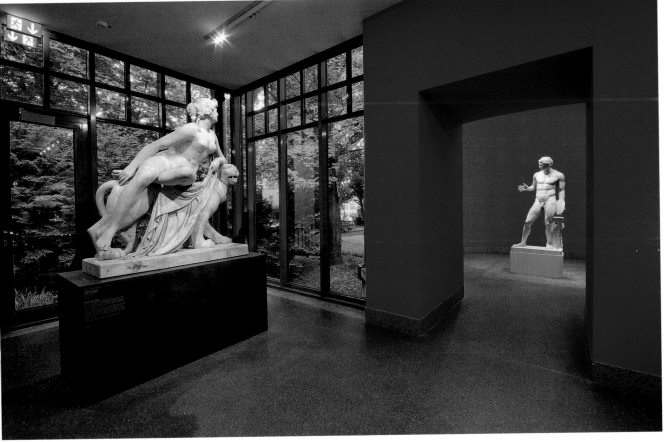

The Liebieghaus houses one of Europe's major collections of sculpture. The individual exhibits are lovingly presented in a Historicist villa once belonging to textiles manufacturer Baron Heinrich von Liebieg. The collection includes sculptures from the Middle Ages, the Renaissance and the neoclassical period and from Ancient Greece and Rome, with works from Eastern Asia and Egypt also on display. One of the highlights is Johann Heinrich von Dannecker's Ariadne on the Panther, completed in 1816.

The Städelsches Kunstinstitut or Städel has around 600 works of art from the Middle Ages to the Modern Age in its permanent collection on show in a neo-Renaissance building on the south banks of the Main. These include paintings by such artists of renown as Cranach, Botticelli, Dürer, Vermeer, Monet, Beckmann and Picasso. The museum has much more than it can display, however, and an extension is planned to also include a new photographic section. The museum started out as a foundation endowed in 1815 by banker and businessman Johann Friedrich Städel.

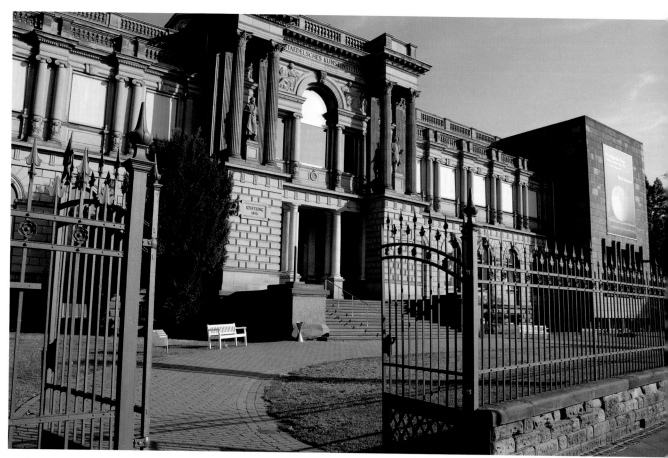

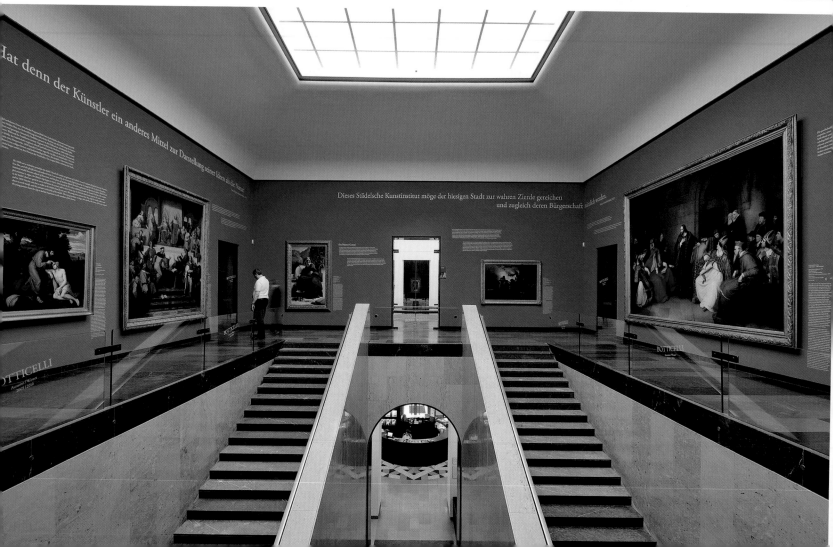

Above:
The Portikus exhibition hall funded by Stiftung Giersch rotates its display of artwork by contemporary artists. The building on an island in the river next to the old Main bridge is reminiscent of the old mills and gatehouses and belongs to the Städelschule, Frankfurt's academy of the fine arts.

Left:
With its varying exhibitions the Museum der Weltkulturen or museum of world culture tries to encourage people to take a proper look at the various cultures and global topics of our planet. The idea is to promote dialogue between the peoples of the world.

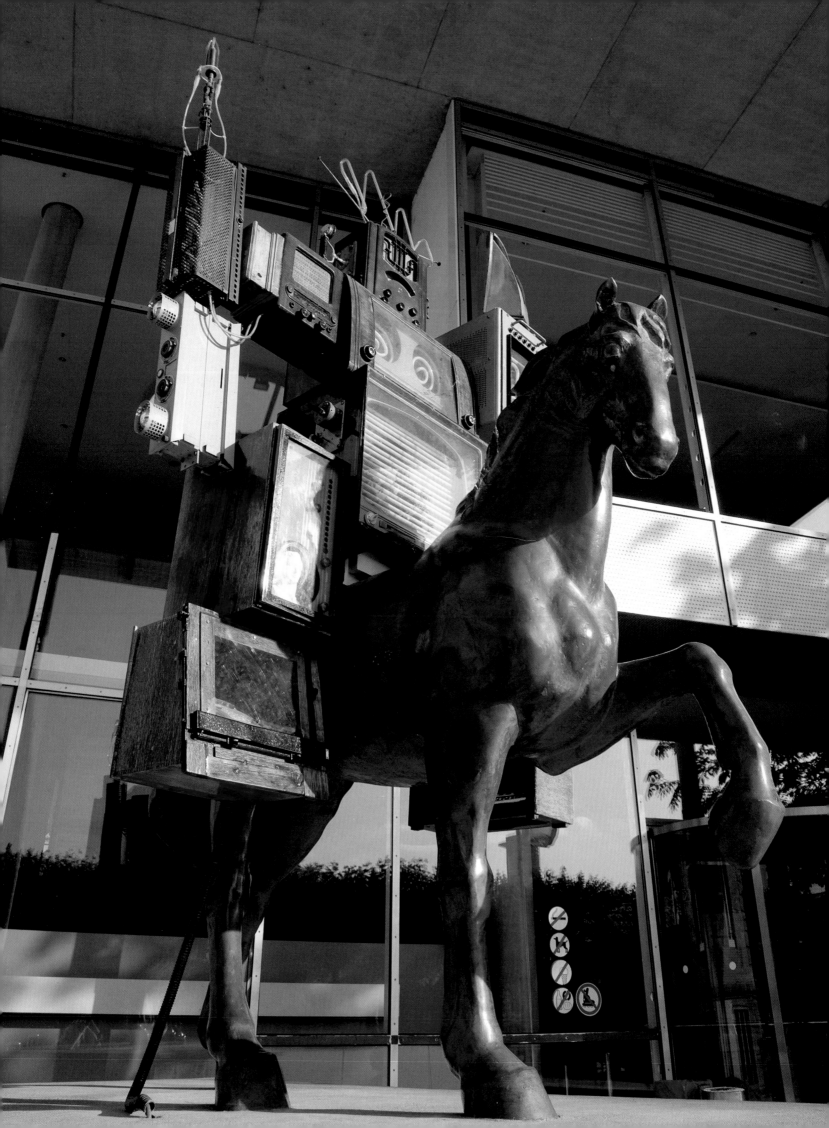

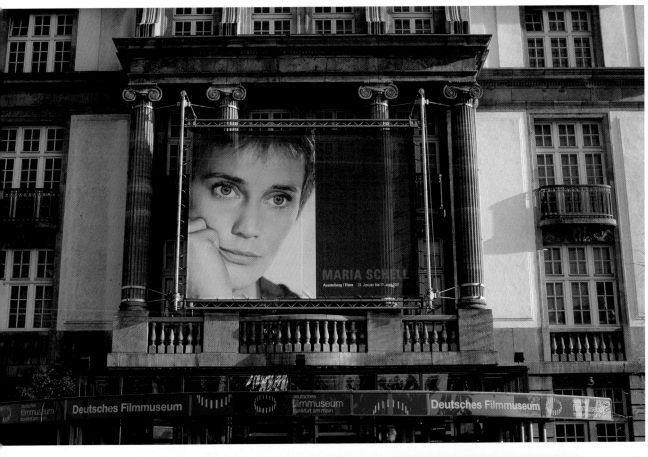

Left page:
Korean artist Nam June Paik's Pre-Bell Man guards the entrance to the museum of communication. As opposed to the materials he is made of (electronic scrap), the rider is intended to represent how messages were relayed in the days before Alexander Graham Bell's invention of the telephone. With his raised sword and shield he is vaguely reminiscent of Don Quixote, off to battle not with windmills but with the ever more new-fangled developments in the field of communication. The museum itself traces the history of communication from the wax tablet to the birth of the postal service, from telegraphy to the Internet.

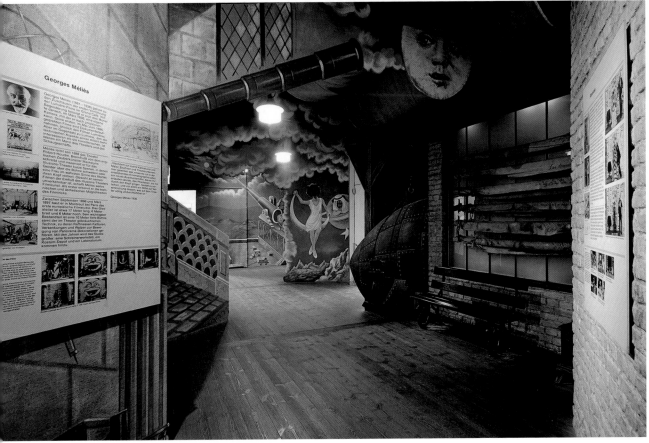

Photos, left:
The Deutsches Filmmuseum is devoted to the development of film and the movie theatre. It also has a cinema screening interesting historic and experimental films. Silent movies are shown as they were originally intended, with music provided by a cinema organ. You can also explore the optical illusions and faked movement that sparked off the evolution of film and investigate the mock-up studios and backdrops of the film industry of the 20th century. Special attractions for visitors are the re-enacted chases and rides on magic carpets over the rooftops of Frankfurt – just like pretending to be in Hollywood!

91

The Museumsuferfest at the end of August is one of the city's cultural highlights. This is when the museums put on interesting special exhibitions, complete with guided tours, talks and workshops. Both sides of the River Main are a hive of multicultural activity, with music, dance and cabaret on tap. There's also ple[...] to whet your appetite, w[...] wide range of specialitie[...] from all over the world t[...] try. The only downside [...] to the festival is the mu[...]

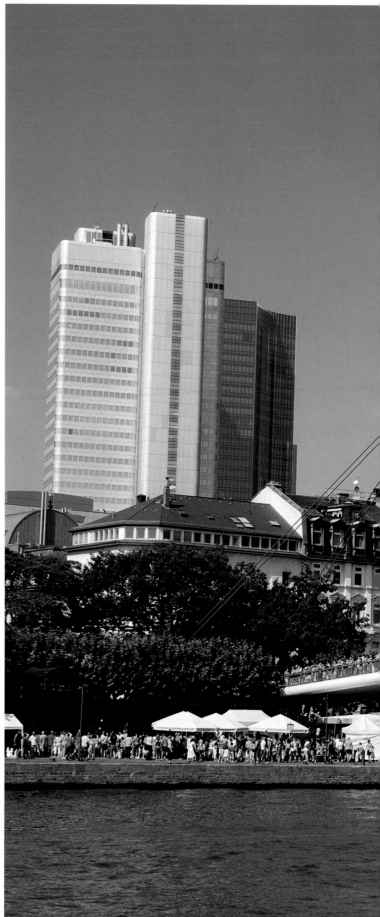

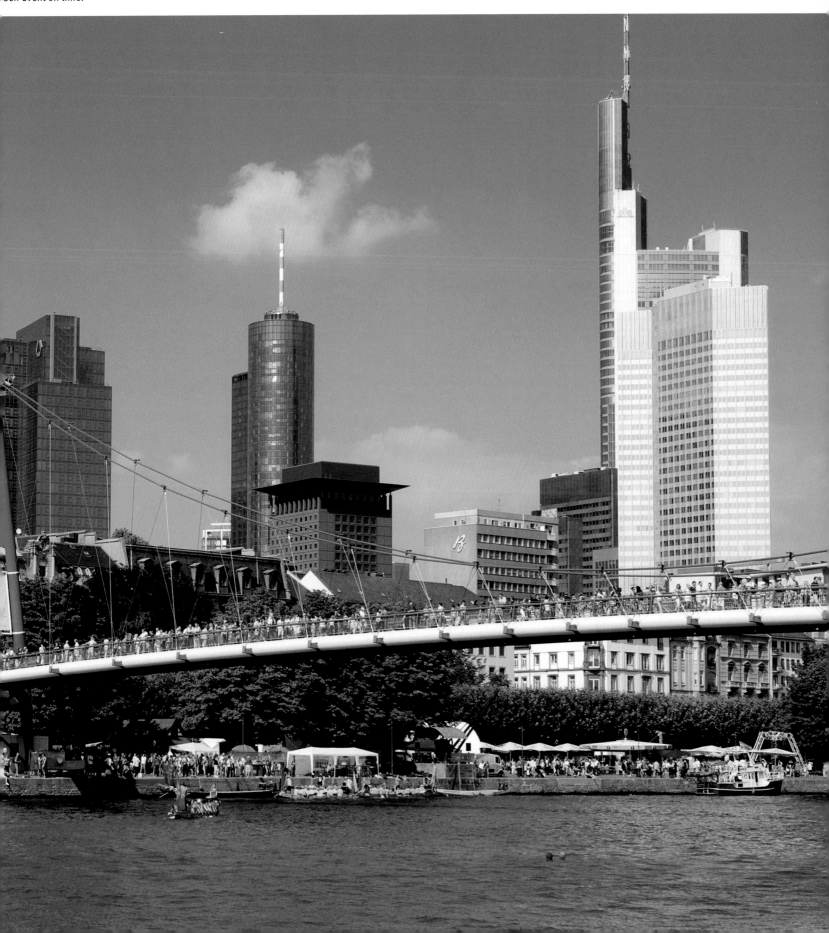

e of visitors; on a good
it can be difficult to
t your way through the
ry throng to get to your
sen event on time.

There are curiosities, bargains and all kinds of jumble to be had at the Saturday flea market in Frankfurt. Handicrafts and cut-price goods complete the range of items on sale. The venue is alternated each week between the south bank of the Main and Osthafenplatz. The markets between Holbeinsteg and Eiserner Steg along the river front particularly have a very special flair.

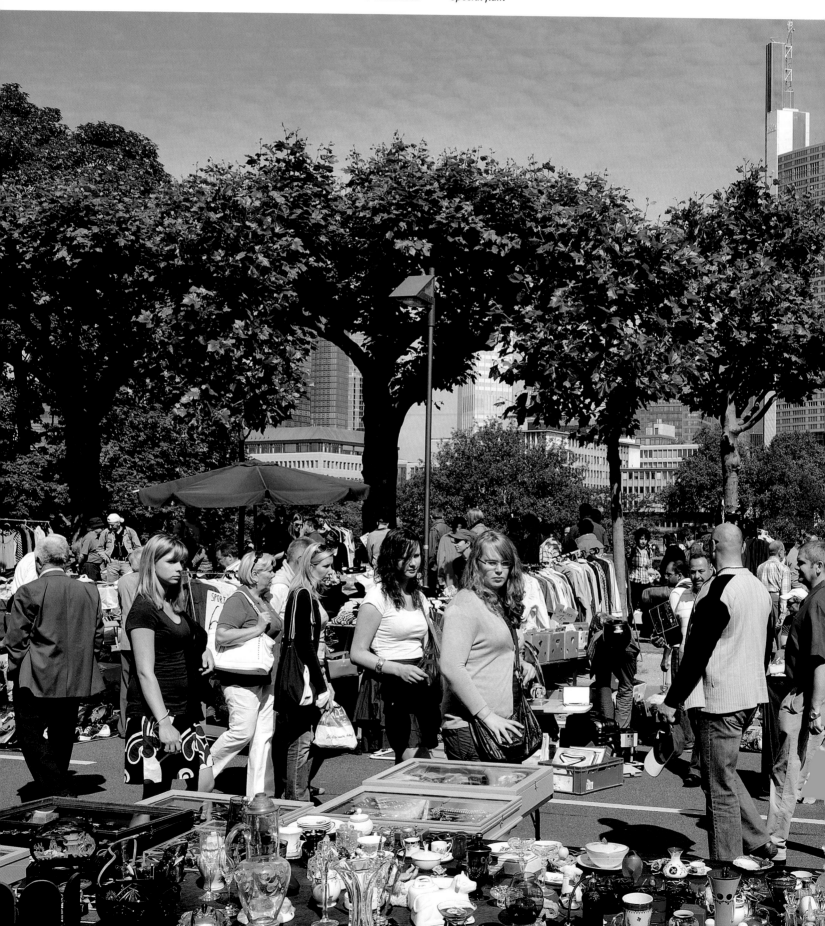

Right:
Sachsenhausen and especially the streets around Klappergasse are familiar to tourists all over the globe. At night the pubs, bars and clubs in the quarter, which is also known as Old Sachsenhausen, compete for custom with loud, pulsating music.

Far right:
The Gorjel Schwenker inn, selling beer of the same name. Theme pubs like these are ten a penny here. At Gorjel Schwenker the décor on each storey is completely different, with the quest for a particularly original interior making no sanction for the possible sensitivities of its guests; the bar on the top floor, for example, is done up like an altar, complete with a figure of Jesus.

Right:
Taking a drink or two at Zum alde Germane, on the other hand, is like stepping back into the Middle Ages.

Far right:
On first sight the Marco Polo Taberna Royal looks like a medieval castle. Like everywhere else in Old Sachsenhausen, particularly at the weekends the place is positively humming.

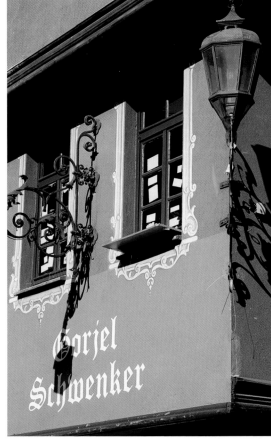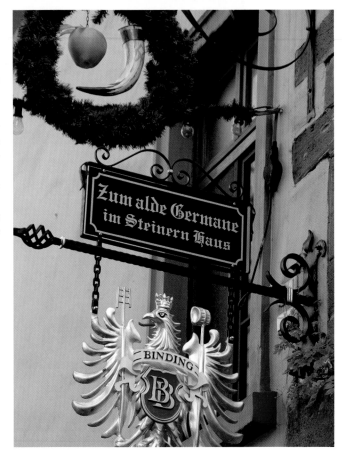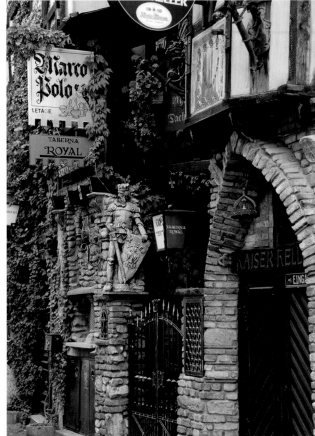

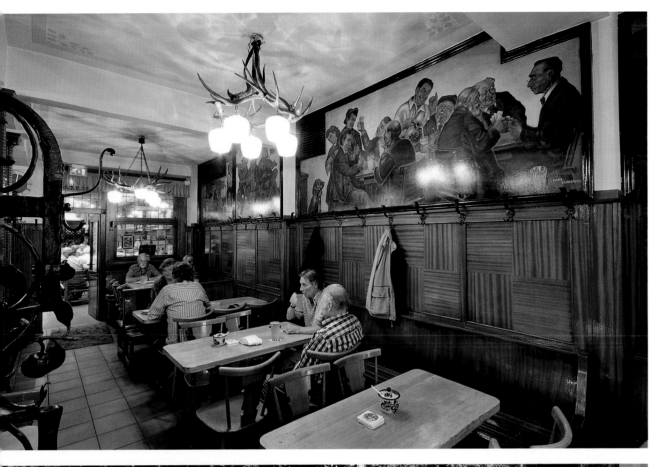

If it all gets too much, you can always creep off to one of the traditional cider taverns in Sachsenhausen, such as the Gemahltes Haus. It's at places like these that you'll also find the locals supping a ribbed glass or two of their favourite alcoholic beverage.

Dauth-Schneider is a traditional pub that started out 150 years ago as a small wine tavern welcoming people into its living room. Even if the interior has since grown, the tavern still serves its own homemade cider.

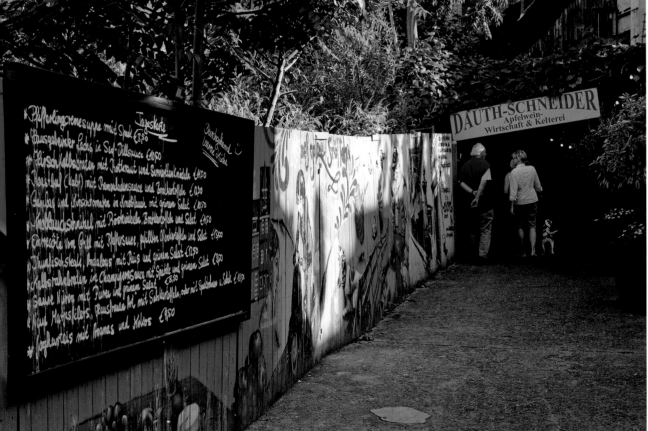

Right:
Walther-von-Cronberg-Platz forms the centre of the new Deutschherrn-viertel in Sachsenhausen. At the edge of the square is the Main Plaza designed by Hans Kollhoff which quotes the vaguely neo-Gothic skyscrapers of New York and Chicago from the 1920s.

Far right:
In the old refectory of the Teutonic Order the museum of icons displays Christian Orthodox images from the north of Russia to Ethiopia.

Below:
In July 2005 the Wald-stadion football stadium of Eintracht Frankfurt was renamed Commerzbank Arena under a new sponsorship for an initial period of ten years.

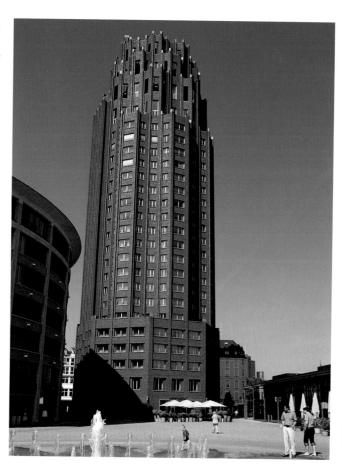

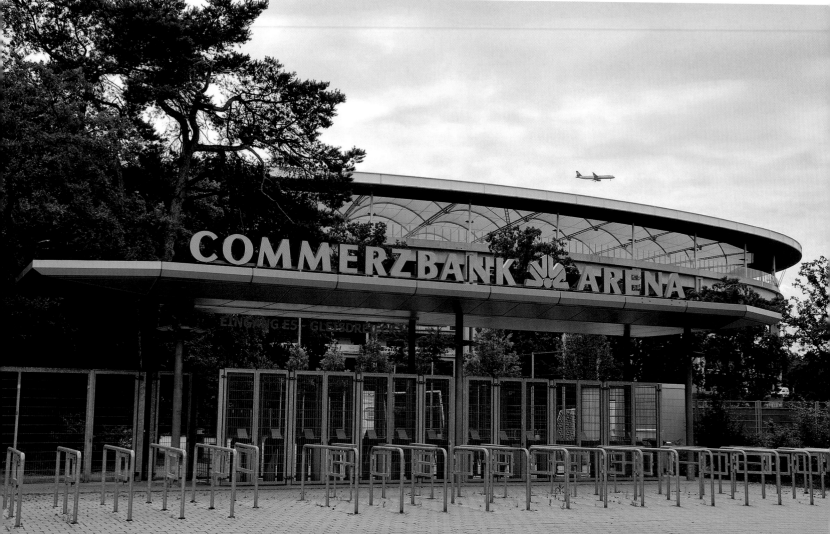

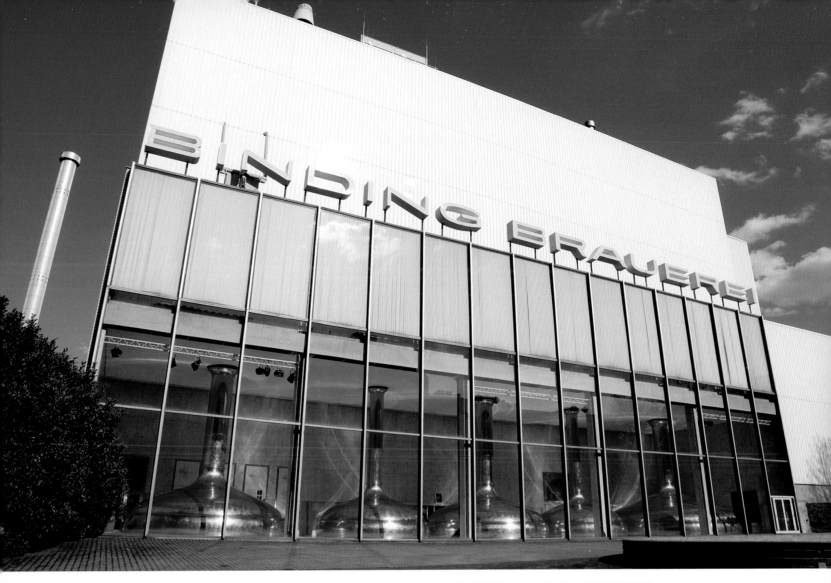

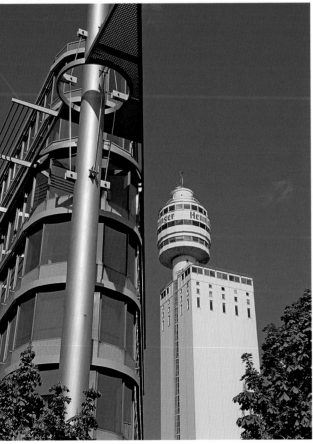

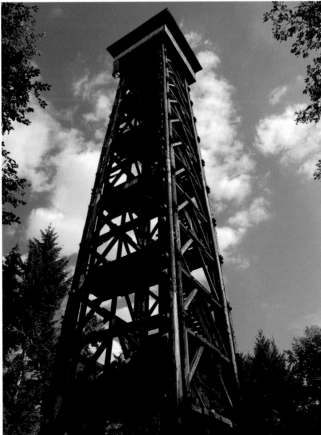

Above:
Sachsenhausen is also the site of the largest brewery in Hesse, Binding Brauerei, which is now part of the Radeberger Group.

Far left:
At 120 metres (394 feet) the Henninger Turm, once the Henninger Brewery's grain silo, is one of the shorter spires to puncture the skies above Frankfurt. Until its closure revolving restaurants and a visitors' platform provided generous views out over the roofs of the city.

Left:
The Goetheturm (43 m / 141 ft) on the northern edge of the forest around Frankfurt is one of the highest wooden towers in Germany.

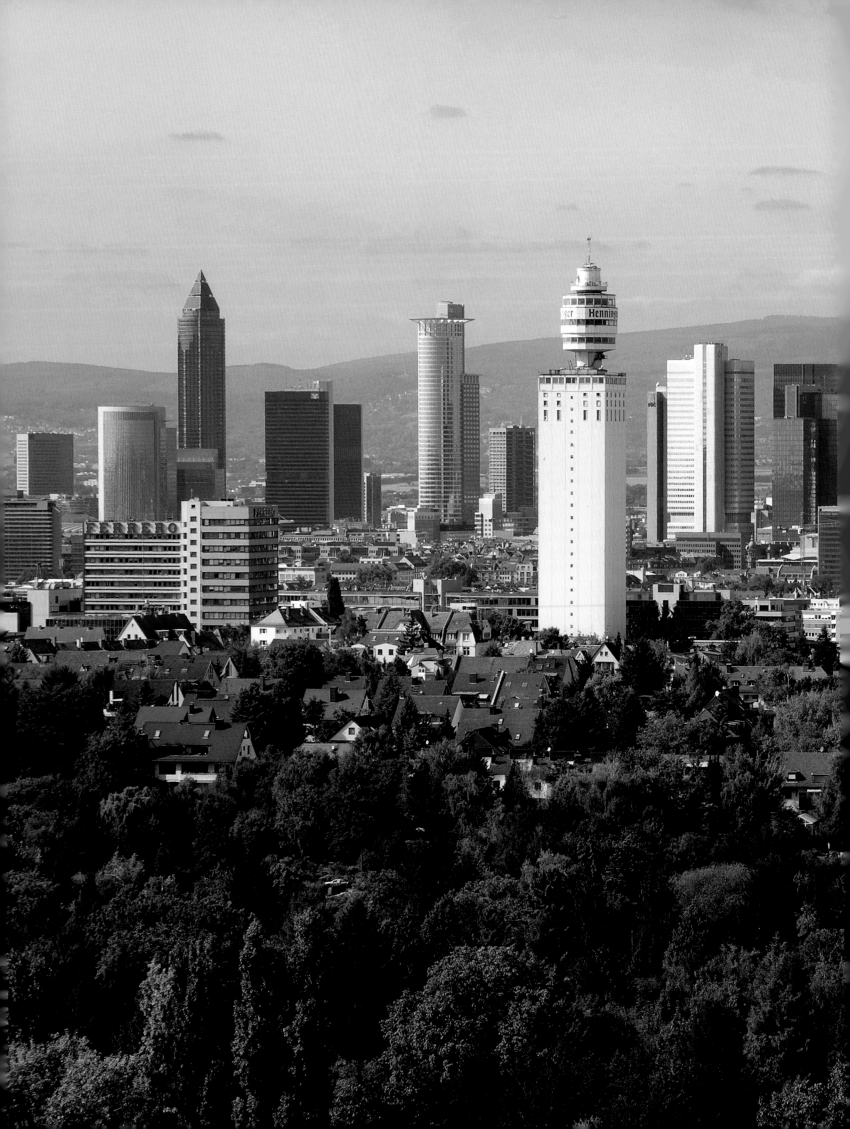

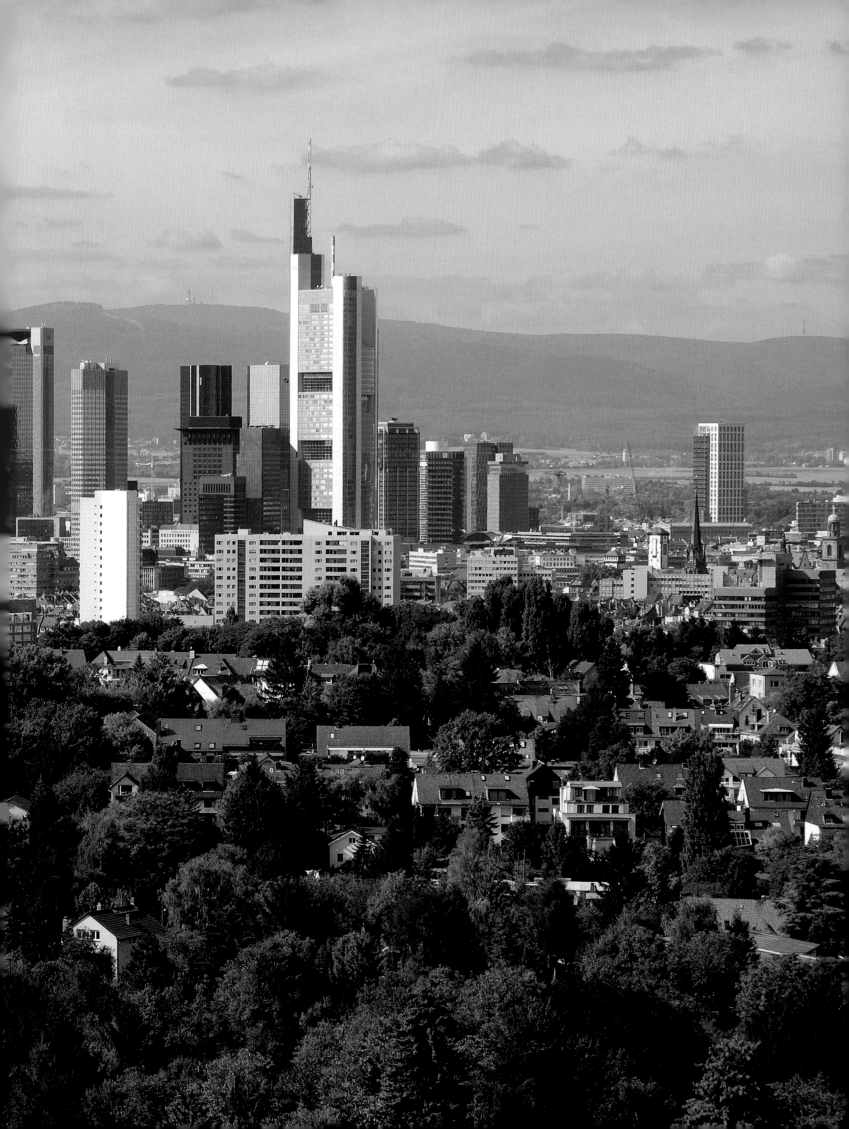

Page 100/101:
Once you've climbed the 196 steps of the Goethe-turm your reward is a grand view of the green belt and skyline of Frank-furt. If the weather's fine, you can spot the hills in the distance.

Right:
In 1993, in homage to Frankfurt's love of its river, the foundations were laid for a new city quarter on the old west harbour, complete with pubs and restaurants, offices and residential flats placed along the river front. These developments have greatly altered this part of town, the Gutleutviertel, which in the past was mostly industrial.

Top right page:
The new quarter is distin-guished from afar by the Westhafen Tower. Its triangular, glittering green panes of glass represent the water of the River Main that not only makes the location attractive but is also used to cool the offices in summer.

Bottom right page:
Some of the new apart-ments on the Westhafen even have their own moorings, making them extremely exclusive. There is also a marina catering for river users who happen to be passing through.

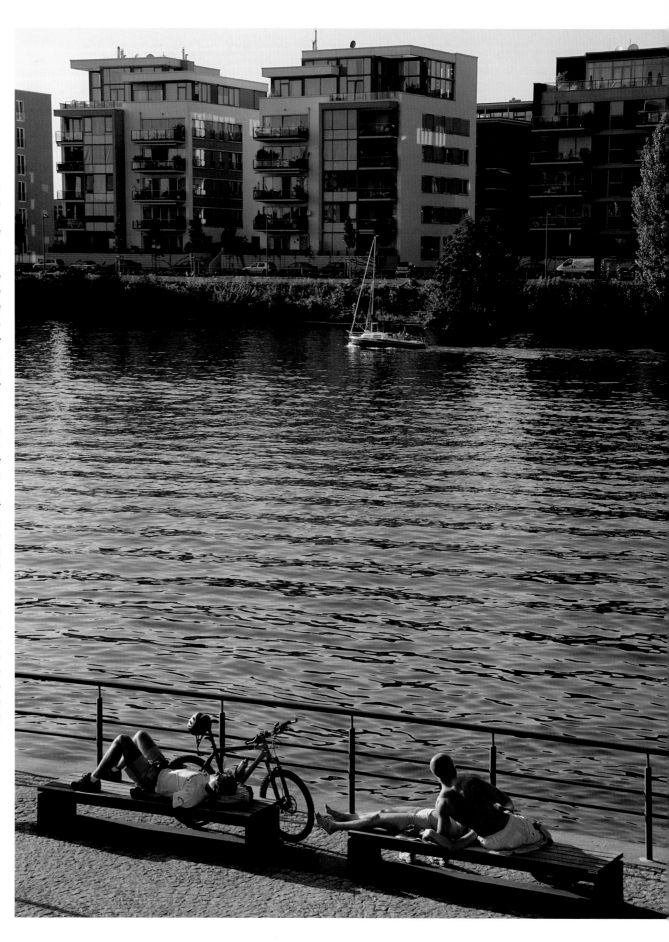

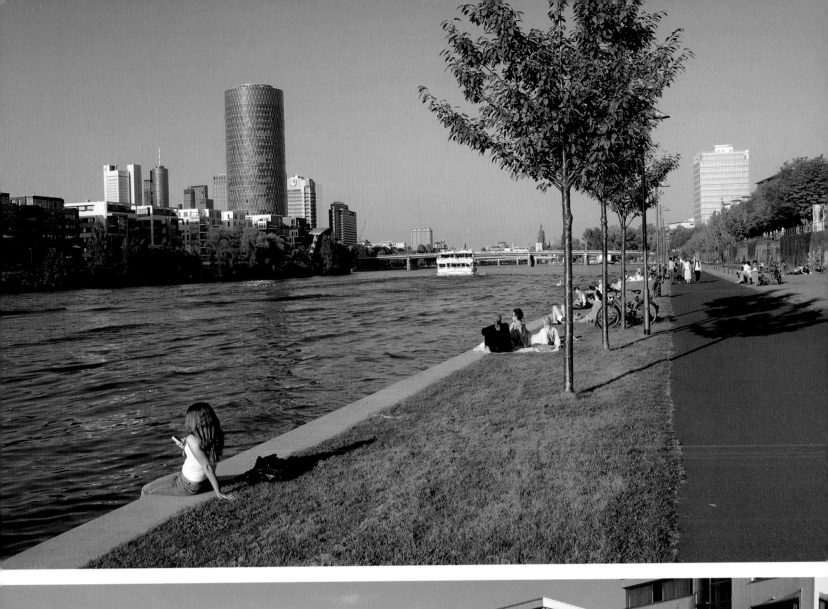

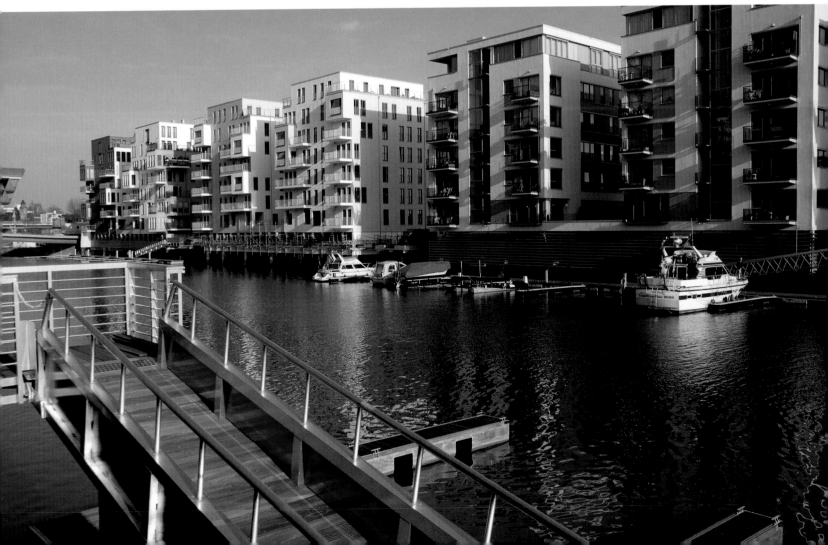

Right:
Sitting on the balcony of one of the new Westhafen flats, you're rather exposed to the curious gaze of your fellow residents and passers-by. What counts, though, is the view which, with the River Main beneath you and the city just around the corner yet far enough away to be quiet, is admittedly pretty good.

Below:
A number of cafés, bars and exclusive restaurants breathe life into this serene quarter of Frankfurt. As there is very little traffic and the mass of people gravitates away from here once the offices have closed, you can enjoy the evening hours in peace and quiet.

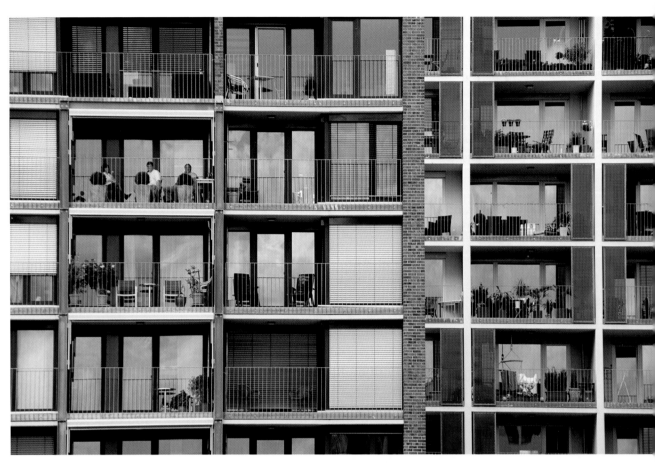

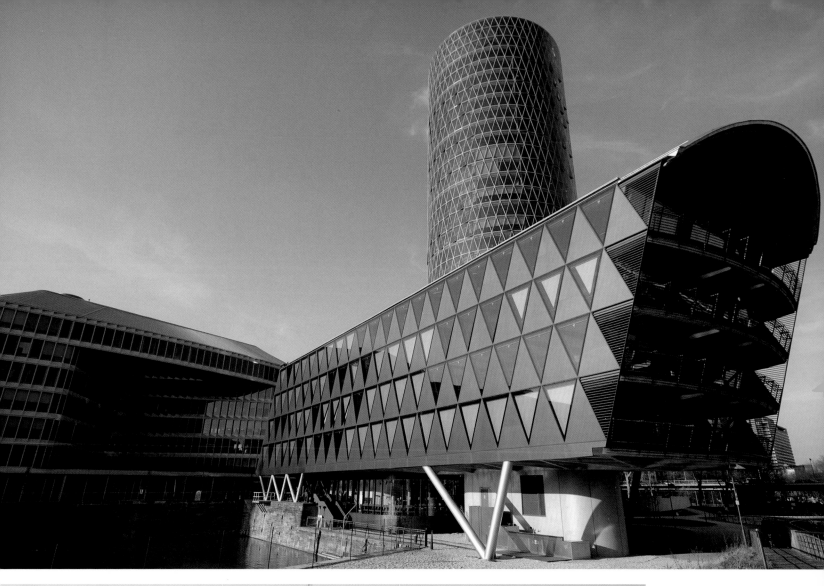

Above:

The new quarter kicked off with the construction of the Westhafen-Haus, Westhafen Tower and Brückengebäude or bridge building. The latter, depicted here in the foreground, is intended to forge a visual link between the green banks of the Main and the west harbour.

Left:

On its construction in 1877, what is now the headquarters of the local authorities was a barracks and a demonstration of Prussian power designed to intimidate the liberal populace of Frankfurt.

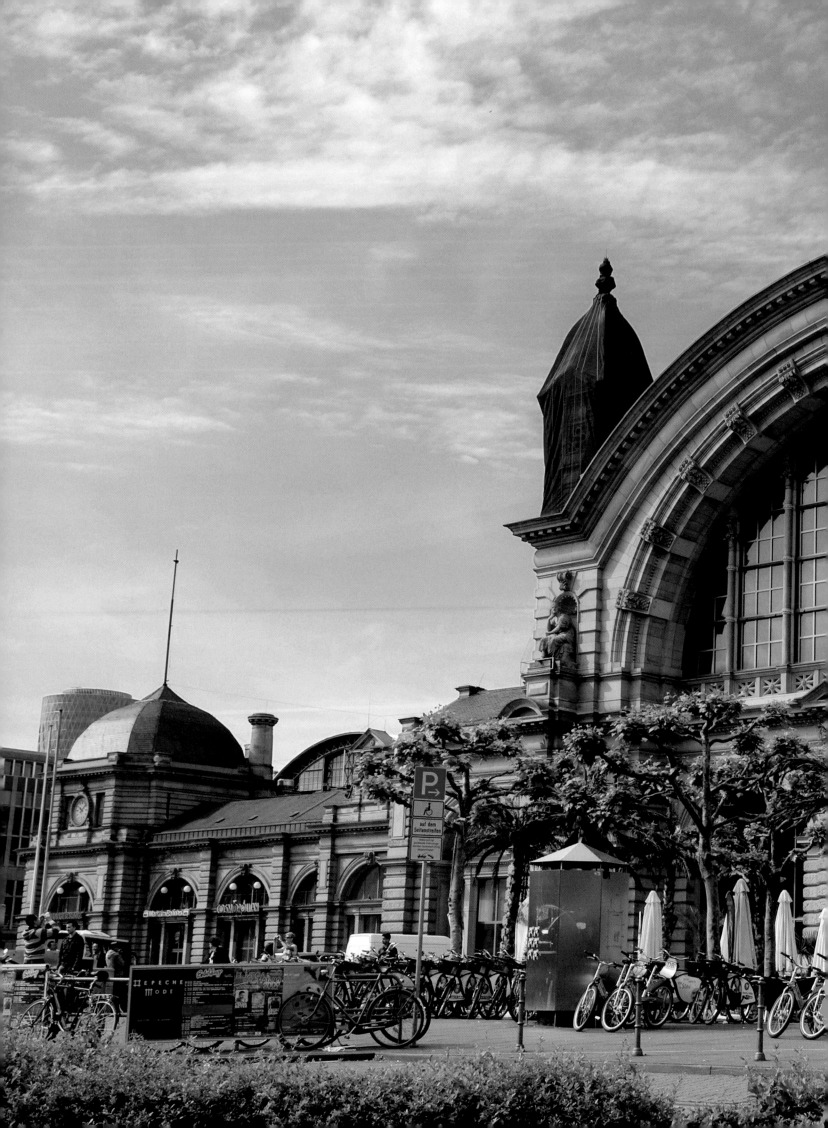

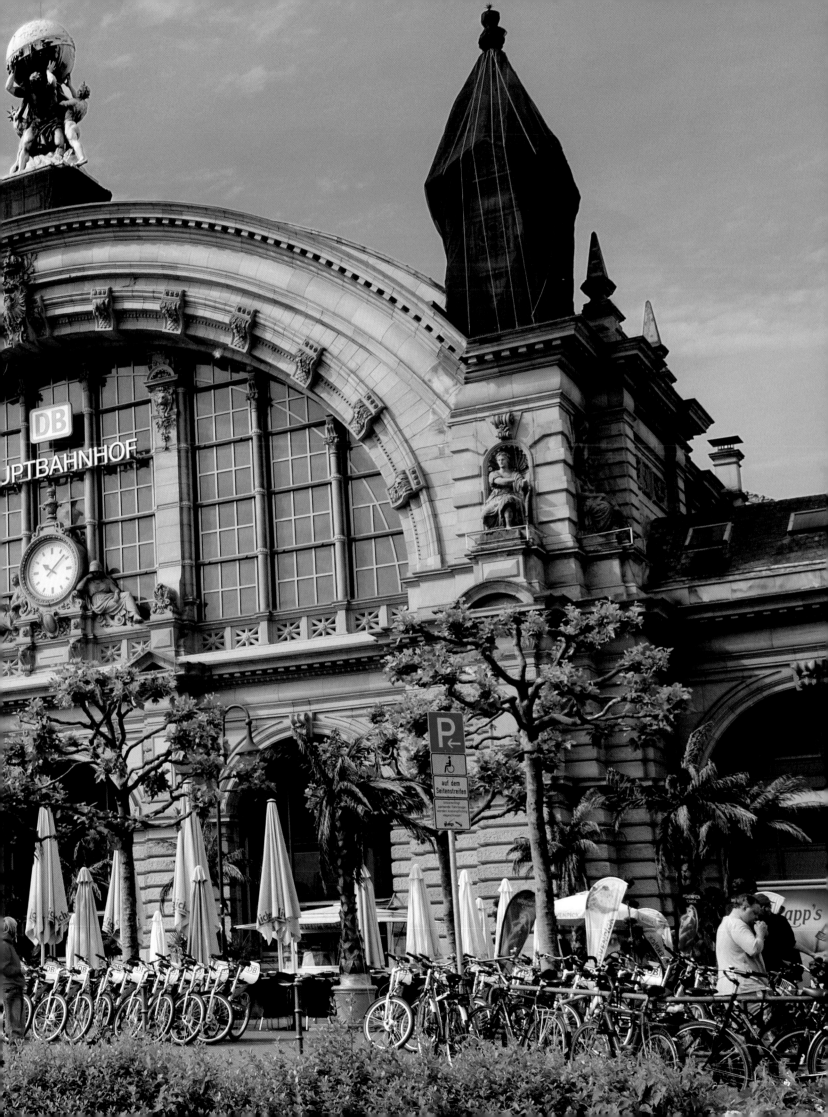

Page 106/107:
Page 106/107:
It was a big day for progress when in 1888 the neo-Renaissance central station was opened in Frankfurt. The development of the railways later demanded its further extension, with a neoclassical section added in 1924.

Right:
The exhibition grounds on Europaallee measure 578,000 square metres (around 6,221,600 square feet) in size and are the third biggest in the world. The ten halls and congress centre mirror the developments of the age, with architectural styles ranging from neoclassicism to Bauhaus to Post-Modernism.

Right page:
The Messeturm pierces the skies 257 metres (843 feet) up from the ground like an extremely sharp pencil, making the Messe Frankfurt visible for miles around. Its architectural make-up – base plus tower and pinnacle – pays its respects to the Art Deco high-rises of 1920s America.

Right:
The neoclassical Festhalle forms the historic hub of the exhibition grounds and effuses a real sense of charm. It was built at the beginning of the 20th century in order to permanently house Frankfurt's new exhibitions that had superseded the older trade fairs and markets. It's now not only used to display goods but also for concerts, with pop singers and rock legends taking to the stage here.

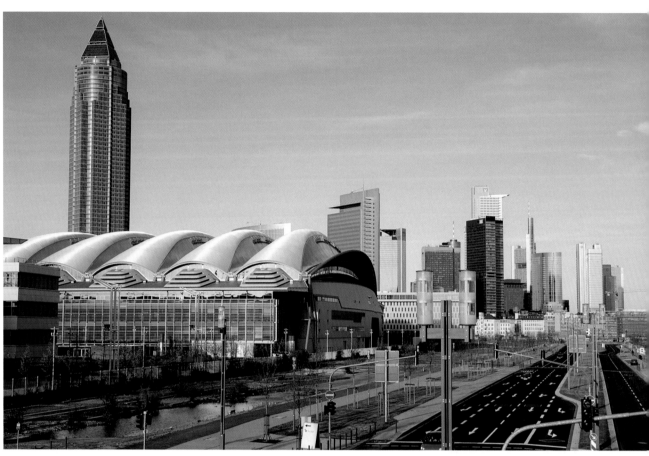

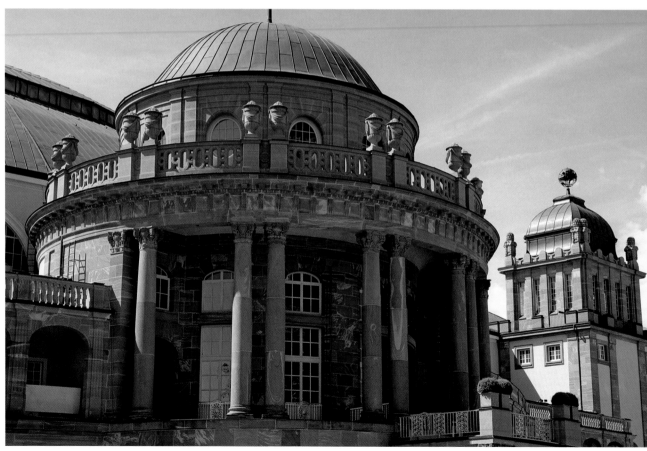

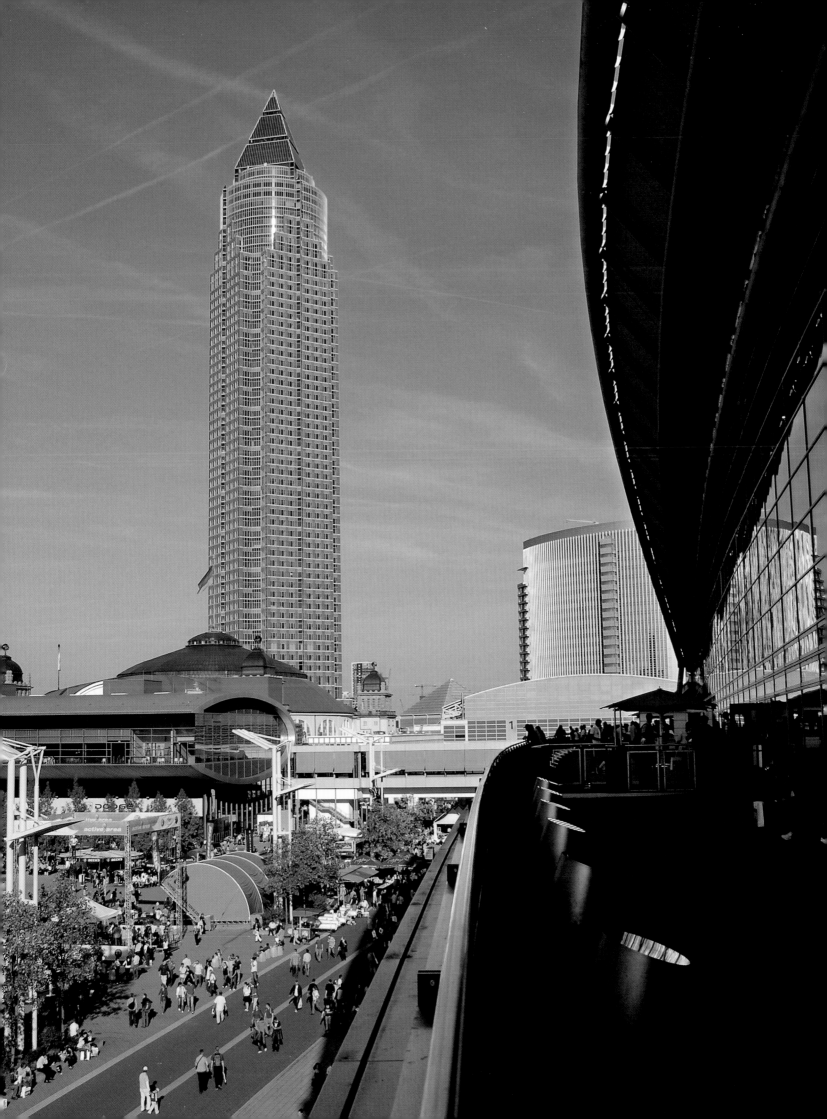

FAIRGROUND AND TRAFFIC HUB – TRADING POST FRANKFURT

Frankfurt's tradition as a centre of trade and exhibitions goes back to the early Middle Ages. The trade fair in Frankfurt was first mentioned in 1150. The official right to hold fairs, granted in 1240, guaranteed everyone travelling to the fair safe conduct. Frankfurt's favourable location proved another advantage; it wasn't just on a ford across the River Main, the crossing of which was made easier by the building of a bridge in the 11th century, but also on a major trade route running straight through Europe. The Via Regia or king's highway, starting in Flanders, linked the trade fair cities of Frankfurt and Leipzig before carrying on to Silesia. This helped the fair to rapidly develop into a major trading post for international business, patronised by merchants from France, Italy, Hungary and Bohemia. By holding an additional fair in spring Frankfurt boosted its standing from 1330 onwards, provoking Martin Luther in the 16th century to revile the city as a "hole of gold and silver through which everything passes that grows and thrives, that is coined and minted here."

Flourishing European trade introduced a vast number of currencies to the city. To make changing foreign coinage easier, in 1585 the merchants set up a standard rate of exchange. Official trade in coinage led to the first stock market transactions, laying the foundations for the later trading of securities and marking an important step in Frankfurt's evolution as a financial metropolis.

The fairs held on Römerplatz soon became tourist attractions. Besides edibles, traded goods included silks, cloth, leather, tools, jewellery and, with a launch in 1485 that was to prove very successful, books. Attracted by the crowds at the fair travelling minstrels and entertainers also flooded into Frankfurt, greatly contributing to the city's cultural life.

The only exhibitions to now draw comparable numbers of spectators are the Frankfurt Book Fair and the International Motor Show. Both trade visitors and interested consumers flock to the city for the duration and despite the extortionate prices the hotels are fully booked months in advance.

Third-largest exhibition centre in the world
After a brief lull in trade fair activities during the French Revolution due to taxes and increased competition from Leipzig, on sensing a first new upswing in the fates of the German Empire the city decided to build a new, permanent exhibition hall in 1907/08. The Festhalle was just the beginning; the entire exhibition grounds are now the third largest in the world, with the Messeturm visible for miles around. Beneath it Jonathan Borofsky's Hammering Man sculpture, 23 metres (75 feet) tall, beats his hammer incessantly, symbolising his solidarity with all the working people of the world. Messe Frankfurt puts on around 40 fairs a year covering a vast range of topics.

The centre of trade within Frankfurt has now shifted to the Zeil. The street has become such a magnet for locals and visitors that on Saturday, the big shopping day of the week, you can hardly get through. For many years, like in many other German cities, the street was dominated by the facades of department stores erected in the 1950s and 1960s. New building projects, such as the Zeilgalerie shopping centre and myZeil, are intended to make the street more pleasing in future.

To this very day Frankfurt's success as a centre of trade is closely tied to the fact that it is also a major traffic junction. Frankfurt Kreuz at the intersection of several major motorways is one of the busiest road junctions in Europe. At the main station Germany's ICE and intercity trains connect with those of its neighbouring states. As the eighth biggest airport in the world Frankfurt Rhine-Main links the rather small city of Frankfurt to the rest of Germany, Europe and the world. For both the trade fair and the many companies based here, fast connections and a good travel network are what make Frankfurt so attractive.

Left:
Frankfurt was granted the right to hold fairs by Emperor Friedrich II in 1240. Today around 40 trade shows and exhibitions take place in Frankfurt, among them big crowd-pullers such as the Frankfurt Book Fair and the International Motor Show.

Above:
With its excellent links all of the major cities Germany and Europe Fra furt's main station is c good reason for mo companies to settle he The growth of the one see to encourage the grow of the other, making Fra furt both a success economic centre and ma traffic h

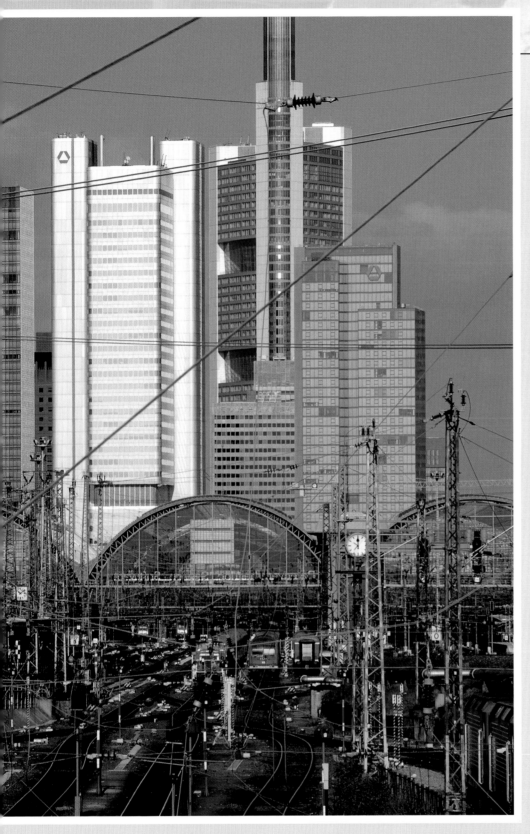

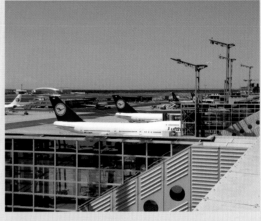

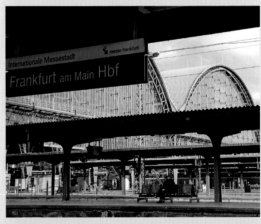

Right, from top to bottom:

In 1958 Frankfurt International Airport was the first to service jet aircraft in Germany. The number of passengers then rocketed. Today it's by far the largest airport in Germany and in terms of passengers the eighth biggest in the world. In order to be able to cope with the increasing influx of traffic and to stop airlines moving to other airports a new terminal and additional runway are planned.

The main station in Frankfurt is the country's chief nerve centre for the Deutsche Bahn, Germany's rail network. The tracks running into the main station are busy with trains for most of the day. Its position in the centre of Europe, plus its good air connections and vast number of businesses make Frankfurt a major stop for many Intercity and ICE services.

Right:
There seems to be no end to the innovative ideas being thought up to make Frankfurt's skyscrapers and co. ever more appealing to the eye. The Kreditanstalt für Wiederaufbau hasn't just changed the shape of its new offices in the west end but also introduced strong elements of colour. Depending on how you look at it, the many coloured components that make up the façade turn it an intense red or blue.

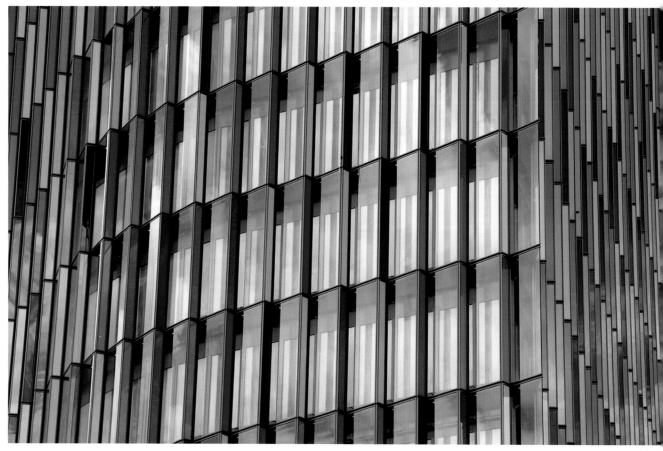

Right:
The distinguishing feature of the Westend Tower (208 m / 682 ft) is without a doubt its 'crowning glory'. So that no icicles are formed on it in the depth of winter, which could prove deadly to passers-by below, the top is heated. The Inverted Collar and Tie sculpture outside the building makes ironic reference to the 'uniform' the bankers and office workers here have adopted.

Far right:
The days of the Lutheran church of St Matthew's are numbered. As increasingly fewer people are coming to the services here, the church has decided to sell up. What becomes of it could prove exciting as the building is to be preserved and integrated into any new structure erected on the site. No seriously interested buyer has yet been found.

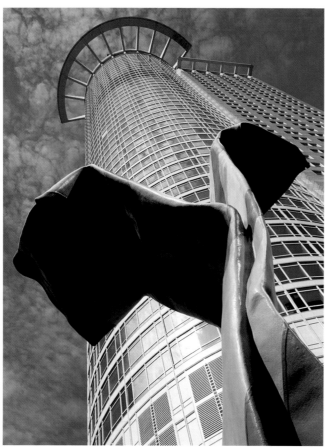

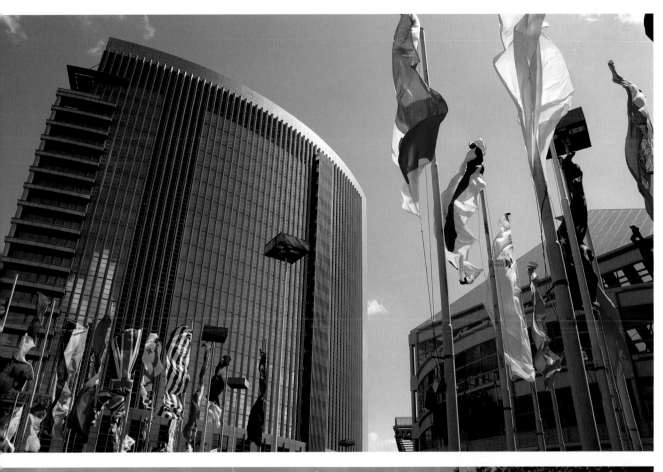

Like in Greek mythology the Castor and Pollux of Frankfurt are also non-identical twins. The Castor building (95 m / 312 ft) is clearly dwarfed by Pollux (127 m / 417 ft). For many years both of them stood on the edge of waste ground, marking the end of the expensive inner city. Now they are to form the gateway to the new Europa-viertel or European quarter.

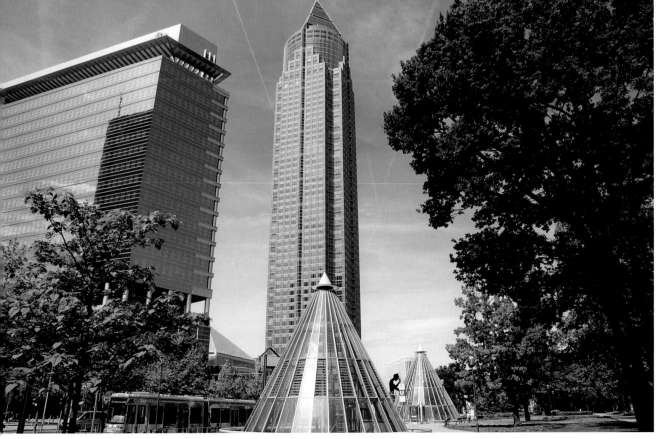

The Friedrich-Ebert-Anlage has had its pond, fountain and stream since the be-ginning of the 20th century. The park is now a welcome patch of green in the midst of mad traffic zooming around the exhibition grounds. The spheres of glass in the middle of the photo are a recent addition and mark the entrance and exit to the Messe Frankfurt underground station.

At the yearly skyscraper festival visitors have the chance to see these giant houses from inside. As space in the lifts is limited, it's quite difficult to get hold of one of the much sought-after tickets. By way of compensation there's plenty going on outside the enormous towers. Performers put on regular entertainment and the strong-hearted can test their nerves at a number of activities designed to get that adrenalin coursing round your veins, such as balancing on the tightrope strung up between Castor and Pollux in 2007.

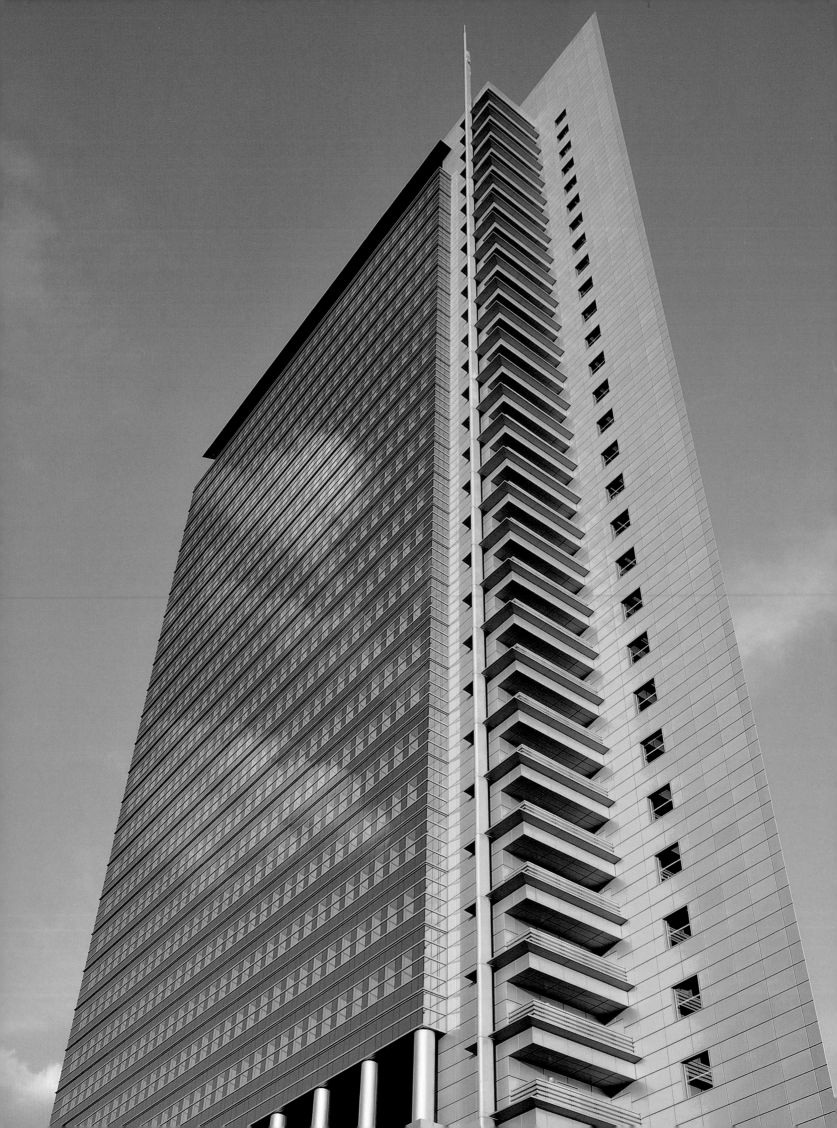

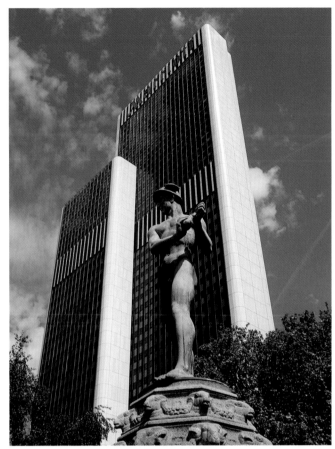

Far left:
Beneath the Messeturm Jonathan Borofsky's Hammering Man sculpture (23 m / 75 ft) beats his hammer incessantly, symbolising his solidarity with the working people of the world. The sculpture can be found in many variations in other major cities around the globe.

Left:
The Westend Gate erected by the Marriott Hotel Group in 1976 (159 m / 522 ft) is one of the older generation of skyscrapers that grace the Frankfurt skyline. The fountain in the foreground, not far from the trade fair, is topped by Mercury, the ancient god of trade and commerce.

Left:
The Radisson Blu Hotel, opened in 2005, is also of architectural interest. It resembles a disc placed on end and was designed by the English architectural bureau John Seifert.

Left page:
Clouds mirrored in the façade of Pollux in the warm light of the evening sun.

117

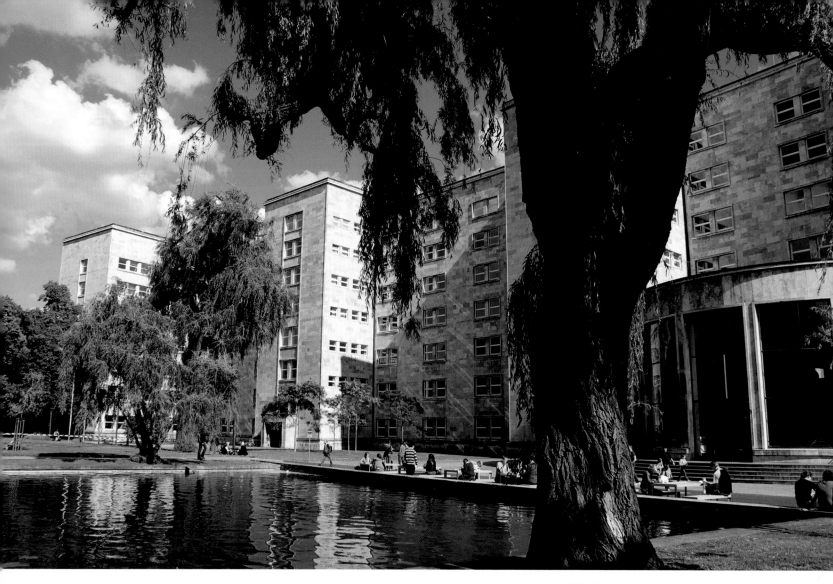

Photos, right, and right page:
In the hothouses of the Palmengarten botanical gardens you can explore the various climatic zones of the planet, from the subtropics to the savanna to the fog desert. The historic palm house is particularly charming, planned by expert gardener Heinrich Siesmayer on seeing the hothouses on show at the World Exposition in Paris. Winding paths thread around the palm house through a rock garden to an artificial grotto where a tiny waterfall splashes into the deep.

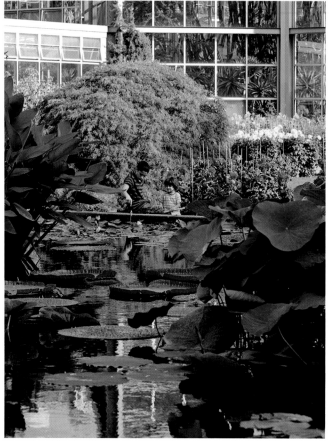

Right page:
Banking family Rothschild, who took over the land in the 19ᵗʰ century, had a small palace built here. Under the Nazis the Jewish Rothschilds were dispossessed and the big house itself, the Grüneburg, was destroyed in an air raid. The park is now dominated by the twig-like UFO of the Frankfurt television tower poking up behind the trees.

The Korean Gardens in Grüneburgpark were laid out for the 2005 book fair, where Korea featured as guest country. Experts from Korea were flown in especially. Typical elements include wooden pavilions such as these with their respective pond.

All year round joggers can be found in Grüneburgpark running off their day at work. Banker von Bethmann-Metzler procured the estate in 1789 and renamed it Grüne Burg (green castle), turning it into magnet for local society that also attracted the likes of Johann Wolfgang von Goethe and Bettina von Arnim.

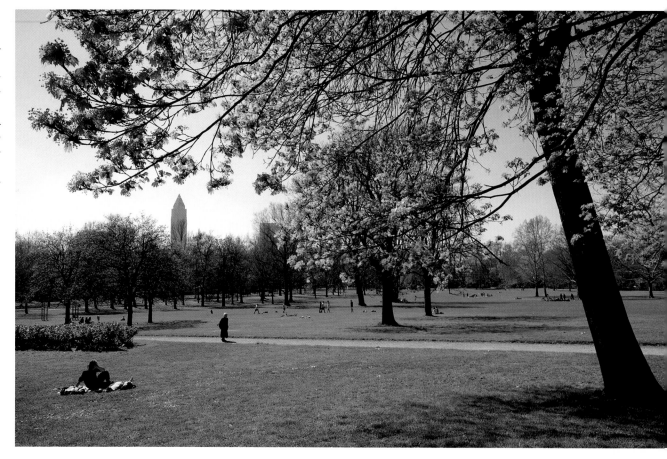

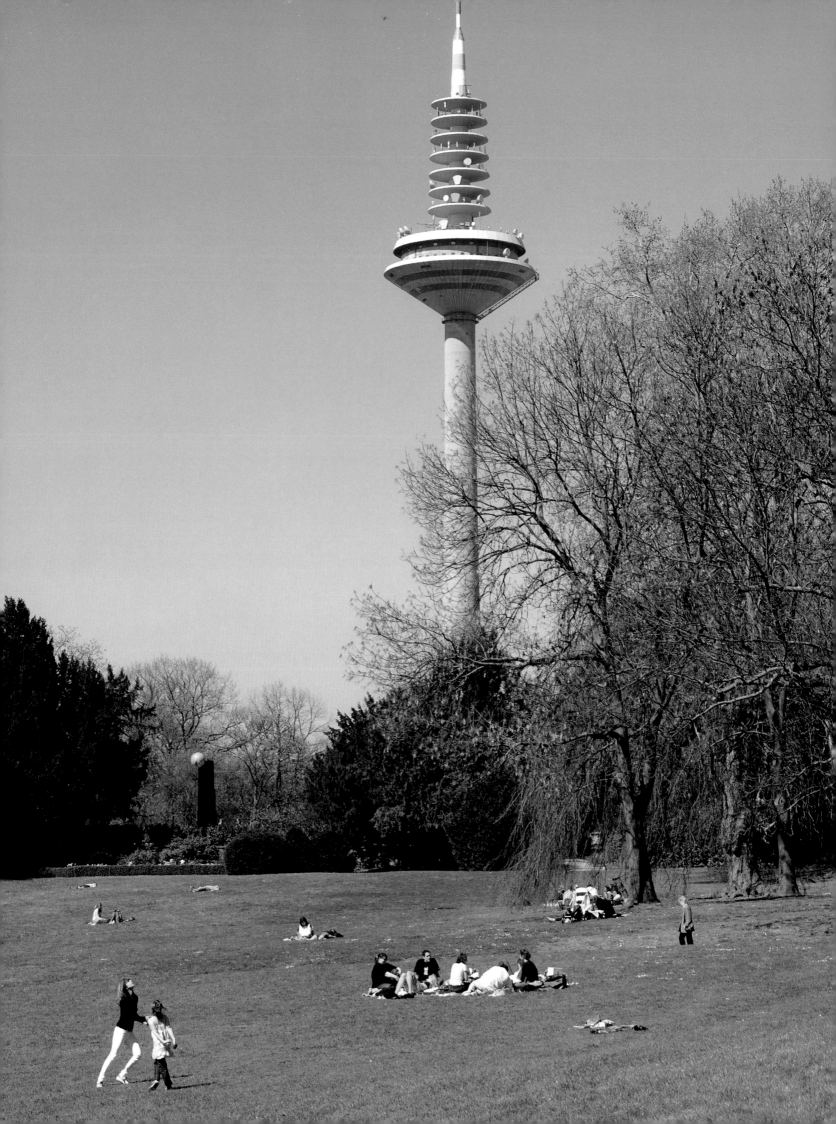

Above:
The Senckenberg museum of natural history houses one of the biggest collections on the subject in Europe and has some truly unique items on display. Founded in 1817 by the citizens of Frankfurt who constituted the Senckenberg Society of Natural Historians, the gallery was a huge attraction right from the start.

Right:
It's not just children whose eyes widen in wonder at the many enormous dinosaur skeletons on show here. The museum has an absolutely vast collection of other 'younger' animals, too, from large mammals, birds and fish to insects and invertebrates to artefacts documenting the history of the human being.

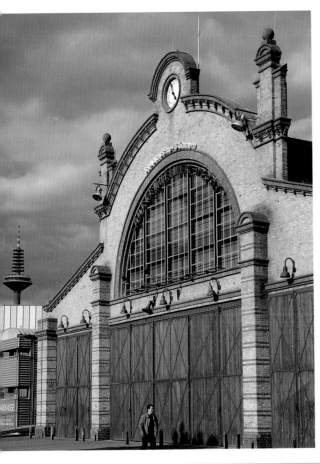

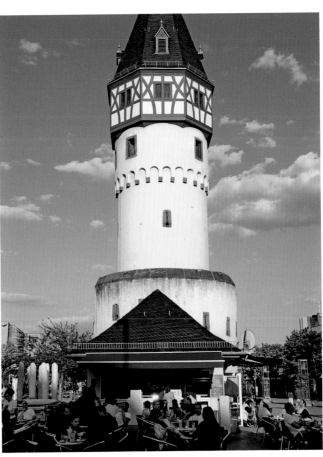

Far left:
The depot in Bockenheim, erected in 1900, was where trams were once repaired and stored. It's now a venue for contemporary works staged by the Frankfurt theatre and opera.

Left:
Although technically in Frankfurt-Westend, the Gothic Bockenheimer Warte, the watchtower constructed between 1434 and 1435, is heralded as the local landmark of Bockenheim.

Below:
The impressive entrance to the Bockenheimer Warte underground station was designed by Polish architect Peter Pininski. The old tram seems to rise up out of the ground to personally welcome its passengers.

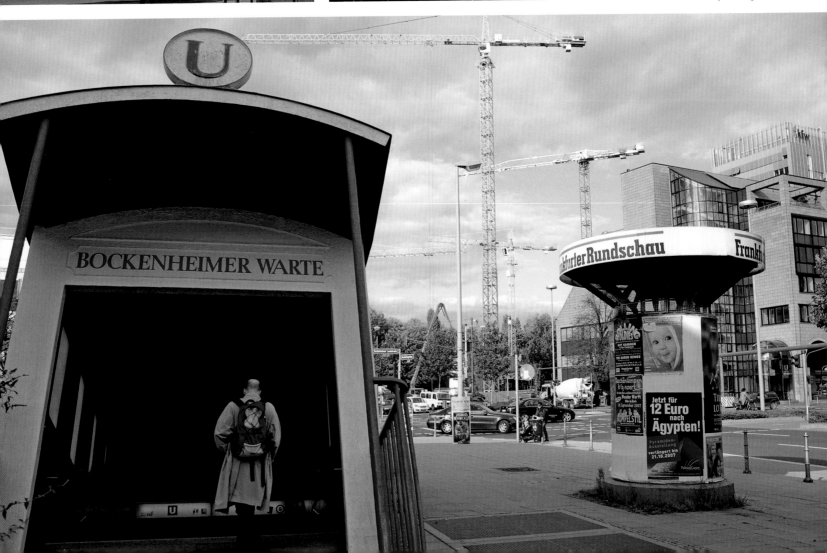

Right:
The industrial estate of Frankfurt-Höchst, now 460 hectares (over 1,130 acres) in size, started out as a small chemicals factory specialised in paint in 1863. After the IG Farben concern was broken up at the end of the Second World War, the ensuing company Farbwerke Hoechst was active here until the 1990s. The estate is now crammed full of ultra-modern facilities making products primarily for the chemicals and pharmaceuticals industries.

Below:
This crane reminds us that the quay in Höchst was once a harbour. Shipping activity here is now largely limited to the ferry running between the two banks of the River Main.

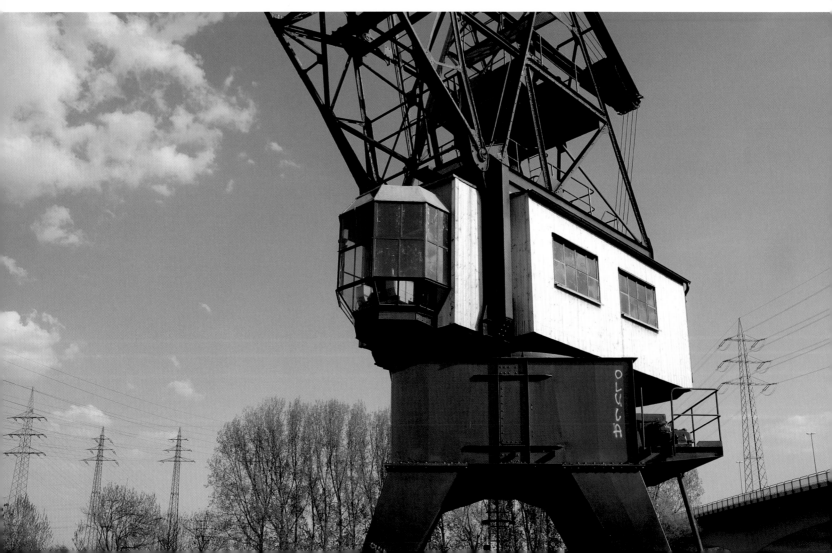

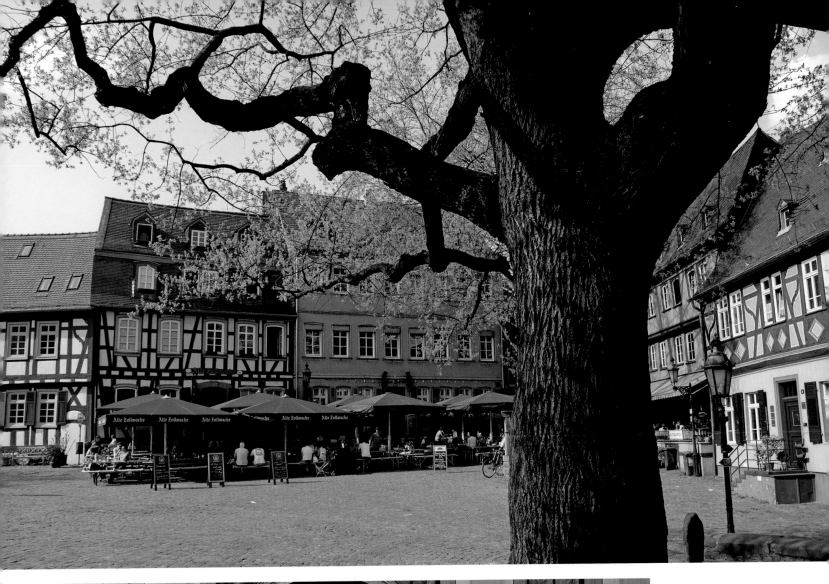

Above:
The absolute highlight of the old town of Höchst is Schlossplatz, now a listed site. Sitting outside one of the traditional pubs, you are surrounded by half-timbered buildings from the 14th to 16th centuries. The great oak on the square was planted over 130 years ago as a sign of peace commemorating the end of the Franco-Prussian War.

Left:
The Renaissance gate-house at the palace in Höchst is splendidly decorated, with a statue of St Martin halving his cloak placed ceremoniously above the entrance.

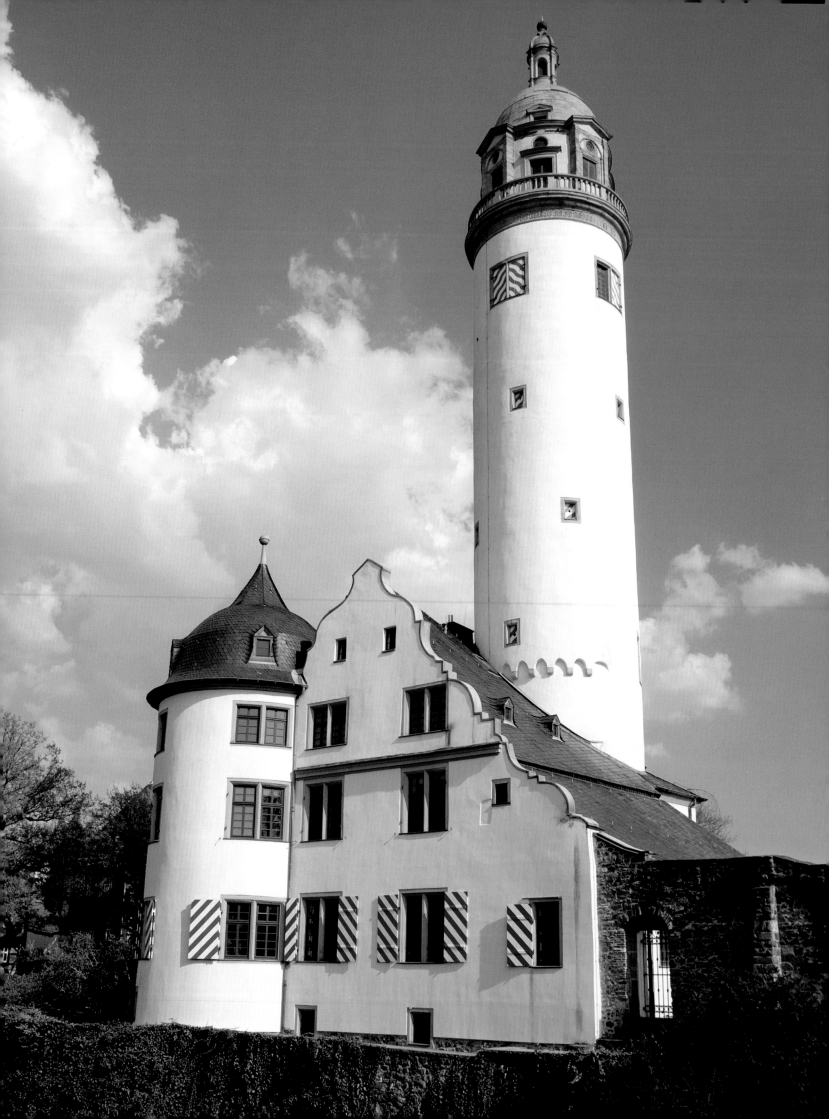

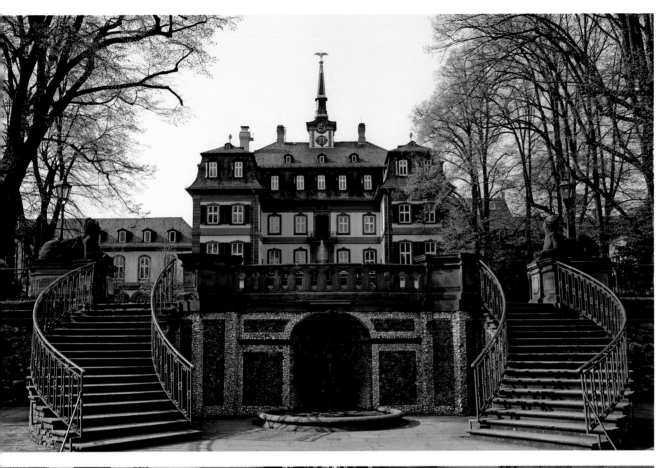

The keep of Schloss Höchst still seems to sternly watch over the town and surrounding area. It is the only remnant of the Gothic toll castle from the 14th century, with the present dome at its top added in the baroque period. Not much of the original castle is left as the main buildings burned down during the Thirty Years' War.

The late baroque, hoof-shaped palace of Bolongaro was built in Höchst by two Italian tobacco manufacturers in 1772–1775 who had been refused their civil rights in Frankfurt. The palace, now home of the local administration, still bears their name.

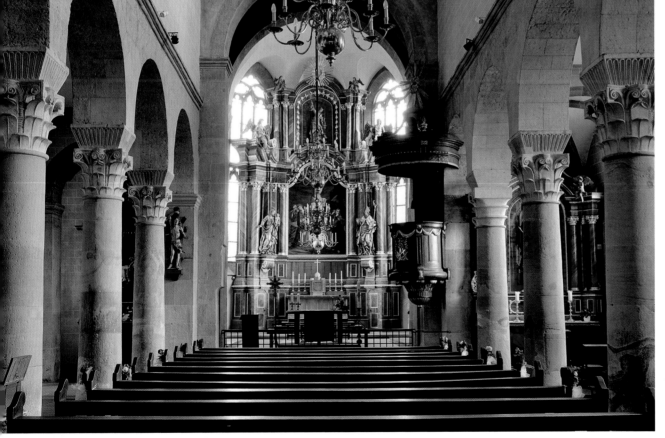

The Carolingian Justinus-kirche is the oldest surviving building in Frankfurt and one of the very few early medieval churches still standing in Germany. The aisled basilica that makes up the heart of the church dates back to 830. The late Gothic high chancel was added from 1441 onwards. The interior is largely baroque.

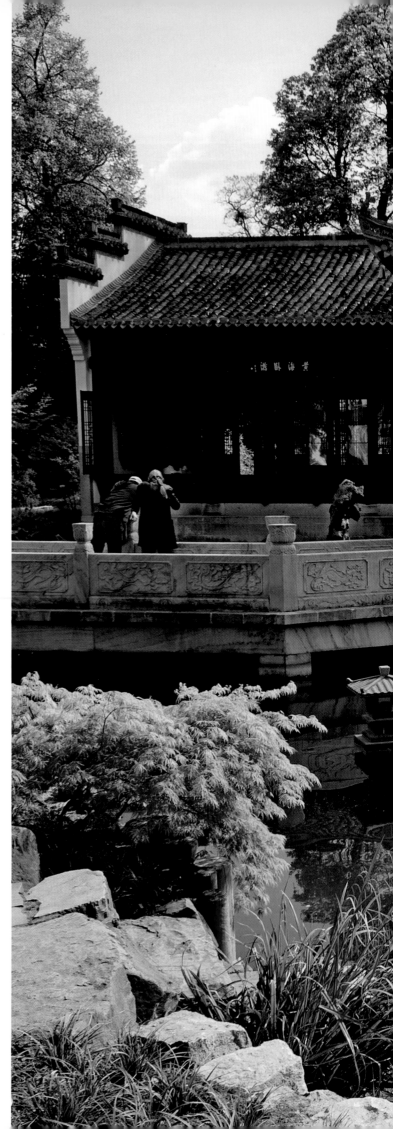

Below:
The French baroque palace in Holzhausenpark is a real gem. When in 1727 – 1729 Johann Hieronymus von Holzhausen had it erected on the foundations of an old Gothic moated castle, it was surrounded by fields. It's now in the middle of the metropolis, only protected from the skyscrapers by a small park. Today the palace is the seat of Frankfurt's citizens' foundation.

Right:
Shut away behind high walls is the Garden of Heavenly Peace, the Chinese garden in Bethmann Park. On entering you really do find yourself in a haven of green, with a serene pond sparkling at its centre.

Above:
Bethmann Park in Frankfurt-Nordend has always been extremely in vogue, changing in tune with the fads and fashions of the day from Rococo garden to informal landscape to Historicist park. This did little to hinder its popularity, attracting famous names such as Napoleon, Goethe and Emperor Franz Joseph of Austria-Hungary, in whose footsteps the more modern inhabitants of Frankfurt still like to tread.

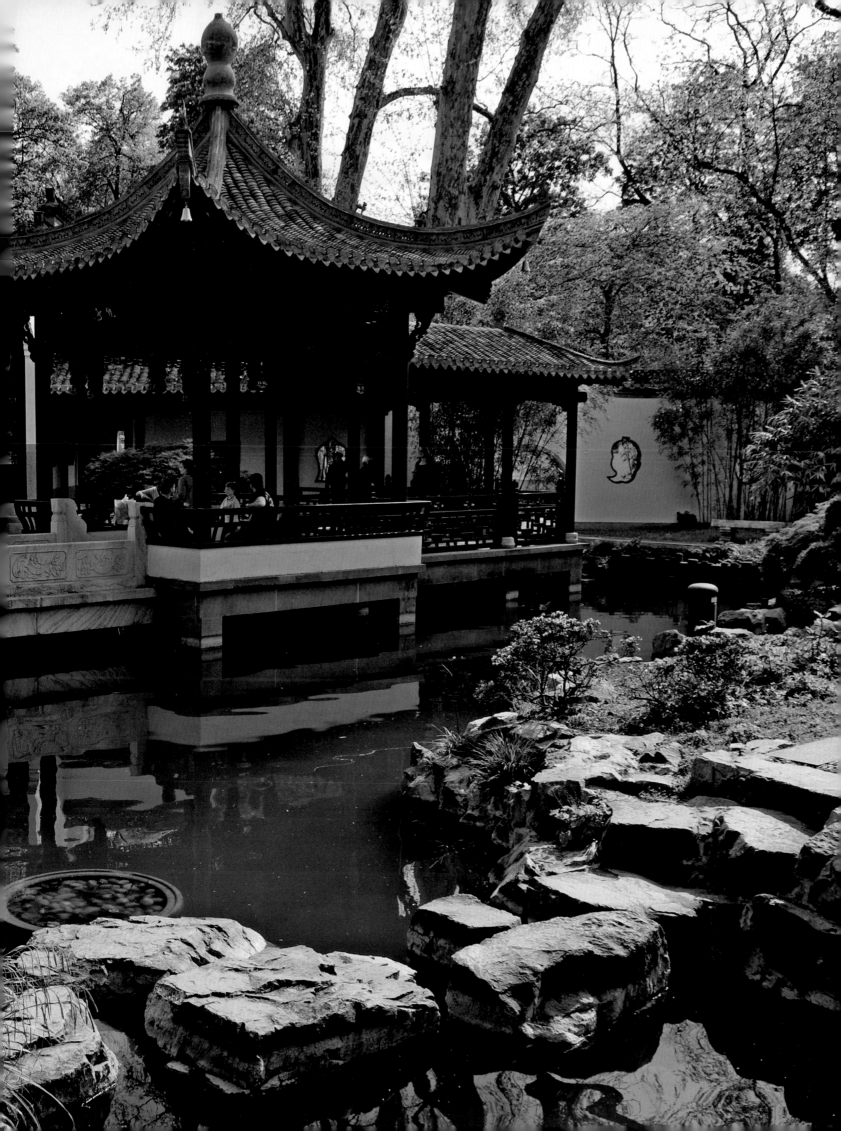

Above:
The Expressionist Mousonturm, erected from 1921 to 1926, was where Mouson soap was once made. Thanks to a local conservation order, the tower was saved when the company went bust. It is now an international art venue of renown.

Right:
Tradition dictates that at Fischhaus Ohrmann only the freshest fish is served! The lovingly furbished fish restaurant is just one of the many little pubs and shops that line the Oederweg in Frankfurt's suburb of Nordend.

Page 132/133:
Frankfurt's local hill is the
Lohrberg, 185 m / 607 ft
above sea level.

Far left:
The large number of wine
and cocktail bars and
trendy pubs on Bornheimer
Landstraße, such as
Harveys (shown here), are
extremely popular at night.

Left:
Friedberger Warte is part of
the Frankfurt fortifications
erected in the 14th and
15th centuries. It's now a
traditional cider tavern.

Below:
Per Kirkeby's monumental
brick sculpture outside
the German National
Library underlines the
institution's ambitious aim
to collect and catalogue
everything written in
German since 1913.

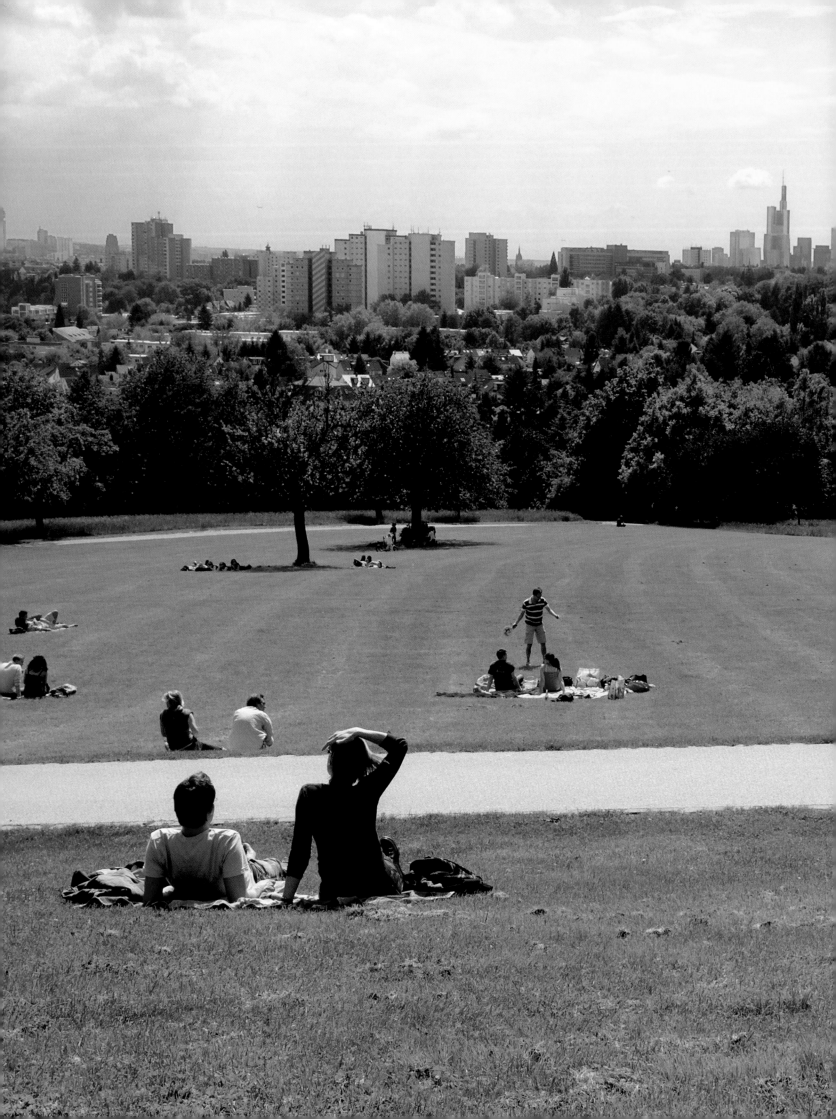

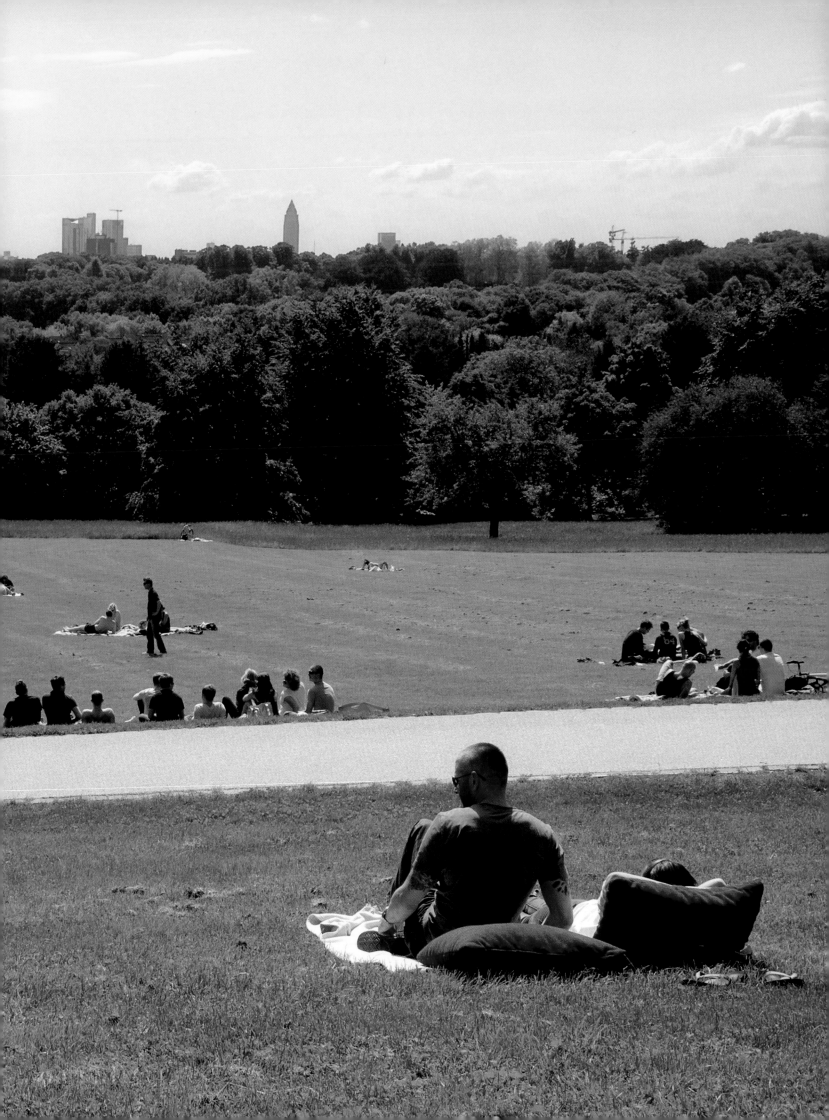

INDEX

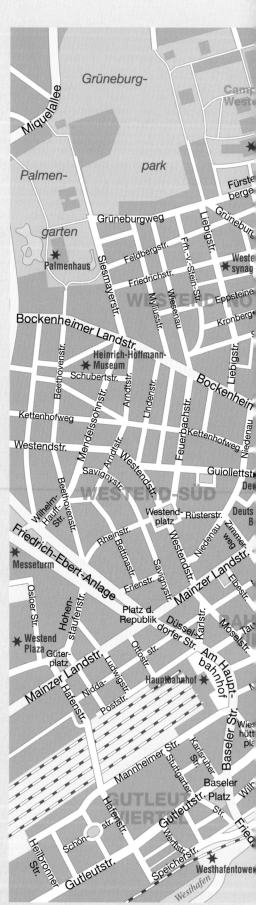

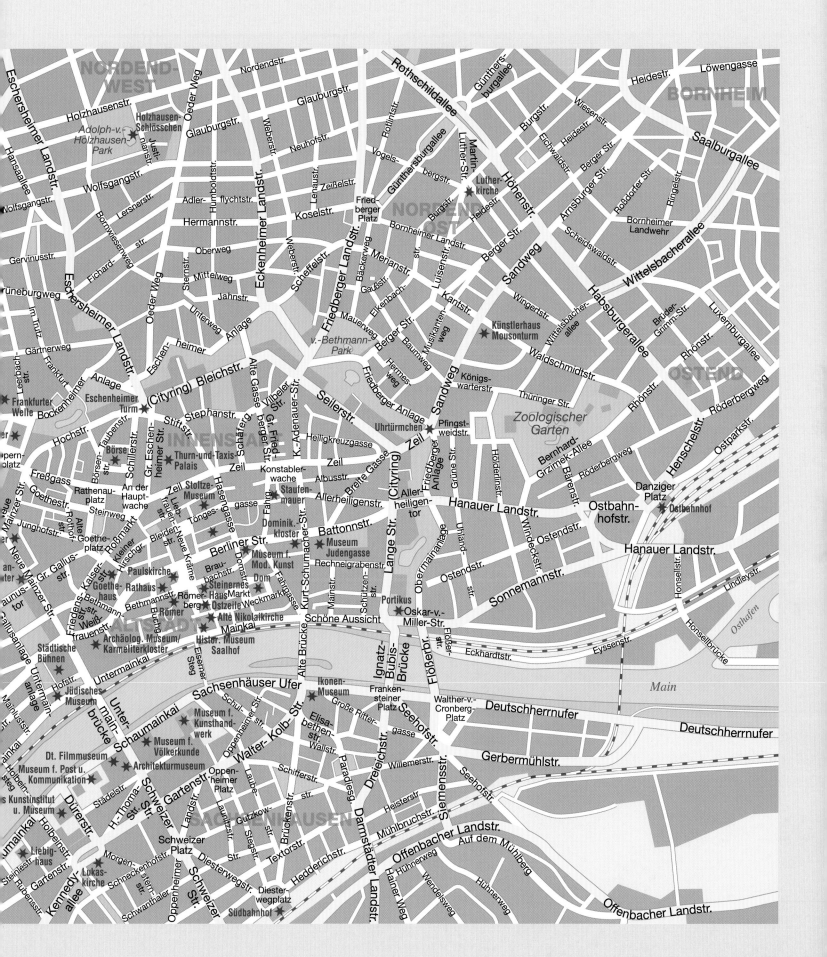

Frankfurt's national drink has always been and probably always will be cider. The beverage – and the taverns it was sold in – once made the narrow streets of Old Sachsenhausen famous far beyond the boundaries of Germany. This stone set into the pavement pays its respects to the fruit that made the area so famous.

Design
www.hoyerdesign.de

Map
Fischer Kartografie, Aichach

Translation
Ruth Chitty, Stromberg
www.rapid-com.de

Printed in Germany
Repro by Artilitho, Lavis-Trento, Italy – www.artilitho.com
Printed/Bound by Offizin Andersen Nexö, Leipzig
© 2009 Verlagshaus Würzburg GmbH & Co. KG
© Photos: Tina and Horst Herzig
© Text: Kerstin Wegmann

Picture credits
All photos by Tina and Horst Herzig, except on page 109:
© Liza Herzig

ISBN: 978-3-8003-4039-2

Details of our programme can be found at
www.verlagshaus.com

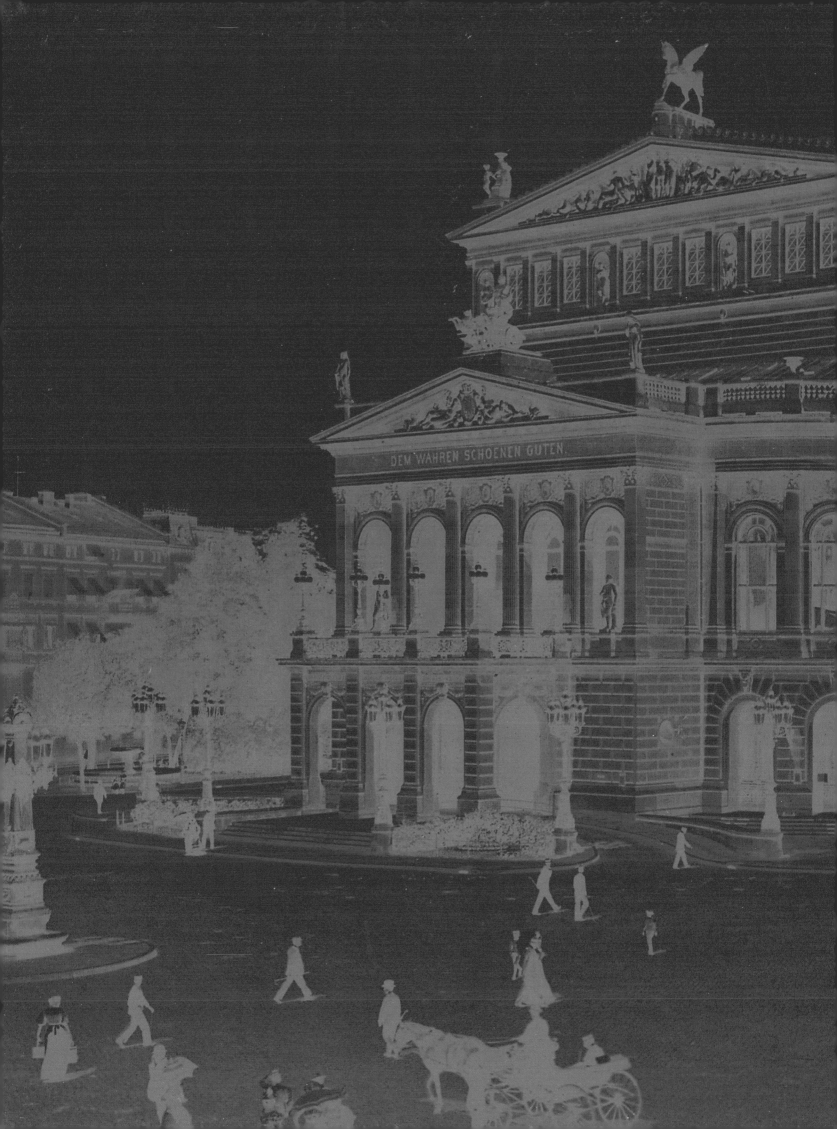